MW01069613

Nora Ephron at the Movies

Nora Ephron *at the* Movies

A Visual Celebration of the Writer and Director Behind
When Harry Met Sally, You've Got Mail, Sleepless in Seattle, and More

ILANA KAPLAN

Abrams, New York

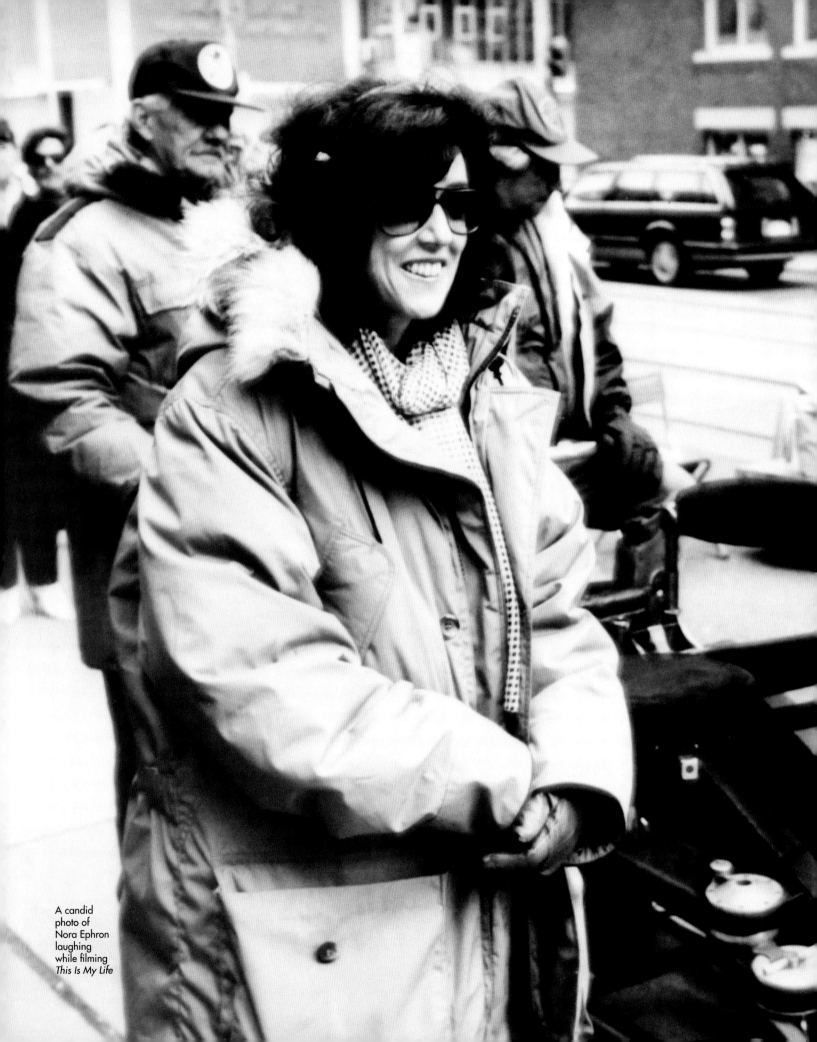

A candid photo of Nora Ephron laughing while filming *This Is My Life*

Contents

Foreword

by Jason Diamond

If you ever want to understand Nora Ephron and Nora Ephron movies, find a copy of the eulogy she read for her mother, the screenwriter Phoebe Ephron, in 1971. There, you'll read one of the earliest mentions of the Ephron family creed, "Everything is copy," but you'll also notice she brings up two other important things throughout the tribute to her late mother: books and movies. When she was a girl, Phoebe "would bring us books the way other mothers brought children toys or clothes or food." Her mother also wrote beautiful letters to Nora when she was apart from her daughter for whatever reason (travel, summer camp, etc.), giving her little insights into the world she worked in, the goings-on of people who worked on the lot, and other little tidbits. Phoebe had an eye for detail and got the good gossip. She helped instill a love of literature in Nora, as well as an appreciation for movies and the world that made them. Today, it seems so obvious what Nora was going to do with her life, simply

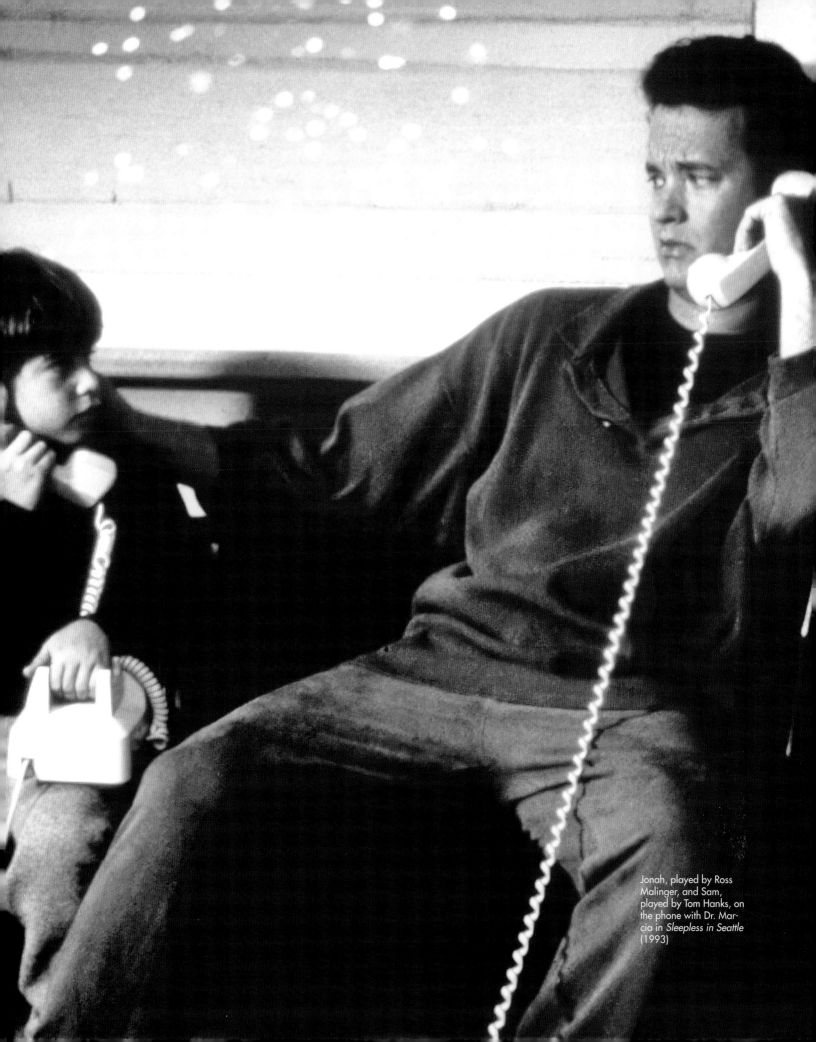

Jonah, played by Ross Malinger, and Sam, played by Tom Hanks, on the phone with Dr. Marcia in *Sleepless in Seattle* (1993)

because she did it. We can see her work. It's always going to be there. But there was also once a time when the idea of somebody—especially a woman, let's be honest here—going from Hollywood kid to big-time journalist to novelist and screenwriter, to writing, producing, directing—sometimes all at once—some of the most iconic films ever, seemed pretty improbable.

Yet if anybody was truly born to make movies, it was Nora. Today, we might label her a "nepo baby" because she ultimately found her way into the industry her parents—her father, Henry, co-wrote, among others, the 1957 Spencer Tracy and Katharine Hepburn rom-com *Desk Set*, with Phoebe—worked in. But I've come to hate that term, especially for somebody like Nora. Writing was—and still is—the Ephron family trade the way people used to learn to make horseshoes or tan leather and take over the family business. But unlike Phoebe and Henry, Nora initially made her name, back in the 1960s, reporting and typing some of the wittiest essays that writers are still trying to match even today. Then, in 1983, priorities began to

shift. That was the year her semiautobiographical (but not *too* semi) novel *Heartburn* came out in the spring, and *Silkwood*, adapted for the screen by Nora and Alice Arlen, arrived in theaters a few weeks before Christmas. The film eventually hit the top of the box office, and Nora and Alice—along with director Mike Nichols and stars Meryl Streep and Cher—were nominated, and lost, at the Oscars.

But really, who cares about awards? Nora was learning. She spent the next decade writing scripts and watching how other people directed, until it was time to try yelling "Action" herself. 1992's *This Is My Life* was her first actual time in the director's chair, but 1988's *When Harry Met Sally*—all due respect to the film's actual director, Rob Reiner—is when the phrase "Nora Ephron movie" became shorthand for something, like how we say "Google it" instead of "Type it into a search engine."

Seriously, can you even think about that movie *without* Nora being involved? You may as well remove the sound. The dialogue, scenes, and that perfect blend of ROMance

Kathleen (Meg Ryan) speaking with Joe (Tom Hanks) in *You've Got Mail* (1998)

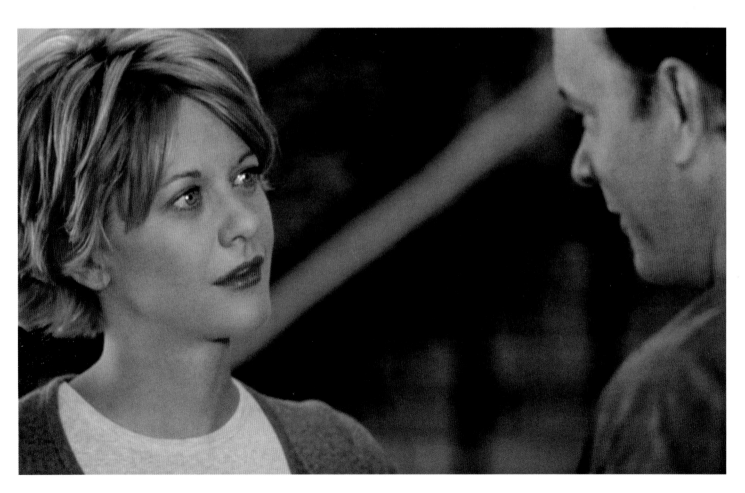

and COMedy are so singular that—again, all due respect to Mr. Reiner, whom I love—only Nora could have created them. The movie features a murderers' row of talent, but Ephron had their characters so fleshed out that even today you're likely to hear Meg Ryan's name and think *Sally Albright* or see somebody post a photo of Billy Crystal as Harry in his cable-knit sweater on their Instagram with a caption asking men what's stopping them from looking like that. God bless him, Billy Crystal wasn't meant to be a sex symbol, yet here we are. Bruno Kirby had a supporting role in *The Godfather 2*, but my guess is more people recall him for lines like "You made a woman meow" or his fight to save that stupid Roy Rogers wagon-wheel coffee table over any of the lines he delivered in Italian as the young Peter Clemenza. I'll give you that Carrie Fisher as Princess Leia is her most iconic role, but I'd counter you that Sally's married man–chasing best friend, Marie, is her *best* role. Just the way she says *"Married"* as she looks at the name of a man on a card in her Rolodex at the Loeb Boathouse in Central Park still cracks me up.

The other reason *When Harry Met Sally* will always be the first Nora Ephron movie to me is because it set the template. Some of the movies she created as writer, director, or both take place in New York City, and her beloved adopted metropolis is a main character; others take place in places like Seattle or San Diego. Three of them starred Ryan, one had Crystal as her romantic co-lead, and two of them swapped in Tom Hanks. Some were huge hits, others weren't, and a few I tend to think are hugely underrated. 1990's *My Blue Heaven*, a buddy comedy starring Steve Martin with a terrible, awful, hilarious Italian American New Yorker accent, being based on the life of real-life gangster Henry Hill, is funny enough of a setup to me. The fact that Nora's then husband, Nicholas Pileggi, had written the nonfiction book *Wiseguy*, about Hill's life, and that a month after *My Blue Heaven* was released Martin Scorsese's take on the story hit theaters, is downright hilarious. That movie, of course, is *Goodfellas*. It's an all-time classic work of cinema and one of my favorite movies ever. *My Blue Heaven* did meh at the box office, was mostly panned, and is also one of my favorite movies ever.

I mention all of this so I can get to the thing that truly ties all Nora Ephron Movies together, and probably why I keep going back to them time and time again. The witty conversations, the good clothes, the references and admiration of Hollywood's Golden Age—all those things play into it. But when I watch any of the movies talked about in this book, what I can't get over is how I saw many of them as a child and thought *This is what being an adult is like*. Everybody is so smart and witty. They have careers and love lives. They eat at trendy restaurants, but they also stop in at diners and Jewish delis. A lot of them are journalists, but there are also architects and bookstore owners. Then there's Parker Posey in *You've Got Mail* as Hanks's publishing industry power-player girlfriend, Patricia Eden. She's the most perfect Nora character, because some people see her and think *Oh god, she's horrible.* They can't wait for Hanks to leave her for Ryan. But if you've ever lived in New York City for any amount of time, you've known one or a dozen ambitious, self-absorbed, and downright fabulous people who will say things like "You know, what's always fascinated me about Julius and Ethel Rosenberg is how old they looked when they were really just our age," over cocktails and caviar in a fancy apartment. I don't know what it says about me, but these were the people I wanted to be and know when I was a kid, and they're the people I want to be—to some degree or another—and know as an adult.

I didn't know Nora. I never talked with her, and I've heard and read plenty about how tough and biting she could be. And the truth is, I'm fine with all that, since the whole thing about how you should never meet your heroes is sound advice. But because of that distance, because of the way I know her through the characters, scenes, and dialogue she created, not a day goes by when I don't think, *This scene I'm currently living through could use a little more Nora Ephron.* And whenever I watch any Nora Ephron movie, I can't help but think about how nobody did it like her, and no one can follow her. ◆

Introduction

I've spent most of my life daydreaming that I was living in a rom-com. I grew up on a cultural diet of Nora Ephron movies, fantasizing about being Meg Ryan in *When Harry Met Sally* or *You've Got Mail*. Today, much of my writing career focuses on film and nostalgia—dissecting the rom-com as a contemporary cultural phenomenon through features, retrospectives, and oral histories. And when I'm not examining and analyzing these films, I'm watching them.

Nora's work transformed the way I saw myself—I could be frustrating and flawed and resist tradition: I could be *seen*. Being a woman was an imperfect and nuanced experience that Nora captured perfectly in her writing and portrayed on-screen, nervous breakdowns and all. With a knack for expressing unfiltered emotions and naked inclinations for romance, Nora coined an aesthetic moment of chunky sweaters, autumn leaves, and cozy, lived-in brownstones. She encapsulated a nineties New York City

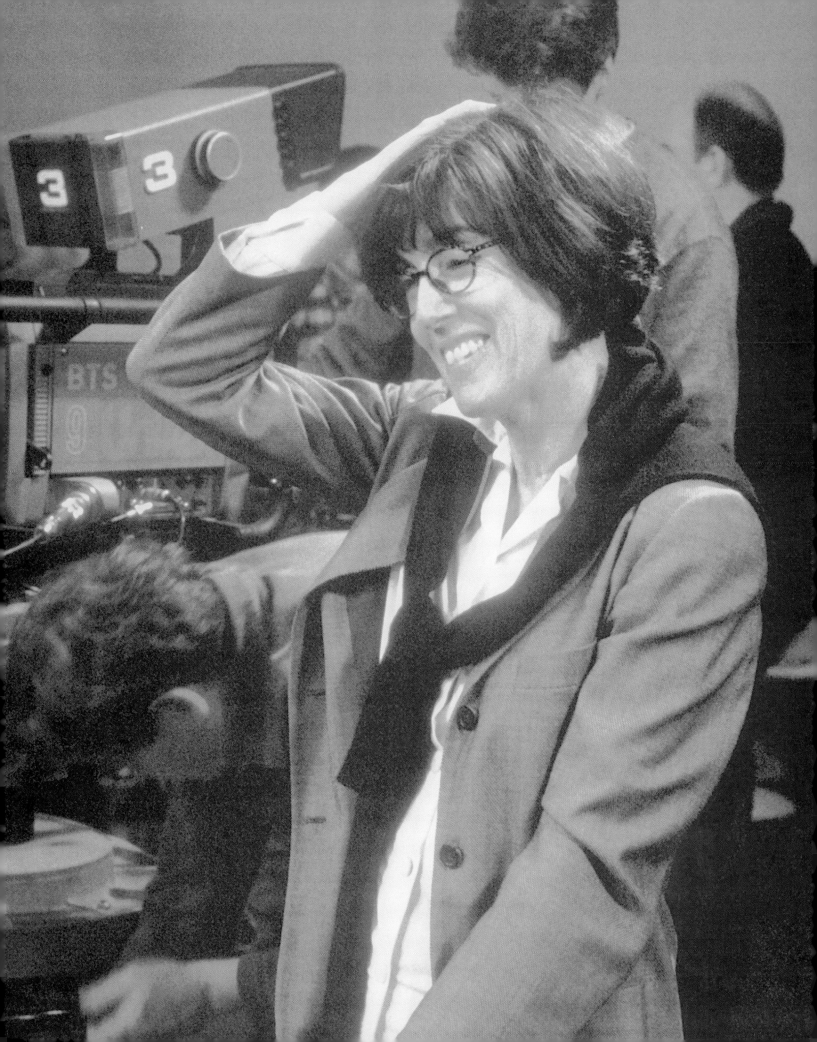

intellectual glamour that everyone craved and she brought to life. I believed wholeheartedly in the fantasy: my Prince Charming would stroll into the indie bookstore I worked at and sweep me off my feet, or maybe a sweet story on the radio would lead to a meet-cute with me and my future husband. To some, I may have been delusional (I prefer the term "hopeless romantic"), but I was far from alone in my sublime reveries. And they could be beautiful thing.

Like so many others who longed to be writers, Nora and her real-life impressive

PREVIOUS PAGE Nora clutches her head laughing while filming on set.

BELOW Nora's parents, Phoebe Wolkind and Henry Ephron, who were screenwriters

career became aspirational for me. Her razor-sharp wit and brutally honest tone made her a maverick writer—a brave, bossy confidante who never held back. In many ways, Nora's personal life was the antithesis of the relationship-focused storylines of her sugary rom-coms I devoured.

Nora's mantra "Everything is copy" became words I too aspired to live by: advice passed on from her screenwriter mother, Phoebe, about the power of autofiction. The way Nora put it: "When you slip on a banana peel, people laugh at you. But when you tell people you slipped on a banana peel, it's your laugh."[1] In short, oversharing personal anecdotes could make you the protagonist of the story while simultaneously reclaiming control of the narrative. When Nora tackled her insecurities

about her small breasts, confronted her aging neck skin, or eviscerated her philandering ex-husband, she didn't spare herself or others. And she certainly didn't feign indifference. She told the story as hers and made space for others to relate, and readers like me clung to every word. As film critic Rex Reed so aptly noted, she was "a fresh, inventive observer who stalks the phonies and cherubs alike, sniffing them out like a hungry tiger, clamping her pretty teeth down in all spots where it hurts the most, then leaving all of her victims better off than they were before they met Nora Ephron."[2]

Though I've admittedly been much more selective than Nora, that principle has guided me through the tough years when I've wanted nothing more than to dig deep into my own personal foibles and lean into a spiral of self-pity. Guided by Nora, I managed to reclaim these insecurities and struggles by writing about them, finding humor in even the most traumatic of experiences.

Through her keenly self-aware humor and semi-autobiographical stories, Nora left behind a groundbreaking legacy as a beloved journalist, essayist, screenwriter, author, producer, and director who delivered stories of resilience embedded in unparalleled humor and upper-crust landscapes. She became emblematic of rom-coms, shifting and redefining conversations around the complexities of relationships and the women who have them. With her singular voice, Nora flourished as a dominant force in the industry, focusing on the idiosyncrasies of romance that we could all relate to. There was a balance to the women in her stories that paralleled reality—the veil was lifted, the glossy sheen removed—and yet you always sympathized with them. The women in Nora's stories had an unwavering sense of humor about life's mishaps and never took themselves too seriously—like Julie trying to master the art of cooking lobsters in *Julie & Julia*, Sally's theatrical orgasm display in Katz's Deli, or Rachel perfecting a Key lime pie in *Heartburn* only to throw it in her cheating husband's face. Those liberating moments of feral, unapologetic emotion added a deeply human quality to Nora's protagonists and a layer of levity and accessibility to her movies.

Born on the Upper West Side of Manhattan to Hollywood screenwriters Phoebe Wolkind and Henry Ephron—the duo behind

films such as *Carousel* and *There's No Business Like Show Business*—Nora and her three sisters, Delia, Amy, and Hallie, were primed for the family business.[3] "Nora was the smart one. Delia, the comedian. I was the pretty, obedient one. And Amy was the adventurous mischief-maker," Hallie wrote in an essay for Oprah.com. "But in reality, we were more alike than we were different—all bossy and opinionated, witty and articulate, like our mother."[4] Nora, Delia, Amy, and Hallie would all ultimately end up as writers, like their parents.

When Nora was growing up during the

and dine with the family, including, as her parents told her, the great Dorothy Parker.[6]

But Phoebe and Henry were complicated parents who didn't coddle their children. They were also alcoholics. Phoebe's drinking was seemingly worsened by her husband's infidelity, something that she never quite recovered from. She never wrote about it either—in Henry's memoir, he seems to speak around the subject and blame the pain of her father's death for her drinking. Still, Nora admired how much trust her mother instilled in her: "I remember, on yet another of those nights

1940s, women were largely housewives. But not Phoebe. Though she initially quit her job when she got pregnant with her firstborn, Nora, she never intended to be a homemaker. Instead, she collaborated with Henry on the plays he was writing. Their first success, released in 1943, was *Three's a Family*, a play Phoebe dreamed up that turned a mother's despair into comedy. According to Nora's sister Hallie, Phoebe "insisted her name come first on the credits," even though the production was made by both Phoebe and Henry.[5] Their accomplishments soon prompted a move to Hollywood, where they would host gatherings and dinner parties in their Spanish-style home. Over the years, Nora was lucky enough to witness a handful of fascinating people wine

when I came home from a date, going in to curl up and talk with her and, hesitatingly, asking her for some sexual advice. She looked at me and said, 'Nora, you are sixteen years old and, if I haven't raised you to make your own decisions, it won't do [you] any good to tell you what I think.' I thought that was marvelous." In turn, Nora's work ethic and values were largely shaped by watching her mother work. "My mother was a career woman who had successfully indoctrinated me and my sisters that to be a housewife was to be nothing," she wrote.[7]

Like her parents, Nora wanted to tell stories. But unlike her parents, Nora preferred New York to Hollywood. After graduating high school, she moved to the East Coast to attend

Nora and Delia Ephron at the premiere for *Bewitched* in 2005

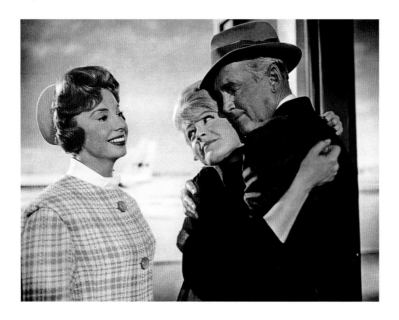

ABOVE Mollie, played by Sandra Dee, hugging father Frank, played by James Stewart, as Audrey Meadows, who plays her mother, looks on in *Take Her, She's Mine* (1963)

OPPOSITE Dorothy Parker in 1932

Doris Lessing at the launch of a collaborative book, *Declaration*, in 1957

Greer Garson as Elizabeth Bennet and Laurence Olivier as Mr. Darcy in *Pride and Prejudice* (1940)

Cary Grant as Nickie and Deborah Kerr as Terry at the top of the Empire State Building, sharing a romantic moment in *An Affair to Remember* (1957)

Suzy, played by Rita Wilson, sobbing while delivering a romantic retelling of the film *An Affair to Remember* to Sam, played by Tom Hanks, and Greg, portrayed by Victor Garber, in *Sleepless in Seattle* (1993)

Wellesley College.[8] But it was a time when a degree was a backup plan for a failed marriage. "We weren't meant to have futures, we were meant to marry them. We weren't meant to have politics, or careers that mattered, or opinions, or lives; we were meant to marry them," Nora said years later in a commencement speech at her alma mater.[9] It was there that her interest in journalism surfaced, writing and editing for the newspaper and later graduating with a degree in political science.

During her time at college, Nora sent "bantering letters" home to her mother about her life as it unfolded, a tradition that began during Nora's years at summer camp and helped shape her style as a storyteller.[10] Nora's college letters eventually became inspiration for her parents' play—and later film—*Take Her, She's Mine*.[11] The play, which featured quotes from Nora's letters,[12] focused on the college exploits of young adult daughters and how their fathers try to cope with the phases they go through while growing up—such as activism and "the lethargy of beatniksville."[13]

Following her studies at Wellesley, Nora landed her first entry-level gig in the mail room of *Newsweek*, where she earned fifty-five dollars per week. In no uncertain terms she was told "women don't write." Nora explained, "There were no mail boys at *Newsweek*. If you were a college graduate (like me) who had worked on your college newspaper (like me) and you were a girl (like me), they hired you as a mail girl. If you were a boy (unlike me) with exactly the same qualifications, they hired you as a reporter." If they weren't mail girls,

the women were clerks who went on coffee runs. The lucky ones were able to fact-check the male reporters' copy. Nine months into her *Newsweek* gig, Nora "blasted out of there while climbing the greasy pole" once she realized the publication's "boys' club" would never hire her as a writer. "Women are loyal and true in a way that men aren't. We have trouble breaking up," she said about leaving. "On some level, you have to choose to not be victimized by the things you should be calm about and focus on the things that should actually upset you." This discrimination fueled her determination and eventually she landed a reporter role at the *New York Post*.[14]

Later, she wrote for *New York* magazine and *Esquire*.[15] And her biting, confessional essays about breasts and body image ("A Few Words About Breasts"), celebrity chef gossip ("The Food Establishment"), and scandal ("Spurned Headmistress Packs Heat Heads to Scarsdale") would become a defining part of her decades-long career.

Nora was influenced by the female writers who came before her, including Dorothy Parker, Doris Lessing, and Jane Austen, whose writing was rooted in defying societal expectations. Parker, who penned vicious poems that detailed the absurdity of her personal life, had the same acerbic wit Nora strived for. Lessing's 1962 radically feminist tome *The Golden Notebook* appealed to Nora because of the topics she covered—"work, friendship, love, sex, politics, psychoanalysis, writing—as well as the novel's heroine Anna and her quest 'to become a free woman.'"[16]

Nora admired Austen in particular for *Pride and Prejudice*, saying it was "one of the greatest romantic comedies ever written, a novel about the possibility of love between equals." She also loved that Austen didn't give the book's heroine, Elizabeth Bennet, a physical description—it wasn't for the male gaze.[17] Her love of *Pride and Prejudice* surfaced in *You've Got Mail*, where Joe and Kathleen are a modern-day William Darcy and Elizabeth Bennet. In *Pride and Prejudice*, Elizabeth believes what she hears about Mr. Darcy's arrogant demeanor, but as she gets to know him, she discovers there's more to him than meets the eye. Likewise for Joe and Kathleen—their initial impressions dissolve once they look beyond their bookstore rivalry and focus on their human (and online) connection. The

film references the Austen classic head-on. As Kathleen pretends to read a copy of Austen's novel while waiting for her mystery date in a coffee shop, Joe teases her: "I bet you read that book every year. I bet you just love that . . . Mr. Darcy."[18] He's not exactly wrong.

Stemming from her upbringing, Nora was inspired by Hollywood's golden age.[19] She found a thrill in the magic of classic romances such as *An Affair to Remember*, *The Shop Around the Corner*, *It Happened One Night*, and *His Girl Friday*. When Nora first saw the 1957 tearjerker *An Affair to Remember* with her mother, she "just lost it."[20]

It became one of Nora's favorite films and a prominent theme in *Sleepless in Seattle*. Rita Wilson delivers a weepy retelling of the movie, and Nora created her own version of the *Affair to Remember* Empire State Building scene. Nora later put an email-centric spin on the 1940 rom-com *The Shop Around the Corner*, turning the feuding clerks who are unwitting pen pals into bickering rival booksellers.[21] The cleverness of films such as *It Happened One Night* and *His Girl Friday* was a hallmark of all of her rom-coms.

Feminist author and journalist Rebecca Traister perhaps said it best: Nora's "movies took interesting, complicated, difficult women and treated them like they were subjects worthy of having movies made about them."[22] In Nora's screenwriting debut, *Silkwood*, the perseverance and ambition of a whistleblower who exposed the flawed safety practices of an Oklahoma plutonium plant drive the film, and in *Heartburn*, it's a thinly veiled, semi-autobiographical story about the emotional roller coaster of Nora's second marriage and the brave decision to choose independence over a man.

In *This Is My Life*, it's about the determination of a single mom to become a stand-up comic. *When Harry Met Sally* focuses on agency and evening the playing field between men and women, while *Sleepless in Seattle* is a story of two pragmatic people who dissect unrealistic expectations of love. And *You've Got Mail* plays with the idea that opposites attract despite professional rivalries and catfishing. Then there's Nora's final film, *Julie & Julia*, which is a love letter to food and the force of creative ambition. Each project focuses on women who were three-dimensional and who had something to prove—either to themselves or to the world at large.

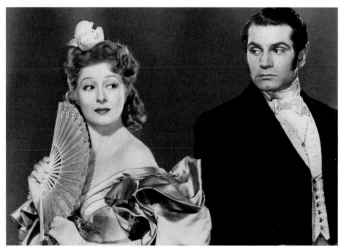
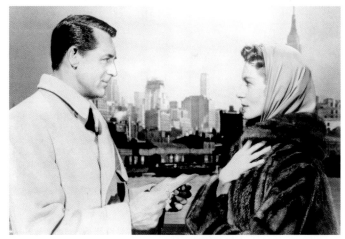

Nora is perhaps best known to the mainstream for her film career and for being a Hollywood trailblazer who broke through the glass ceiling and battled industry sexism. As one of the first female screenwriters, she was a disruptor of the male gaze for writing women who could truly be seen and not trivialized, one of the main reasons her body of work has continued to resonate. Her female characters are complex: they're smart and funny but also flawed, neurotic, and, at times, deeply unlikable. Their beauty isn't solely superficial, and they aren't just there to make their male counterparts look smarter on-screen; in fact, they generally aren't afraid to put them in their place. They're real, and there's always a halo of optimism surrounding them. Despite any insufferable qualities Sally Albright, Annie Reed, Kathleen Kelly, and Julie Powell, for instance, may exhibit, viewers still root for their happily-ever-afters.

Nora believed in ownership of experience—of the tragedies, the love stories, the insecurities, and the horrors that would inevitably come around, someday, to become humor in copy, even when she couldn't see it yet. Her inimitable talent for turning setbacks into success was unmatched. Profound revelations from ordinary experiences defined her essays, films, and plays. And that quality is what made her feel like the blunt, witty best friend you hadn't met yet. ◆

BELOW Nora Ephron with Nick Pileggi and son, circa 1993

OPPOSITE Nora Ephron at the Barrymore Theatre, where her play Imaginary Friends was featured

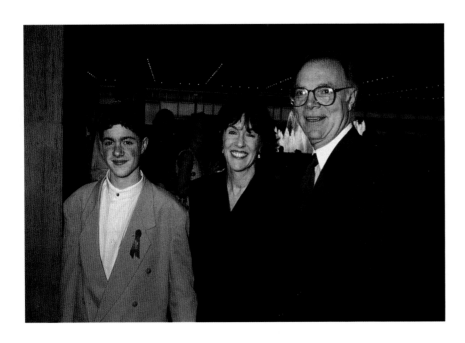

Prologue: Reinventing *the* Rom-Com

Think of Nora Ephron as the fairy godmother of modern-day rom-coms. After years of a genre lying in wait, she waved her magic wand and penned dazzling scripts, equivalent to charming ball gowns for women who wouldn't take any shit. She cast a spell on Hollywood with her charming plots, explosive chemistry, and leading questions about destiny and romance.

Nora deserves significant credit for the rom-com boom of the 1990s and early 2000s,[1] which created regular opportunities for women in writing, directing, and producing, and created a modern commentary on dating and singledom that connected with audiences.[2] The widespread critical and commercial success of Nora's genre-defining film *When Harry Met Sally* and the "hooker with a heart of gold" vehicle *Pretty Woman* (directed by Garry Marshall) ushered in a new era for the rom-com.[3] (The former earned a hefty $92.8 million at the box office, while the latter became the biggest rom-com hit in history by total number

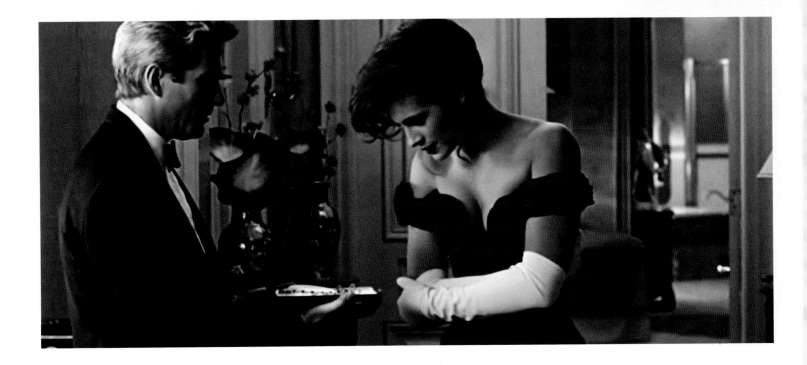

PREVIOUS SPREAD
Samantha, played by
Molly Ringwald, and
Jake, played by Michael
Schoeffling, sitting on a
dining table with a birth-
day cake, gazing into
each other's eyes, in *Six-
teen Candles* (1984)

ABOVE Richard Gere's
Edward gifting Julia
Roberts's Vivian with a
necklace in *Pretty Woman*
(1990)

OPPOSITE Hildy, played
by Rosalind Russell, and
Walter, played by Cary
Grant, as sparring news-
paper staffers on the
phone in *His Girl Friday*
(1940)

Alvy, played by Woody
Allen, and Annie, played
by Diane Keaton, talking
and drinking on a New
York City rooftop in *Annie
Hall* (1977)

of tickets sold and was the highest earner of 1990, per *Indiewire*).[4] Its success helped kick off the era. But a rom-com about a prostitute love story wouldn't have landed on its own. The rom-com renaissance was driven by the quirky "girl next door" types like Meg Ryan and Julia Roberts, the anchors for flawed female hero-ines and their quippy lines. And Nora contin-ued to build on the success of *When Harry Met Sally* with 1993's *Sleepless in Seattle* and 1998's *You've Got Mail*—a trio of canonical projects.

Before Nora, the rom-com had a reliable for-mula: boy meets girl, boy and girl have a con-flict, and then boy and girl resolve that conflict and live happily ever after, with film flourishes including bombshell leads, surface-level chem-istry, and predictable humor.[5] As trends came and went, the rom-com evolved and endured a series of makeovers: the Great Depression was dominated by screwball comedies like *His Girl Friday* (1940) and *The Lady Eve* (1941), elevated by Hollywood's leading stars, such as Cary Grant and Barbara Stanwyck; from the 1950s to the 1960s the rom-com was "radicalized" by the sexual liberation movement and resulted in movies such as *The Battle of the Sexes* (1960) and *Lover Come Back* (1961), where the enemies-to-lovers trope ran rampant.

By the 1970s the rom-com formula turned redundant, aside from the introduction of *Annie Hall* (1977) and *Manhattan* (1979), which homed in on insecurity, anxiety, and bitter-sweet romances. The 1980s birthed high school

rom-coms such as *Sixteen Candles* and *The Breakfast Club*, but the allure of rom-coms had largely dissipated at the box office, until Nora ushered in their golden age.[6]

Growing up enamored with Old Hollywood romance flicks such as *The Lady Vanishes* (1938), *An Affair to Remember* (1957), and *The Apartment* (1960) informed Nora's rom-com framework, but she brought her own personal twists to the genre. She added the neuroses of Woody Allen, quippy dialogue, a sense of nostalgia, and *real* female heroines written through the female gaze. And, as Andrew O'Hehir noted in Salon, "Ephron's best scripts offered the comfort of an old-fashioned love story in what felt like a fizzy, urbane contem-porary setting."[7] She uncovered the perfect recipe for building chemistry, often in a gray metropolis such as New York or Seattle.

In turn, Nora built a distinct sense of famil-iarity in all her characters, which made the genre more universally relatable. She made ordinary connections—an email exchange or a voice on a radio show—feel like destiny, quenching audiences' thirst for old-school Hollywood romance with an added layer of vulnerability and intimacy. Nora may not have invented the meet-cute, but she sure as hell took the reins and made it her own. With meet-cute after meet-cute in *When Harry Met Sally*'s vignettes, we all started to believe that love could come from a cross-country road trip or a chance encounter in a bookstore.

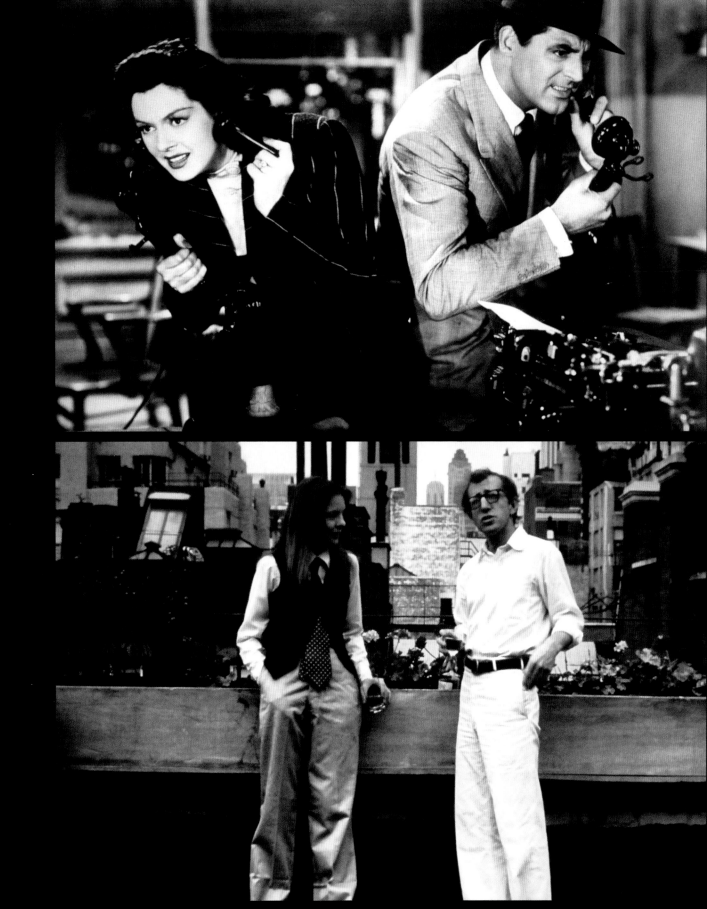

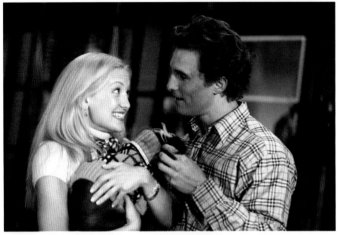

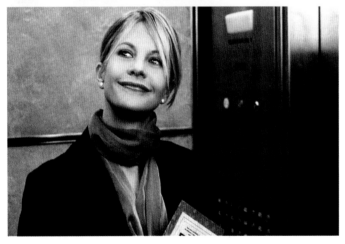

ABOVE Tom Hanks as Ray in *The 'Burbs* (1989)

Billy Crystal smiling in a photo taken for *The Billy Crystal Comedy Hour* (1982)

Andie, played by Kate Hudson, holding the dog she bought Ben, played by Matthew McConaughey, in *How to Lose a Guy in 10 Days* (2003)

Meg Ryan as Kate, smiling to herself in an elevator, in *Kate & Leopold* (2001)

THE RADICALIZATION OF THE ROM-COM

Nora's rom-coms are decidedly not chick flicks: they are explorations of heartbreak, grief, passion, love, and sex through complicated female protagonists with their own ambitions that reach far beyond just having a man's arm draped around them. These women grapple with misogyny, power imbalances, and the nuances of love and pain. As Erin Carlson reasons in *I'll Have What She's Having*, Nora was "a proto–Taylor Swift" who "channeled heartbreak into pop art."[8] Instead of four-minute radio hits, her soul-baring numbers have lived on as ninety-minute-long tearjerkers with lots of cable-knit sweaters. "She dispensed entirely with the requirement that the girls be virginal while the guys are shadowed with dark experience. Her characters are witty, fast-talking city dwellers who discussed previously forbidden topics like politics, religion, and (most of all) sex," O'Hehir wrote.[9] It was radical, and yet comforting, which is what made Nora's films work: she embraced the history of the rom-com genre as much as she subverted it. Rob Reiner believed that "the reason she became such a good director was similar to the way she was able to make a meal: she knew what she wanted, what would taste good, and what would work."[10] And sometimes, it was a recipe for success.

Instead of casting Katharine Hepburn and Cary Grant lookalikes, Nora opted for quirky, endearing leads such as Meg Ryan, Tom Hanks, and Billy Crystal, who re-created that same delicious chemistry on-screen that old Hollywood romances once delivered but with an addition of charming eccentricities that created more space for viewers to see themselves in the leads.

Ryan, Nora's muse, helped carve out space for relatable rom-com leads, including Julia Roberts, Sandra Bullock, and Kate Hudson. Much of their skyrocketing fame was due to their acting alone—Ryan's quirkiness makes you root for Annie's stalker-like tendencies in *Sleepless in Seattle*; Roberts evokes empathy as wedding saboteur Julianne in *My Best Friend's Wedding* because of the underlying fear of losing her best friend; Bullock turns bashful wallflower Lucy into someone radiant and self-assured in *While You Were Sleeping*; Hudson pulls off the role of the guy's girl masking as a high-maintenance diva with undeniable charm in *How to Lose a Guy in 10 Days*.

Like Ryan, Roberts, Bullock, and Hudson became America's sweethearts—prickly heroines who wore their hearts on their sleeves and charmed the silver screen anyway. The massive success of these leading ladies' rom-coms was always shared with an on-screen leading man—Meg Ryan with Tom Hanks; Julia Roberts with Richard Gere; Kate Hudson with Matthew McConaughey—and Hollywood had the clever strategy to recast them as leads in subsequent rom-coms.

The recurring, almost signature, themes in Nora's rom-com trifecta ultimately earned her the credit of reinventing the rom-com. "Since the likes of *When Harry Met Sally*, many films have been inspired by Ephron's groundbreaking writing, trying to emulate its addictive style to greater or lesser success," argues Collider features writer Bethany Edwards.[11] However, the perfect Nora Ephron rom-com was challenging to replicate.

BATTLE OF THE SEXES

At the heart of Nora's rom-com work was the "battle of the sexes"—a theme that leveled the playing field between men and women and allowed viewers to grapple with existential questions about relationship dynamics in a heterosexual context. According to *Guardian* contributor Ronald Bergan, Nora's rom-coms were "the most successful attempts to revive the spirit of the sophisticated Katharine Hepburn/Spencer Tracy battle-of-the-sexes comedies of the 1950s, and the softer-edged Doris Day/Rock Hudson vehicles of the 1960s."[12] Case in point: Ryan's neurotic, feminist, high-maintenance role of Sally falling for polar opposite Crystal's obnoxious chauvinist Harry in *When Harry Met Sally*. But it's the quippy conversations embedded within Nora's films between her leading men and women that subverted the genre and propelled the romantic plots. While *When Harry Met Sally* focused on whether men and women could share platonic intimacy, rom-coms that followed took further the question initially prompted by the film.

The release of *Friends with Benefits* and *No Strings Attached* in 2011—rival rom-coms with near-identical premises—explored whether men and women could have casual sex without falling in love. (Reader: they could not.) But despite diving into anti-rom-com territory––where the leads viewed their flings as practical, not emotional—the films both resulted in "the same fairy tale happy ending

as that Nora Ephron classic."[13] The 2015 indie *Sleeping with Other People* riffed on Nora too, reuniting womanizer Jake (Jason Sudeikis) and serial cheater Lainey (Alison Brie) as friends years after losing their virginity to each other in college. The film pushes Nora's existential question about men and women toward a new generation: "Can two sex addicts be in a platonic opposite sex relationship."[14]

Whereas *When Harry Met Sally* focused on an already established friendship between Harry and Sally, *Sleeping with Other People* sees Jake and Lainey establish their friendship years later. That inquiry even received a tech-forward twist à la Nora in 2021's *Dating & New York*. The film's protagonists, Wendy (played by Francesca Reale) and Milo (Jaboukie Young-White), tackle millennial modern dating—whether men and women can be friends with benefits—where the art of texting and the weight of being Instagram official get in the way. Nora opened the door for these nuanced conversations about men, women,

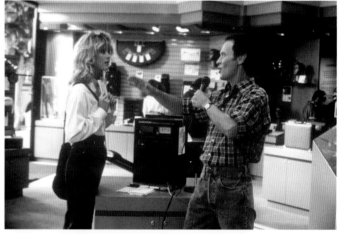

BELOW Billy Crystal singing into a microphone to Meg Ryan in *When Harry Met Sally* (1989)

Lainey, played by Alison Brie, and Jake, played by Jason Sudeikis, in *Sleeping with Other People* (2015)

sex, and friendship in an extremely heterosexual and closed relationship context that could apply to all types of relationships.

ROMANCE WITH A SIDE OF REALITY

Nora's rom-coms weren't solely steeped in the Hollywood magic of romance; they also touched on hard-to-talk-about topics beyond romance, crafting nuanced stories. Doing so ultimately added depth to rom-coms. Though *Sleepless in Seattle* observes the blossoming possibility of love between Annie and Sam, it's also rooted in isolation and grief—what prompts Sam to relocate with his son, Jonah, to Seattle and later grabs Annie's attention during Dr. Marcia's show. Other filmmakers took note. *While You Were Sleeping* director Jon Turteltaub "wanted to be part of the cool group of kids who made excellent romantic comedies" like Nora, so he crafted a fairy-tale romance between Chicago train token collector Lucy (Sandra Bullock) and Jack (Bill Pullman), the brother of Peter (Peter Gallagher), the handsome man Lucy rescues from an oncoming train after he's robbed and pushed onto the tracks.[15] With romance at the surface, *While You Were Sleeping* is really about Lucy's grief and loneliness as she grapples with living her life after the death of her father. It's a love story about Lucy and Jack, and Lucy and Jack's family, the Callaghans, who embrace her with open arms.[16]

Nora's rom-coms made room for other romance-driven films to tackle intense topics with a love slant. Because everyone falls in love. For *Silver Linings Playbook*, that meant featuring the very ugly, very human side of mental illness, between Pat's (Bradley Cooper) bipolar disorder and obsession with reuniting with his ex-wife and Tiffany's (Jennifer Lawrence) grief-fueled sex addiction, throughout a slow-burning romance. Writer Advaita Kala of the *Daily Mail* wrote about how the film's heart felt like a return to Nora's work. "Every once in a while a film has risen to the top of the pile and touched the collective sentimentality of the movie-going audience, but more often than not it has been assigned to the most feared predicament that can befall a film, one of that which has 'come and gone.' The clever effervescence of Nora Ephron's writing or the lovable neurosis of an *Annie Hall* (winner 1977) are things of the past, or so it was felt," she wrote.[17]

Judd Apatow's *The Big Sick*, based on the real-life romance between Kumail Nanjiani and Emily V. Gordon, grappled with the awkwardness of falling in love, the realities of a mixed-race relationship, and having a sick partner. It was a movie that, *Variety* film critic Owen Gleiberman reasoned, should have been a standout in the rom-com space—except the landscape had all but dissipated. He wrote, "'The Big Sick,' the indie-crossover hit of the summer, is the sharpest, funniest, and most touching romantic comedy in a long time, and that should be a shot in the arm for romantic comedies everywhere. Except for one small detail: There aren't any! They've all disappeared! Gone to that great big DVD player in the sky! (Somewhere up in Heaven, Nora Ephron is watching one right now, smirking and sighing.)"

It's those tough conversations, like the ones in Nora's work, that helped refresh the rom-com formula.

PARALLEL STORYTELLING

Another hallmark of Nora's triumvirate of rom-coms is raising the stakes through parallel storytelling—a technique that reinforces the similarities and differences between protagonists. In *When Harry Met Sally*, we see Harry and Sally's acrimonious relationship turn into deep connection over the years through individual rich character portraits of Harry and Sally as they both evolve and eventually end up in each other's lives for the long haul. *Sleepless in Seattle* focuses on building Annie's and Sam's stories separately instead of detailing their relationship together. While *You've Got Mail* features Kathleen and Joe on-screen together more than *Sleepless in Seattle* features its leads, the film still uses parallel world-building to show the symmetry of Kathleen's and Joe's lives—how their disdain for each other is flanked by their own likeness. That theme, prevalent in Nora's films, has become a staple of contemporary rom-coms that lean on developing characters before arriving at the ultimate romantic payoff. *Serendipity*, "a swooning romantic comedy that might have been called 'When Harry Met Sally While You Were Sleeping in Seattle and Woke to Find That You've Got Mail,'"[18] follows Jonathan (John Cusack) and Sara (Kate Beckinsale) as they meet while shopping for gloves, fall for each other, and ultimately part ways in order to let fate decide whether they're

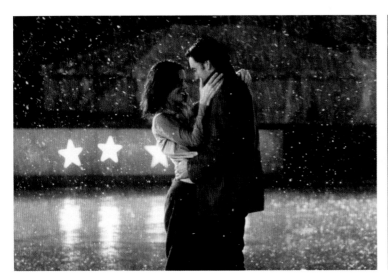

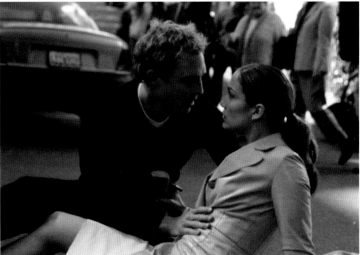

meant to be together. Years later, fate finally intervenes as Jonathan is about to get married. Most of the film unfolds as Jon and Sara live their separate lives, revealing their shifting perspectives on destiny through missed connections and flashbacks.

That same kind of individualized character development also helps build tension—and the eventual love story—between single-parent careerists Melanie (Michelle Pfeiffer) and Jack (George Clooney) in *One Fine Day*, as the film reveals their endearing similarities as they watch each other's kids. In the same vein, *The Wedding Planner* tells a tale of poor timing and fate through character portraits of neurotic type-A wedding planner Mary (Jennifer Lopez) and methodical Steve (Matthew McConaughey), who happens to be her client, as they try to fight their feelings for each other. While there's more screen time of the two individually than together, the film works because it builds on their opposite worlds and ends with a Golden Gate Park movie screening as a callback to their original meet-cute.

Always Be My Maybe, Ali Wong and Randall Park's own version of *When Harry Met Sally*, works because it spends a fair amount of the sitcom-esque movie focused on the stark differences between Wong's Sasha, a celebrity chef, and Park's Marcus, her stoned and aimless childhood sweetheart, instead of solely revolving the story around their relationship with each other.[19] In the end, despite the different directions their lives have gone in, Sasha and Marcus both have a void they're looking to fill. By following in Nora's footsteps, rom-com

filmmakers have continued to create richer character arcs and subsequently more tension before the credits roll.

EPISTOLARY STORYTELLING

There's something inherently romantic about watching Nora's characters writing to each other from afar—a dreamlike, almost anonymous quality that makes room for Kathleen's soul-baring confession to the only man who gets her in *You've Got Mail*. There's a thoughtfulness to the back-and-forth of email or letter writing and a sweet anticipation of when such a note must arrive. In that instant, time collapses—nothing else exists but you and that other person. It's something Nora mastered throughout her work.

Nora used epistolary storytelling, now a retro and cozy form of communication, to propel the plots of both *Sleepless in Seattle* and *You've Got Mail*. Ever since, it's been a plot device that has allowed filmmakers to add even more of an intimate and playful dynamic to their movies. The bedrock of *Sleepless in Seattle* is the letter writing between Annie and Sam/Jonah, culminating in the ultimate written grand gesture to meet atop the Empire State Building. In *You've Got Mail*, Nora turned a tale of hate at first sight into a romantic tale of email pen pals. It helped to smooth the edges between Kathleen and Joe as competing business ventures drove them apart in real life. While *Sleepless in Seattle* and *You've Got Mail* used written communication as a device to build connection, *The Notebook* used letters between Allie (Rachel McAdams) and Noah

ABOVE Sara, played by Kate Beckinsale, and Jonathan, played by John Cusack, about to kiss in the snow in *Serendipity* (2001)

Steve, played by Matthew McConaughey, rescuing Mary, played by Jennifer Lopez, in *The Wedding Planner* (2001)

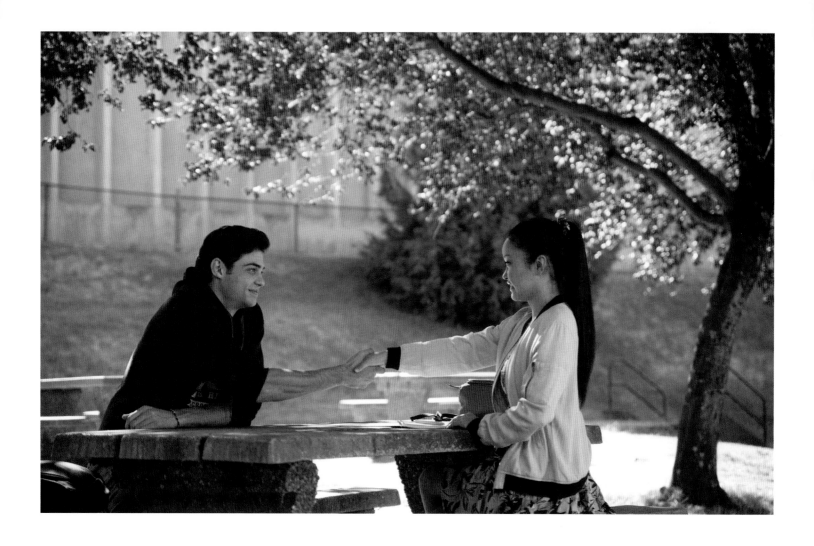

Peter, played by Noah Centineo, and Lara Jean, played by Lana Condor, shaking hands and making a pact in *To All the Boys I've Loved Before* (2018)

(Ryan Gosling) to tell the story of a relationship that spans decades to show how love can grow and evolve. *P.S. I Love You* attempted a similar tactic, with the help of letters left to a widow from her late husband to help her ease into starting over. This method of communication got a teen twist in Jenny Han's *To All the Boys I've Loved Before* franchise when Lara Jean's love letters aren't meant to be sent, but her meddling sister mails them to her crushes. Han has had a lifelong adoration of Nora and cited *Sleepless in Seattle* as "the gold standard of romantic comedy."[20] These letters then lead to a series of meet-cutes that shape the central storylines of the films.

Although *To All the Boys I've Loved Before* returned to the *Sleepless in Seattle* romanticism of letter writing, other films have taken a more modern approach à la 1998's *You've Got Mail*. *Your Place or Mine*, led by Reese Witherspoon and Ashton Kutcher, turns the love letter into unrelenting video chatting as best friends from college swap places for a week and ultimately

realize they were right for each other all along. While Nora's use of epistolary storytelling has been modernized, it remains an essential part of relationship building in rom-coms.

THE LEGACY OF NORA'S ROM-COMS

While Nora established her own voice and aesthetic over the years, her work and legacy has regularly garnered comparisons. Often it's been to "reigning queen of rom-coms" Nancy Meyers, also a writer-director-producer and female trailblazer in Hollywood whose films were often written off as "chick flicks."[21] In their rom-coms, both Nora and Nancy focused on smart, ambitious women and emphasized distinct, curated aesthetics. But their approaches were different. Nancy's rom-coms are coated in a glossy veneer of perfectionism and privilege[22] "steeped in Container Store–type composition":[23] a place where "spiky plants" aren't allowed and everything must be "soft,"[24] white turtlenecks and linen pants are

the norm, everyone has a pristine kitchen, and messiness is the equivalent of Cameron Diaz's character in *The Holiday* going ham at the grocery store on booze and junk food. "Meyers' women never completely unravel the way Ephron's can," Tyler Coates of Decider said.[25]

In contrast, Nora's rom-coms feature teeming women who aren't afraid of emotional outbursts, of being less than perfect—and they're sporting chunky sweaters, tailored blazers, and cardigans and living in cozy, feminine interiors (quilted bedding, striped couches, distressed armchairs) with countertops that have most certainly seen a spill or two. They're having fake orgasms in restaurants, letting men see them when their nose is red and they "have a terrible cold," and letting their frizzy hair fall where it may during an emotional breakdown. There's an age difference, too: Nancy's stories generally center on women who are approaching forty while Nora's focus on women in their thirties. Both breaking the glass ceiling for women in Hollywood, the duo has of course remained intrinsically linked for decades (whether they've liked it or not).

While rom-coms continue to modernize, Nora's influence still permeates. Now rom-coms aren't afraid to be raunchy or unconventional, turning lovers into "casual-sex partners or bisexual polyamorists or ex-lovers of each other's parents."[26] They're turning a one-night stand and abortion into a vehicle for romance, as does *Obvious Child*'s Gillian Robespierre, the "next generation's Nora Ephron."[27] Some tackle a rom-com through a breakup, where its true love story is between a trio of very messy female best friends, as Jennifer Kaytin Robinson does with *Someone Great*. And still others focus on platonic love stories about surrogacy and loneliness, or gay love stories such as *Bros*, which has been described as "Nora Ephron on poppers."[28] But at the heart of these films is Nora's playbook. "They're just spraying Cool Whip on a cake that Ephron baked," says O'Hehir.[29]

Nora's work remains source material for rom-coms, but it's no longer just wealthy white people who are finding their happily-ever-afters on the silver screen. The mainstream success of movies like *Crazy Rich Asians*, *To All the Boys I've Loved Before*, and *Think Like a Man* have allowed for much-needed diversity and representation on-screen for a genre that has long catered to one demographic. People of color are less often relegated to minimal

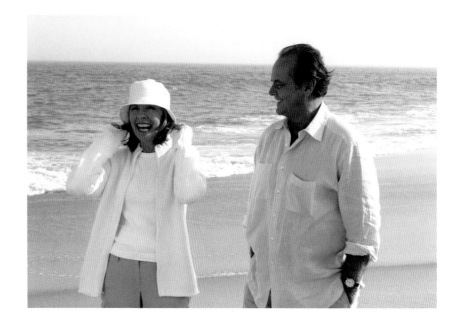

Erica, played by Diane Keaton, and Harry, played by Jack Nicholson, walking and laughing on a beach in Nancy Meyers's *Something's Gotta Give* (2003)

screen time and roles such as best friend or personal therapist to the main white lead—as Kevin (Dave Chappelle) is to Joe in *You've Got Mail*.[30] This was a large blind spot that plagued not just Nora's work but Hollywood as a whole.

Still, it's impossible to deny how deep Nora's influence on film has been since the release of *When Harry Met Sally*, *Sleepless in Seattle*, and *You've Got Mail*. She revived a genre that had been long silent. Through generations, her influence has loomed large, whether it's with a touch of wit, chaos, or a larger take on human nature. After all, they're called "Nora Ephron rom-coms" for a reason. ♦

Rom-Coms

Joe (Tom Hanks) and
Kathleen (Meg Ryan)
in *You've Got Mail*

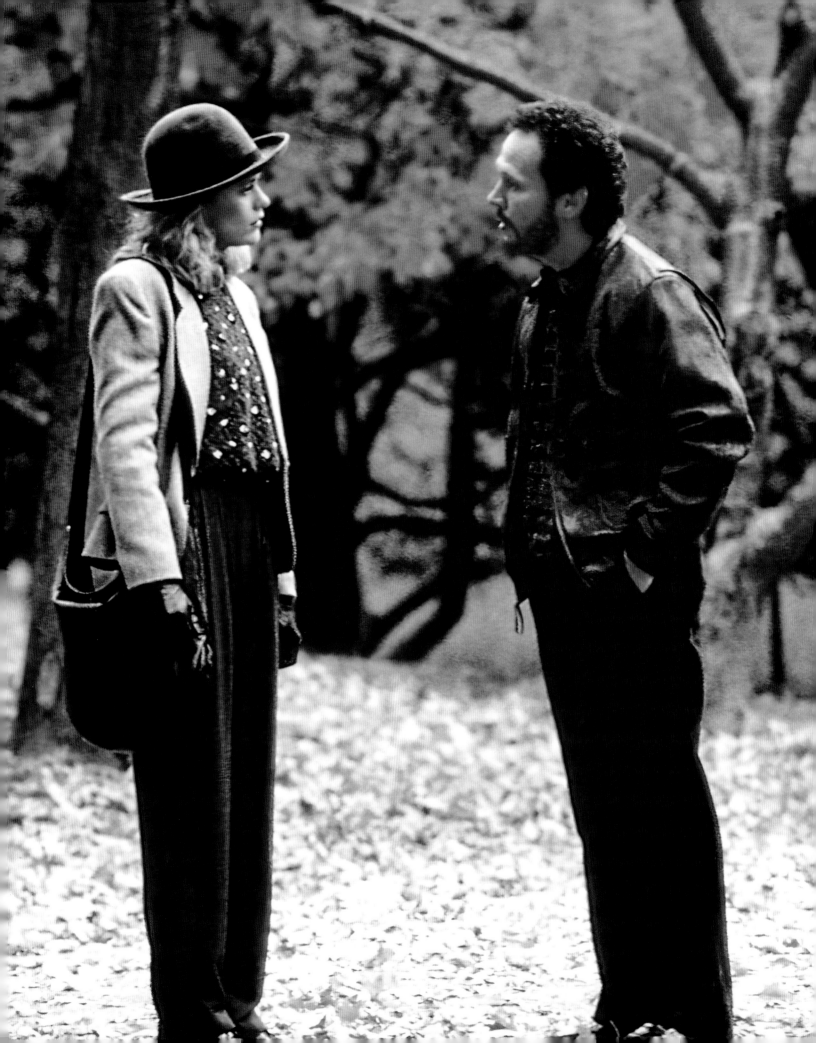

When Harry *Met* Sally

You could say the return of the rom-com began when Nora Eph-ron met Rob Reiner at the Russian Tea Room for lunch in 1984. They hadn't even ordered, and Nora had already turned down an idea from Reiner and his producing partner Andy Schein-man for a movie about a lawyer. But Reiner and Scheinman didn't give up easily and conversation turned to their lives as bachelors, which, after a few more meetings, grew into a script idea. "I had been single for 10 years and making a mess of my single life, and started thinking about how men dated and whether sex gets in the way of a friendship," Reiner told the *Daily Beast*. He was envisioning a film inspired by Ingmar Berg-man's 1973 magnum opus *Scenes from a Marriage*, which he dubbed "Scenes from a Friendship."[1] Among Reiner's scandal-ous details, Nora saw potential for a screenplay—and Reiner knew he needed a female perspective.

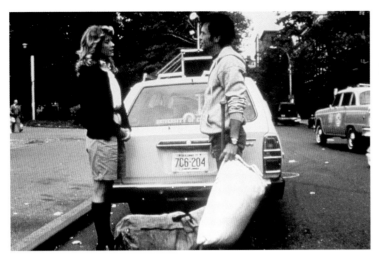

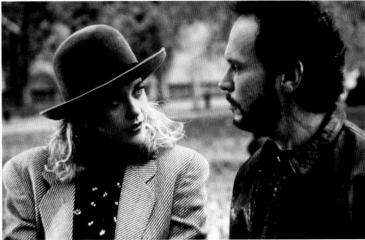

PREVIOUS SPREAD Sally and Harry chatting in Central Park in the fall

ABOVE LEFT Sally and Harry standing in front of the yellow station wagon about to leave on their road trip to New York

ABOVE RIGHT Sally and Harry speaking on a bench in the park

Nora, ever the plucky journalist, interviewed Reiner and Scheinman about love, sex, and singledom, using their responses to inform the characters and script.[2] She later reflected on those conversations as a "horrible experience," but she listened attentively to their cringeworthy anecdotes about what women endured while dating them.[3] And as they shared (and overshared) their sex and dating blunders over meals, Nora's picky orders were written into the script as well, as a quirk of When Harry Met Sally's female protagonist, Sally. Reiner later confirmed that he saw Sally as an extension of Nora and Harry as an extension of himself.

Originally, Reiner had planned to cast his then girlfriend, Elizabeth McGovern, as Sally, but they broke up before the film went into production. Other names, including Molly Ringwald and Debra Winger, came up, but according to casting director Jane Jenkins, Ryan quickly became the frontrunner. "Meg was literally the second actress that came in," casting director Jenkins told From Hollywood with Love author Scott Meslow. "She left the room, and Rob said: 'It's her part. Cancel everything else.'" But there was a hitch: Ryan was already set to star in the 1989 dramedy Steel Magnolias. In the end, she chose the role of Sally, and her Steel Magnolias part went to Julia Roberts.[4]

Casting Harry was trickier on a personal level. As his best friend since 1975, Billy Crystal knew Reiner better than anyone else.[5] But Reiner had to make sure he was the right fit for the role—the last thing he wanted was for their relationship to be compromised if it didn't work out. Before he settled on Crystal, Tom Hanks, Richard Dreyfuss, and Albert Brooks were considered for the role. But there was no pair better than Crystal and Ryan. "They had instant chemistry," Reiner said.[6] The on-screen pairing would become a blueprint for films to come.

Taking cues from the New York backdrop of It Happened One Night, the charming neuroses of Bringing Up Baby, and Annie Hall's affinity for tweed blazers, Nora seamlessly blended and modernized these classic elements into When Harry Met Sally, with a side of romance, of course. Though it's far from a tale of love at first sight, what makes the film so rewarding is that it begins as an unpromising love story: a shared car ride from Chicago to New York between a seemingly mismatched Sally Albright, a neurotic aspiring journalist, and Harry Burns, a carefree future political consultant.

After a ride filled with squabbling, contempt, and a declaration that "men and women can never be friends because of the sex thing," they go their separate ways. But a twist of fate brings them back together again—and again.

What follows is a deep, prickly twelve-year acquaintanceship–turned–tortured friendship where everyone but Harry and Sally is aware they're perfect for each other. Harry and Sally know each other's quirks, wear identical cable-knit sweaters, share nightly phone calls from their respective beds and debate Casablanca, and even make an ill-fated attempt to set each other up with their closest friends, Marie and Jess (played by Carrie Fisher and Bruno Kirby, respectively). Marie and Jess can see Harry

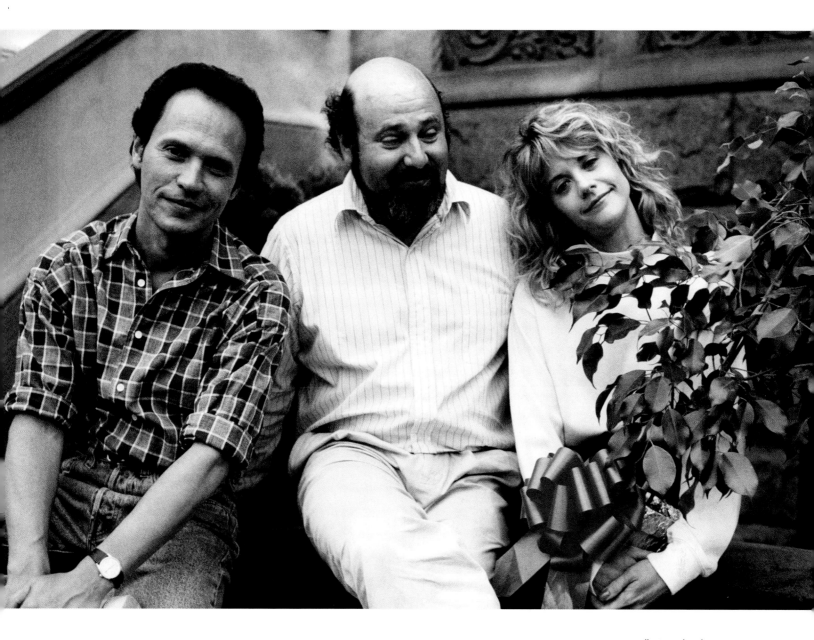

Billy Crystal, Rob Reiner,
and Meg Ryan on the set
of *When Harry Met Sally*

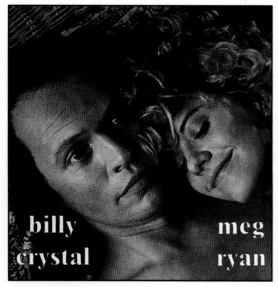

a new comedy by rob reiner
when harry met sally...

The hit comedy of the year ... THE SUN

billy
crystal

meg
ryan

CAN MEN AND WOMEN BE FRIENDS OR . .
DOES SEX ALWAYS GET IN THE WAY?

"Hilarious, you'll love it."
DAILY MIRROR

RIGHT Sally and Harry
discussing sex and
orgasms at Katz's Deli

Sally faking an orgasm in
Katz's Deli

Estelle Reiner, Rob
Reiner's mother, as the
diner who says "I'll have
what she's having"

Harry in bed panicking
after having sex with
Sally for the first time

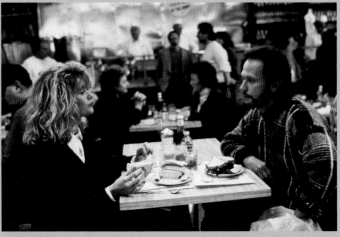

and Sally are meant for each other even when Harry and Sally can't.

Take their four-way phone call, for instance. Both Marie and Jess receive calls from Sally and Harry, respectively, about what led to their first sexual encounter. "We've been praying for it," Jess tells Harry, while Marie says to Sally, "You should have done it in the first place." As Harry and Sally awkwardly dish the details of their night to their best friends, the split-screen scene, filmed in a single take, builds to the climax of the film—the moment when Harry and Sally discover what everyone else already knows: that they're meant for each other. It's the parallel storytelling element teeming with Harry's and Sally's flurry of anxiety and regret that creates the ultimate payoff for this moment.

From there, the "will they, won't they" rom-com became something more—it evolved into a cultural phenomenon. Not only did the Oscar-nominated film spark a conversation about whether women and men could *just* be friends, but it also was steeped in a timely discussion about sexuality. We have all heard the echo of Sally's fake orgasm at a crowded Katz's Deli for decades, along with the shocked reply of an elderly diner (played by Rob Reiner's mother, Estelle): "I'll have what she's having."

We all remember the coleslaw bite and cheeky smile that followed Meg Ryan's convincing—and cringeworthy—performance. It may have been uncomfortable, but it was necessary. In his 2016 book about his friendship with Nora, *Washington Post* columnist Richard Cohen remembered the three-minute performance as "bigger than the movie it came from."[7] And he wasn't wrong.

Watching Sally deliver a faux orgasm made women feel seen—they were not alone in practicing performative pleasure. What had perhaps been kept a secret among women became a wake-up call to men and a universal hot topic: there was probably at least one time their egos had been stroked in the same way. It was affirming to watch Sally shut down Harry's arrogance about his sexual capabilities, considering he represents a classic chauvinistic straight guy from the eighties who saw women as sexual conquests. Consider his eye-roll-inducing diatribe about high-maintenance and low-maintenance women as the duo chat on the phone from their own beds watching *Casablanca* together. ("You're the worst kind—you're high maintenance, but you think you're low maintenance," Harry tells Sally before describing the way she orders food, to which Sally delivers a mic drop: "Well, I just want it the way I want it.")

The fake orgasm scene, which is perhaps more famous than the movie itself, is so striking because it highlights the importance of frank discussions about sex and pleasure between partners. It was empowering to see a woman detail her dissatisfaction with sex so bluntly—for women who felt like they couldn't breach the topic. And no wonder it was iconic: Ryan had to fine-tune the orgasm in thirty takes.[8] This was the beginning of the conversation around prioritizing female pleasure that would take time to progress in pop culture. It also speaks to a larger theme of the film: women will not and should not position themselves to seek love from a man. Sally doesn't drop her ambitions for romance—and she doesn't need to.

It's one of the reasons why *When Harry Met Sally* has become a beloved classic over the years. But at the time, not everyone necessarily saw the potential—reviews of the film were mixed. Film critic Roger Ebert had notes for director Rob Reiner, saying, "This film is probably his most conventional, in terms of structure and the way it fulfills our expectations. But what makes it special, apart from the Ephron screenplay, is the chemistry between Crystal and Ryan."[9] Meanwhile, *New Yorker* critic Terrence Rafferty took aim at the lack of plot: "To keep us busy while we wait for Harry and Sally to figure out that they're in love, Reiner and Ephron simply string together bits of shtick. The debate, of course, is too shallow to engage us, but they might have tried providing a little plot."[10] Yet, it won at the box office, raking in $90 million.[11]

The critics weren't wrong: *When Harry Met Sally* in a lot of ways *was* conventional, and the meet-cutes between Harry and Sally weren't entirely original since Nora liked to reference the structure of old Hollywood films. Yet, the beauty of the movie lies in its simplicity and its clever script. At its core, *When Harry Met Sally* is character-driven—a foundational element of Nora's work and the vehicle for the plot. Nora said it herself in a 2001 interview: the movie works because "it entirely depends on your caring about those two people. There's no real plot."[12] The movie is grounded in Harry and Sally's clashing personalities and opinionated perspectives on sex, romance, and friendship.

Nora's writing was vital to the success and allure of *When Harry Met Sally*: she crafted realistic, hard-hitting dialogue and quirky characters, making the film a blueprint for rom-coms through the 1990s and early 2000s. The familiarity in the banter between Harry and Sally made viewers feel as if they were sitting in the back seat of Sally's Corona wagon. Nora perfected punchy dialogue and long diatribes that made Harry and Sally's relationship feel like a tennis match. And ultimately, Harry's neuroses and Sally's high-maintenance ordering come off as endearing, rather than irritating, to the audience.

Through an hour and a half of on-screen conversations, *When Harry Met Sally* shows that the foundation of a great romance is a great friendship. The movie is less about a dramatic twist that prevents the central couple from being together and more about the nuances that shape a relationship in real life. It rejects the idea of love at first sight and embraces the roller coaster of emotional intimacy.

But love in the movies is a complicated subject. And Nora's rom-coms do create a fantasy world with unrealistic and at times toxic expectations about how relationships form and develop. Still, the film remains relatable for its gradual building of intimacy through mundane moments. Harry and Sally, who grapple with a lack of attraction, bad timing, immature instincts, and narcissism before eventually reaching a level of vulnerability—first as best friends and in the end as a married couple—were an archetype for what a true bond could look like. The sex thing and the love thing came after the friendship thing. ◆

OPPOSITE Harry and Sally kissing at a New Year's Eve party

BELOW Harry pretends to read a book as he notices Sally at a bookstore

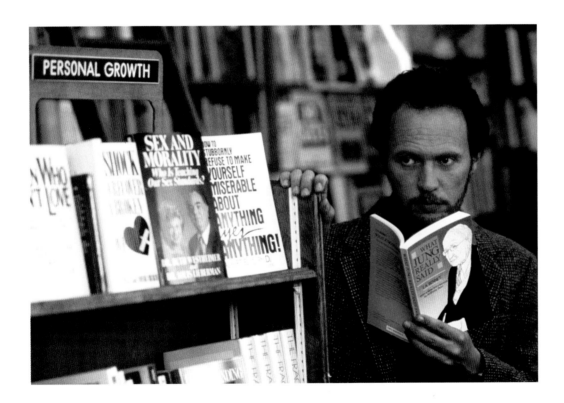

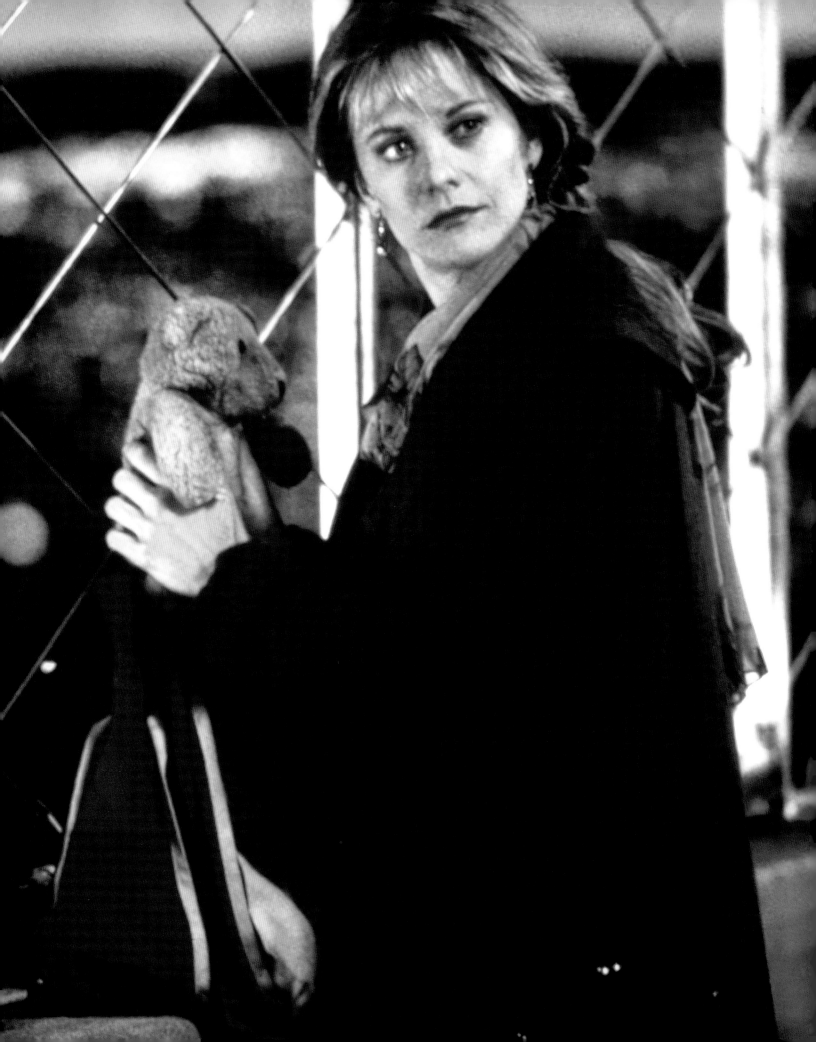

Sleepless *in* Seattle

Meg Ryan's career skyrocketed after the success of *When Harry Met Sally*. The role cemented Ryan as "America's sweetheart"[13] and "the girl next door"[14] but also as Nora's muse. After Nora had established herself in the rom-com space with *When Harry Met Sally*, she'd cast Ryan as the heroine again in *Sleepless in Seattle* four years later, a clever homage to the 1957 Cary Grant/Deborah Kerr–led romance *An Affair to Remember*.

Nora was brought on by producer Gary Foster to rewrite the script and even enlisted her sister Delia for the ride.[15] "What was there was this fabulous dirt you could grow wonderful grass in if you just knew how to do it," Nora said of the script when she began working on it.[16] But this time, Nora wasn't just writing—she was directing, too.

For the role of relentless reporter Annie Reed, names such as Demi Moore, Madonna, and Kim Basinger had been thrown around. But Nora admitted that she wrote the part of Annie with

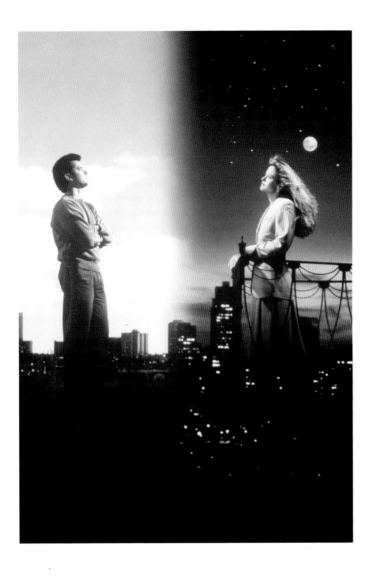

PREVIOUS SPREAD Annie holding Jonah's backpack and teddy bear atop the Empire State Building

OPPOSITE Tom Hanks and Nora Ephron on set during the production of *Sleepless in Seattle* (1993)

Nora Ephron on set

Nora Ephron and Meg Ryan on set

Ryan in mind. "She had a lot of faith in me by then," Ryan said.[17] Originally, Ryan's husband at the time, Dennis Quaid, was in talks to take on the role of widowed father Sam Baldwin, but Nora wasn't convinced. She wanted Tom Hanks, and Hanks wanted a Hollywood hit.[18]

After they'd costarred in *Joe Versus the Volcano* in 1990, *Sleepless in Seattle* would reunite Ryan and Hanks on-screen in yet another rom-com. Later the pair would join forces again for 1998's opposites-attract rom-com *You've Got Mail*. For Ryan, working with Hanks was "just so easy . . . He listens; he roots for other people."[19] Though Ryan and Hanks have limited scenes physically together in *Sleepless in Seattle*, their dynamic is the backbone for its palpable chemistry: layered love stories and well-intentioned scheming.

The scheming happens to be extremely essential for the plot of *Sleepless in Seattle*. Missing his mother, who died of cancer eighteen months before, a precocious eight-year-old kid named Jonah rings a radio station—hosted by the Dr. Laura–inspired Dr. Marcia—to help his hapless, widowed father, Sam Baldwin, find a new wife. What follows is a connection forged across the country between Seattle and Baltimore—an emotional love story, tempered by comic relief, about two complete strangers connected by a radio show.

For much of the movie, the relationship between Sam (Tom Hanks) and Annie (Meg Ryan) is largely one-sided and built on infatuation—Annie can't stop thinking, and talking, about the man she heard on the radio.

Of course, like all of Nora's characters, Annie is flawed—and not always likable. She not only hires a private investigator to stalk her crush but carves out an assignment for herself surrounding his story. She goes to Seattle to find Sam and his son (played by Ross Malinger)—and almost gets hit by a car while watching him from across the street. Annie is undoubtedly scheming, which grants her the power of pursuit. Like men often do, Annie has the agency to go after what she wants, albeit impulsively. Through all of this, she's engaged to an allergy-prone Walter (Bill Pullman), who we—and she—have largely forgotten about as she swoons over this alluring mystery man she's never met. Annie isn't alone in her desire for a more exciting romance. In all three of Nora's famous rom-coms, Ryan's alter egos reject stable, dull relationships in favor of

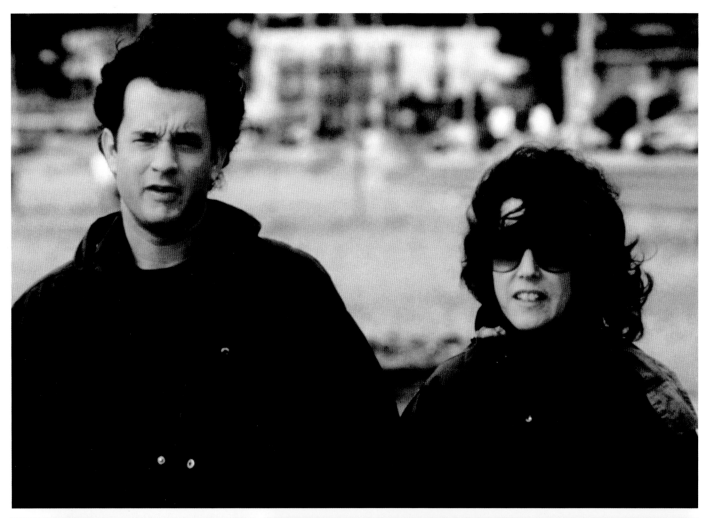

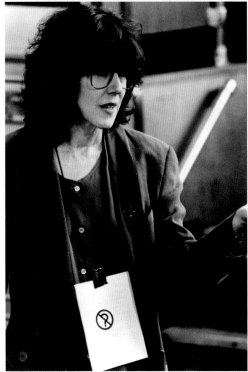

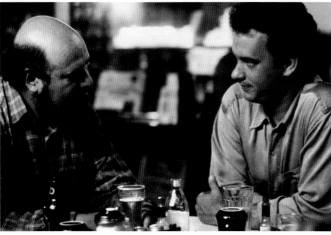

chasing a man with an affinity for crewnecks and windbreakers.

And Annie is quite willing to take that risk. She is quite literally a closeted romantic, who gets caught listening to Dr. Marcia's show by Walter while hiding in a closet.

"You make a million decisions that mean nothing, and then one day you order takeout and it changes your life," she quips earlier on about her meet-cute with Walter. Initially Annie strives for practicality, but she really craves excitement. She isn't ready to settle for an "okay" life with Walter—she wants one with her soulmate, Sam, a projected fantasy of her own creation. He is "the takeout"—the thrill.

Originally used as a love song in *Casablanca* to represent Rick and Ilsa's forbidden romance, the jazz standard "As Time Goes By" soundtracks the beginning of *Sleepless in Seattle* and sets the scene for a storybook romance. And yet, as deeply rooted in Hollywood love stories as this film is, Nora chides relentless rom-com lovers. Annie and her matter-of-fact best friend, Becky (Rosie O'Donnell), are beyond inconsolable while watching *An Affair to Remember*. There's a double meaning to the hilarity when Becky says that Annie, in fact, doesn't want to be in love but wants "to be in love in a movie." As ridiculous as she knows it is, the movie becomes the inspiration for Annie to ask Sam (well, Jonah) to meet her on top of the Empire State Building for their first proper encounter.

Like Becky and Annie, Sam's sister, Suzy (played by Hanks's real-life wife, Rita Wilson), is completely distraught over the beauty of Annie's request and how it parallels *An Affair to Remember*. What follows is a brief yet standout moment of the film where Suzy delivers an overly romanticized synopsis of *An Affair to Remember* through tears, as if this women-supporting-women moment is Nora speaking directly through her. How lucky Sam could be to have the plotline of a romantic story play out! And yet Sam and Suzy's husband, Greg (Victor Garber), can't help but mock her after she delivers this overwrought monologue in wonder. And then, Sam and Greg cry—over sports. It's Nora's cheeky way of poking fun at masculinity and the context for when male vulnerability is acceptable. It also was an opportunity to give Wilson's character her "moment," as Nora aimed to do for all the film's characters. "It doesn't move the plot along. You just can't imagine the movie without it because it is

what the movie is," Nora said of the scene.[20] It's for people who love love in the movies.

And while the romance between Sam and Annie is what people remember *Sleepless in Seattle* for, there's another prescient emotional narrative in *Sleepless in Seattle*: the connection between Jonah and Annie. Of all the letters received by him and Sam after their radio venture, Jonah is awestruck by Annie's—and the fact that she's a Baltimore Orioles fan. He insists he wants her to be his mother, but Sam writes it off. It's a letter from a stranger, after all. But his instinct that Annie is the one for his dad is undeniably sweet—even when he decides to jet off to New York City and sends his father into panic mode.

Annie and Jonah's connection echoes the sentiment of a child being raised by a single parent and the emotional burden of finding your parent's soulmate for them so you can see them experience love and companionship again. And what surfaces is the ultimate meet-cute, thanks to Jonah. But Jonah's precocious, wise friend Jessica (played by Gaby Hoffmann in her second Nora film) is the one who first encourages him to organize a meeting for Annie and Sam in New York. "You have to go to her!" Jessica exclaims through sobs while she watches *An Affair to Remember* with Jonah.

She's confident a grand gesture will work and ultimately ends up helping him maneuver to buy a ticket to New York. While they're playing Cupid, a childhood romance blooms between Jonah and Jessica, perhaps predicting the next generation of lovers.

Sleepless in Seattle was received largely favorably upon its release—it was a critical and commercial success. But critics weren't blind to how it easily could have missed the mark. *New York Times* film critic Vincent Canby was blown away by the execution: "Nora Ephron's 'Sleepless in Seattle' is a feather-light romantic comedy about two lovers who meet for the first time in the last reel. It's a stunt, but it's a stunt that works far more effectively than anybody in his right mind has reason to expect."[21] The stunt could have fallen flat considering the chemistry of the movie was built on individual character portraits, phone calls, and limited screen time. And it has in other films—while the Reese Witherspoon/Ashton Kutcher–led *Your Place or Mine* took cues from the *Sleepless* playbook, the separation made the two best friends–turned-soulmates seem as if they were strangers.

Peter Travers of *Rolling Stone* noted the realistic sentimentality of the film: "Ephron homes in on what's been missing in movies and in life: ardor, longing and smart talk about the screwed-up notions that pass for love."[22]

It would have been easy to write off *Sleepless in Seattle* as a "chick flick"—of course, some people did—but the film's grand gestures and callbacks to Old Hollywood helped refresh the rom-com. There's nothing quite

OPPOSITE Annie and Walter (Bill Pullman) sitting in bed

Becky (Rosie O'Donnell) and Annie weepy while watching *An Affair to Remember* on the couch

Sam and his sister, Suzy (Rita Wilson), as he spots Annie

Rob Reiner plays Jay, Sam's best friend

BELOW A split-screen of Annie driving and Sam on the phone

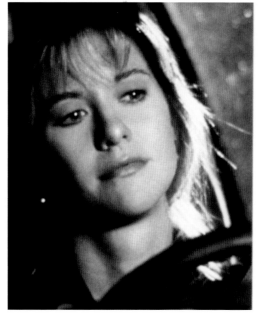
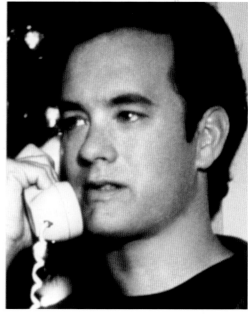

ABOVE Jessica (Gaby Hoffman)

ABOVE Jessica (Gaby Hoffman)

OPPOSITE Annie meeting Jonah and Sam for the first time atop the Empire State Building

as satisfying—after a movie full of homages to *An Affair to Remember*—as finally getting that sparks-flying moment atop the Empire State Building. Two little words—"You're Annie?"—are the end and the beginning for Sam and Annie. That dose of nostalgia paired with the visceral chemistry of the film's protagonists made it stick.

But even with its allusions to classic cinema, the film was ahead of its time in some ways. Though it's situated squarely in the nineties, Annie's through-technology fascination with Sam mirrors modern romances that begin over social media—noticing someone before they notice you through their Instagram story, tweet, or TikTok video. Both *Sleepless in Seattle* and *You've Got Mail* in some sense forecasted how relationships would blossom in the future. In the 2020s, it's doubtful Annie would have traveled cross-country for Sam (most people in Brooklyn consider a relationship in Upper Manhattan to be long distance), but the notion maintains its romantic relatability. ♦

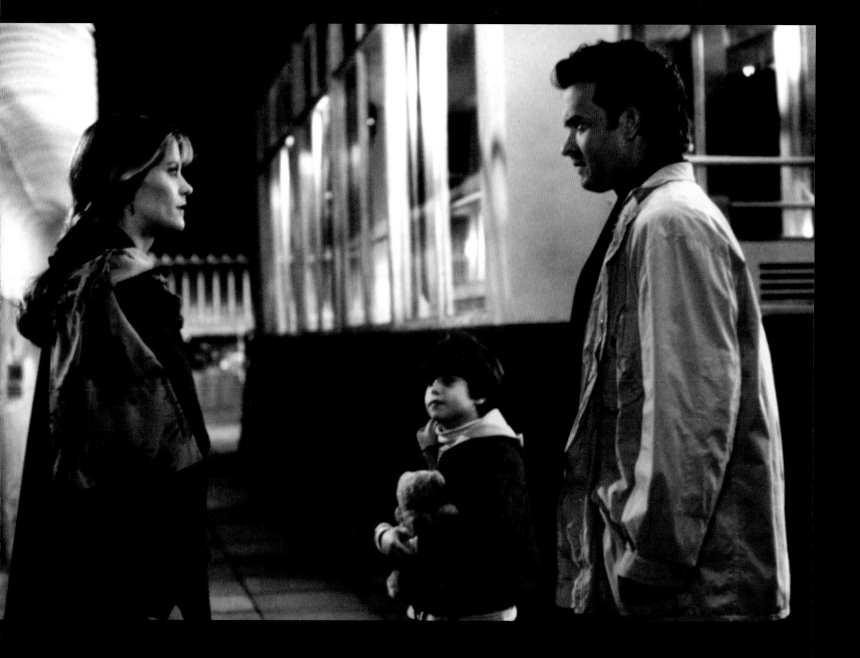

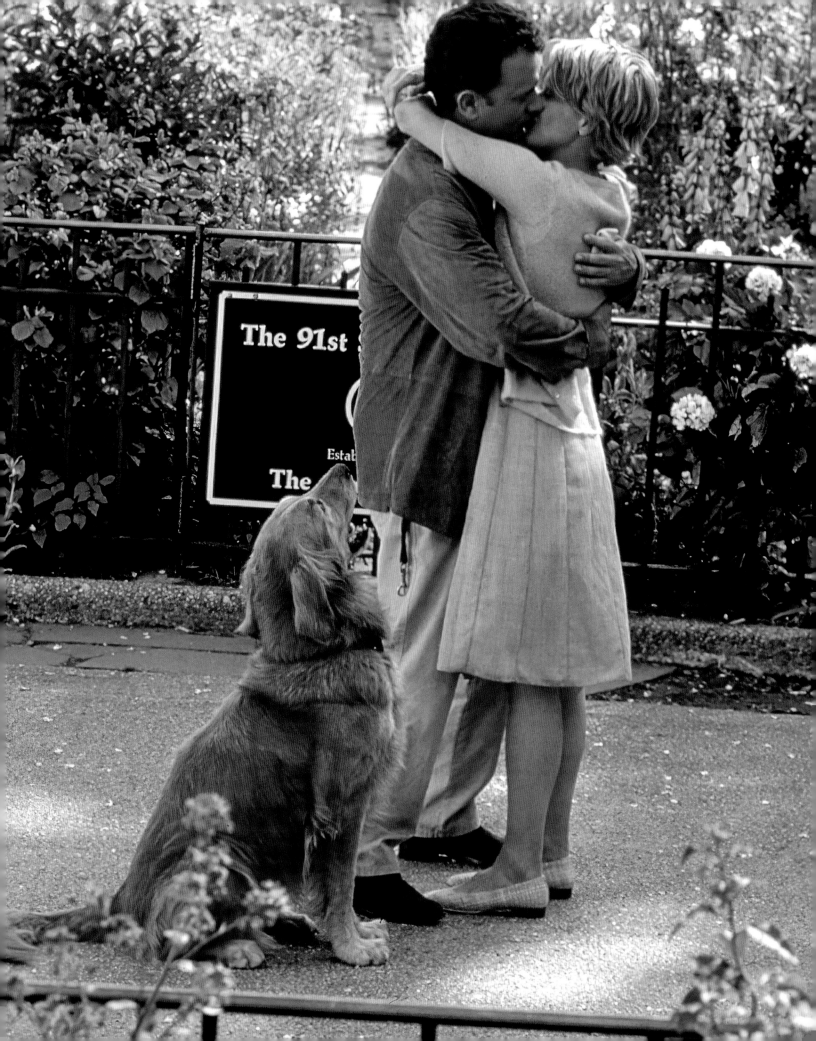

You've *Got* Mail

There's nothing quite like the ecstasy of the AOL dial-up tone ending with "You've got mail." And Nora made a whole movie about it—sort of.

You've Got Mail was Nora's version of a sequel to *Sleepless in Seattle*. "In our heads it was the sequel even though it isn't strictly speaking 'the sequel,'" Delia Ephron said.[23] (Nora maintained it wasn't.[24] But it was another film of Nora's that once again reunited Tom Hanks, Meg Ryan, and their unmatched chemistry. It was impossible to ignore the parallels between *You've Got Mail* and her 1993 rom-com, yet to Nora, *You've Got Mail* proposed a different idea: "Can Mr. Wrong turn out to be Mr. Right?"[25]

Based on the 1937 play *Parfumerie*—the source material for Ernst Lubitsch's rom-com *The Shop Around the Corner*—*You've Got Mail* gave the concept an updated twist.[26] "I was watching *Shop Around the Corner* one day and it hit me—update it with

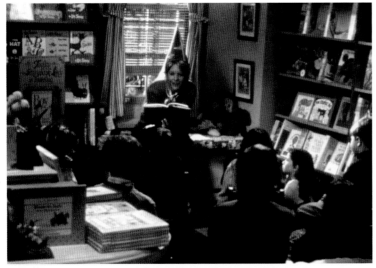

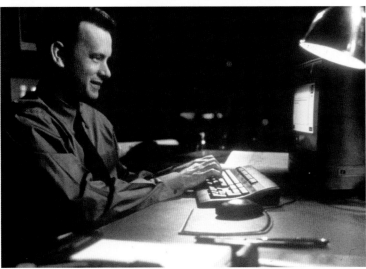

PREVIOUS SPREAD Joe and Kathleen kissing in the Ninety-First Street Garden of Riverside Park

LEFT Kathleen (Meg Ryan) reading to kids at the Shop Around the Corner

BELOW Joe typing at his computer

Kathleen smiling to herself at her computer

OPPOSITE Joe and his girlfriend Patricia, played by Parker Posey, talking at a party

Kathleen with her hands on her hips while talking to her boyfriend Frank, played by Greg Kinnear

email," says executive producer Julie Durk. She pitched the idea to her boss, Lauren Shuler Donner at Donner/Shuler-Donner Productions, and Amy Pascal, then head of Turner Pictures, who owned the rights to the 1940 film, before Nora was approached. That was the easy part.

But getting Hanks and Ryan on board came with its challenges. Hanks wasn't thrilled with the comparisons he was getting to Jimmy Stewart and felt hesitant to take on a role of Stewart's. He was eventually talked into it. "I mean, you'll never see me remake *Mr. Smith Goes to Washington* or *It's a Wonderful Life*. But *Shop Around the Corner* is very different," Hanks said. Ryan, on the other hand, was wary of being pigeonholed by rom-coms. In the end, they both came around.[27]

You've Got Mail wasn't a regurgitation of *Sleepless in Seattle*. Instead, the 1998 film offers

a clever shift in perspective—with Nora's third rom-com, she considers: What if Hanks and Ryan were talking directly to each other and Hanks knew it was Ryan's character he was speaking with, instead of the other way around? Also, instead of letters, let's give it a tech-forward spin with this concept that Luddites hate: email, but with a timeless, retro element like an indie bookstore.

Once again on-screen, Hanks and Ryan's chemistry was palpable. In Nora's Upper West Side opposites-attract tale, Kathleen Kelly, played by Ryan, is an old-soul, cable-knit-sweater-wearing, heart-on-her-sleeve owner of an independent bookstore she inherited from her mother. And she can't stand Joe "F-O-X" Fox (Hanks), the multimillionaire owner of a bookstore chain that aims to drive her shop out of business. But there's one problem: the bookstore rivals happen to unknowingly be in the

midst of an internet affair, despite their real-life disdain for each other.

In a larger sense, the characters represent the political era of the time—the Clinton years—when corporate mergers were making small businesses obsolete, when cheaper was better, when Americans were oversold with neoliberalism.[28] But with Hanks and Ryan at the helm, the banter between the characters is largely witty and endearing—even when Kathleen is scolding Joe for hoarding all of the caviar at a party ("That caviar is a garnish!"). It's romance in the time of chat rooms, with threats of corporate greed and catfished

intellectuals—the former a book editor who loves the sound of her own voice; the latter a left-leaning writer who speaks over women and thinks he's smarter than everyone else.

Needless to say, Joe and Kathleen are in the midst of an emotional affair that neither seems to feel too guilty about. Their email exchanges are arguably much more romantic when you find out that Joe's father exchanged letters with Kathleen's "enchanting" mother years before.

You've Got Mail was ahead of its time in predicting online dating trends. Tinder, Hinge, and OkCupid were eons away, yet with her

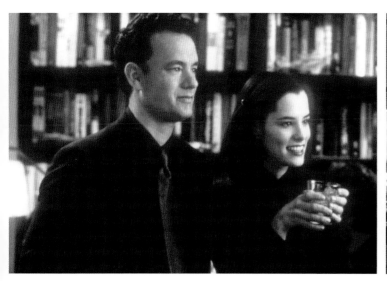

seduction looming over Kathleen's dreamy little local mom-and-pop bookstore. Joe, after all, is the patriarchy preying on Kathleen and her business. And still, we root for them.

In *You've Got Mail*, Nora once again writes relatable, flawed protagonists. Joe's (NY152) and Kathleen's (Shopgirl) emails are more than just innocent exchanges. Despite the romantic pretense, Joe and Kathleen are both in committed relationships, sneaking around in the mornings after their partners leave to check whether they have emails from each other.

At the beginning of the film, Kathleen even admits she's "in love," before quickly saving face with a line about her live-in boyfriend, Frank (played by Greg Kinnear). Meanwhile, Joe is dating Patricia (played by Parker Posey). Both Patricia and Frank represent self-absorbed, career-obsessed nineties

tech-forward approach, Nora revealed both the intrigue and pitfalls of internet dating at its start. Before you could swipe right, chat rooms were a potential dating pool if you were ready to wade through. There was an excitement—a purity—in divulging your deepest hopes and dreams through a screen with someone who understood you without really knowing you. There was an intimacy with that kind of anonymity, a power that came with choosing how you wish to present yourself. Still, there was always the caveat that an online love interest could be a catfish, or worse. For Kathleen and Joe, their first meetup is rife with disappointment. Kathleen is upset and embarrassed because she thinks her date stood her up, and she's seemingly stuck with Joe, her established foe, who sits with her at the coffee shop. Later on, the big reveal where they "meet" at Riverside Park is enough to make you forget

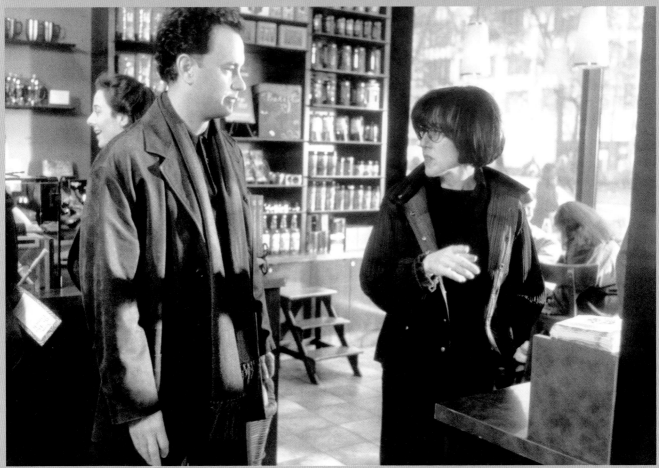

about Joe's capitalist antics and just swoon. Joe wipes Kathleen's happy tears away with a hanky as she confesses, "I wanted it to be you," and you're ready to throw any—or all—of his red flags to the wayside. Of course, real life might look a little different.

Like Nora's previous rom-coms, *You've Got Mail* is fueled by the classics and offers a nod to them in the fabric of the film—Kathleen's store even pays homage to its original framework in name. *The Godfather* is also a reference point for *You've Got Mail*—Joe quotes lines from the Francis Ford Coppola classic to encourage and charm Kathleen, who exclaims she doesn't understand why all the men in her life keep referencing it. Then, there's the Jane Austen of it all.

While Kathleen is waiting to meet her internet beau at the coffee shop, she places a red (or crimson) rose in a copy of her favorite book, *Pride and Prejudice*, on the table to signal her identity. He supposedly doesn't show, but Joe does, and the duo quibbles over Elizabeth Bennet and Mr. Darcy. Not only does it pay homage to one of Nora's favorite books, but *You've Got Mail* is arguably a modern version of Austen's novel that chooses brownstones, the Upper West Side, and the Ninety-First Street Garden[29] as a stand-in for rural England. Just like Elizabeth and Mr. Darcy, Kathleen and Joe initially hate each other. And because of pride, Kathleen—much like Mr. Darcy—is determined to dislike Joe even when it becomes clear that Joe isn't all that unlikable. After they continue to spend time together, they fall in love. Sound familiar?

For the most part, critics fell in love with it, too. *Variety* film critic Lael Loewenstein said, "Hanks and Ryan, meanwhile, already proved their chemistry in 'Seattle,' a pic in which, ironically, they were rarely onscreen together. In this, their third outing as co-stars (the first was the less-successful 'Joe vs. the Volcano'), they show why they are two of Hollywood's most bankable and, in many ways, most traditional stars."[30] Roger Ebert agreed, calling Hanks and Ryan "immensely lovable."[31] That's what made *You've Got Mail* comfort food; viewers didn't have to hope for the leads to be magnetic, they already had a proven track record.

But not everyone agreed. *Washington Post* staff writer Michael O'Sullivan took issue with the film's use of product placements. "The protagonists of Nora Ephron's new romantic comedy spend so much time either logged on to

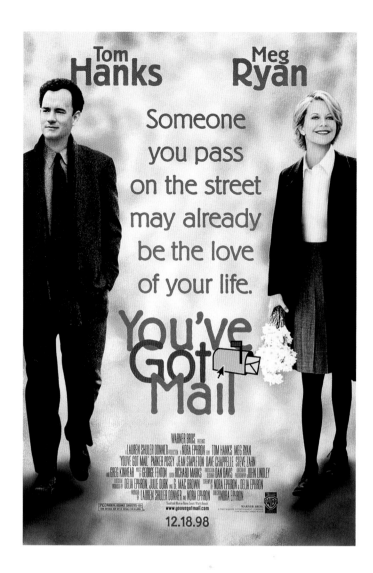

their e-mail accounts or ordering designer coffee that the film feels like an extended commercial for AOL and Starbucks."[32] His criticism wasn't entirely unfounded, but it missed the point: that the film was a metaphor for capitalism. The "You've got mail" notifications and Starbucks cups were as necessary to the story as Kathleen and Joe's love story.

Like *Sleepless in Seattle*, *You've Got Mail* is cherished for its simplicity. The film is one big buildup to a meeting in Riverside Park that ultimately reveals Kathleen and Joe have known each other all along.

There's no anticipation of a sex scene: you're simply waiting for these two people to really see each other. The most affecting moments come in the form of longing: casual lines of dialogue delivered with wistful stares and gradual but seismic realizations about each other. In Nora's world, meaningful love can come from the most unexpected of places—even the guy trying to put you out of business. ◆

OPPOSITE Nora Ephron talking to Meg Ryan while filming *You've Got Mail* (1998)

Nora talking to Tom on set in a coffee shop

Resilience

Dottie (Julie Kavner)
sending her kids, Opal
(Gaby Hoffman) and
Erica (Samantha Mathis)
off to school in *This Is My
Life* (1992)

This *Is* My Life

By the time Nora Ephron had reached page 30 of Meg Wolitzer's 1989 novel *This Is Your Life*, she knew she had to direct it: "It kept reminding me of things in my own life."

For years she hadn't considered directing; after all, Hollywood was a "boys' club." It wasn't until *When Harry Met Sally* found success that she began receiving offers to direct. Producer and friend Lynda Obst said it was "an insult" that Nora hadn't been given the opportunity yet, while actress Carrie Fisher noted that "if she were a man, she would have done this eight years ago." It happened to be Obst who, with the help of Columbia Pictures president Dawn Steel, helped find the right directorial project for Nora: an adaptation of Wolitzer's book.[1]

It was hard to ignore the parallels between *This Is Your Life* and Nora's own life. The way cosmetic-counter comedienne Dottie Ingels (Julie Kavner) would turn her children's mishaps into material was something Nora inherently understood from growing up with

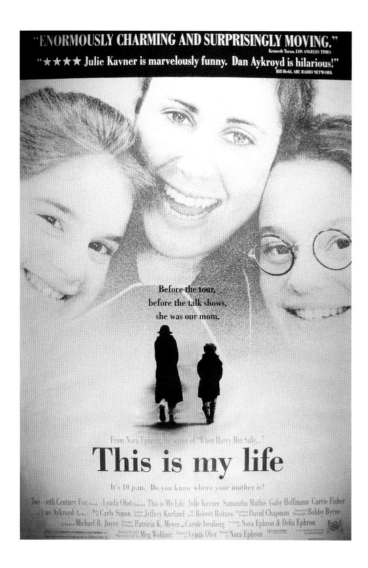

"ENORMOUSLY CHARMING AND SURPRISINGLY MOVING."

Kenneth Turan, LOS ANGELES TIMES

"★★★★ Julie Kavner is marvelously funny. Dan Aykroyd is hilarious!"

Bill Diehl, ABC RADIO NETWORK

Before the tour,
before the talk shows,
she was our mom.

From Nora Ephron, the writer of "When Harry Met Sally..."

This is my life

It's 10 p.m. Do you know where your mother is?

Twentieth Century Fox · Lynda Obst · This is My Life · Julie Kavner · Samantha Mathis · Gaby Hoffmann · Carrie Fisher · Dan Aykroyd · Carly Simon · Jeffrey Kurland · Robert Reitano · David Chapman · Bobby Byrne · Michael R. Joyce · Patricia K. Meyer · Carole Isenberg · Nora Ephron & Delia Ephron · Meg Wolitzer · Lynda Obst · Nora Ephron

PREVIOUS SPREAD Erica
and Opal laughing while
sitting in their kitchen

screenwriter parents.[2] With Nora and her sister Delia penning the script, Wolitzer's story became more nuanced and rife with compassion. They relate to not only Dottie's struggles for success in a cutthroat industry (all four of the Ephron sisters were, after all, scribblers), but also the complex sisterly bond between her daughters.

This Is My Life also allowed Nora to bring New York City to life again on-screen. But it wasn't actually filmed in New York City; instead, Nora made her movie at a studio in suburban Toronto, aside from a few days shooting exteriors.[3] For the film, Canadian brownstones were decorated with graffiti and heaps of garbage were used to make the street scenes feel more authentic.[4] This attempt to pull off a working-class aesthetic set the scene for the struggle of a single mom balancing her day job and her dream. Dottie and her two daughters are initially "crammed" into a tiny Queens apartment owned by her aunt Harriet, and they spend their nights reenacting late-night show hosts sandwiched together on a worn pullout couch. When they relocate to a sizable place in Manhattan, Nora attempts to turn a mansion-like apartment with uneven blinds and clutter into the home of a starving artist where Thanksgiving dinner is eaten on TV trays with friends in the living room. It's Nora's glamorized version of a working-class home—beautiful, lived-in interiors like the ones owned by bookshop owners (*You've Got Mail*) and secretaries (*Julie & Julia*).

Although less mainstream than her other films, *This Is My Life* has remained one of Nora's most impactful works to those who are familiar with it. *Girls* creator and star Lena Dunham, for instance, wrote in the *New Yorker* that "'This Is My Life' is the movie that made me want to make movies." Dunham admired Nora for helping the actresses "express the minutiae of being a human woman onscreen." Dunham first watched the film when she was in the second grade and recalled rewatching it twelve times one summer.[5]

In this charming portrait of a single mom and aspiring comedian struggling to find balance between her career and the demands of parenting, Dottie—a comedienne composite of Joy Behar and Totie Fields—goes all in pursuing her dream job after she inherits her aunt's home when she dies unexpectedly.[6]

While Dottie bounces back and forth across the country in her signature "dot dress"

trying to make a name for herself in the comedy world, her young daughters Erica (Samantha Mathis) and Opal (Gaby Hoffmann) are cared for by a rotating cast of friends with comic ambitions of their own.

Along the way, viewers witness the Ingels sisters enduring a host of growing pains, filling the screen with heartwarming, moody moments young girls can relate to. The audience are voyeurs getting a glimpse into the lives of three generations of ordinary women as they navigate life to a vaudevillian score from legendary singer-songwriter Carly Simon.

Throughout the film Dottie, Erica, and Opal are portrayed as deeply flawed without being villainized—instead, there is unwavering empathy for each of the characters. As Dottie, who has spent her life working tirelessly as a single mother determined not to give up on her dreams, finally begins to break through comedy's glass ceiling, her selfishness in her all-consuming fame becomes a point of contention for her kids.

And while Dottie is funny—she has a zinger about a man breastfed until he's forty-eight—the humor of *This Is My Life* isn't rooted in her stand-up routine. From the start of the film, Dottie's humor is woven into everyday life, as she turns every makeover with her Macy's cosmetics counter clientele into a skit, plumbing the darkest of moments—even her aunt Harriet's collapse at a Loehmann's in her underwear—into material. "And when they carried Aunt Harriet out, she set off all the store alarms—really!" Dottie remarks to a store crowd. At home, before she's famous, Dottie charmingly banters with her daughters as she trains them to imitate Johnny Carson from *The Tonight Show*. But it's not just Dottie driving the laughs: Claudia (played by Carrie Fisher), an assistant to Dottie's talent agent, provides them, too. For instance, during one of Dottie's stand-up sets, she takes a drag of a cigarette and dryly unloads her problems onto Erica and Opal like they're her therapists. "I'm basically terrible," she laments.

LEFT Gaby Hoffmann as Opal

Angela, played by Kathy Najimy, babysitting Opal

While Dottie's landing guest spots on TV, Erica is stuck at home navigating being an angsty teen and the awkwardness of losing her virginity. In an effort to fill the void of their loving but sometimes absentee mother, Erica and Opal often critique Dottie and even decide to find their father. Ultimately, those moments that push Dottie, Erica, and Opal to the edge bring them closer and make them relatable to the audience. They are, after all, human, and the choices that Dottie faces as a woman trying (and failing) to *do it all* feel familiar.

"I'm trying to kick my dependency on 'Mr. Can't-Finish-His-Analysis.'"

While it's largely the women of *This Is My Life* providing the laughs, Dottie's oddball talent agent–turned–boyfriend Arnold (played by Dan Aykroyd) is written as a human gag: a man whose approval of Dottie's routine comes in the form of eating a napkin.

This Is My Life features the hallmarks of Nora's beloved works—witty dialogue, awkward dinner parties, and flawed, determined female protagonists. But it's not one of Nora's

Julie Kavner talking to
Nora Ephron while on set

Dottie onstage in her
signature polka dots per-
forming stand-up during
the Catch a Rising Star
showcase

ABOVE Arnold's assistant, Claudia (Carrie Fisher), talking to Erica and Opal at Dottie's comedy show

Claudia and Arnold speaking to Dottie and her kids over coffee

OPPOSITE Opal, Dottie, and Erica laughing together on a futon

Arnold sitting on a couch talking to Dottie

more famed films for two main reasons: it was a box office flop, earning roughly $3 million with a $10 million budget, and it received lukewarm reviews from critics.[7] Film critic Roger Ebert acknowledged that Nora's material worked to draw attention to the double standards of being a woman with domestic responsibilities and dreams of your own. "It is hard to imagine this material being about a man. The notion dies hard that a mother's place is with her children, even if society also requires that same mother to work full time in order to support them," he wrote.[8] But Dottie refuses to settle for doing bits in the Macy's cosmetics department. In fact, she rejects the whole notion that she should give up on her ambition because she has children.

On the other hand, film critic Owen Gleiberman of *Entertainment Weekly* found that Nora was too "generous" to her characters: "*This Is My Life* wants to show us that people act selfishly even when they mean well."[9] That, however, is the reality of what single, working mothers grapple with on a daily basis as they try to raise children and also maintain their career. It's something that Nora wanted to depict with a refreshing sense of honesty. "If you are a working mother, everything that's good news for you is bad news for your kids," Nora told Bobbie Wygant in a 1992 interview. "We're always at work thinking 'I should be at home.' We're always at home thinking 'I should be at work.'"[10]

New York Times film critic Janet Maslin noted how Nora largely ignored the possibility of Dottie's failure. "The toughest thing that

happens is a wrenching, passionately staged family argument that paves the way for greater understanding," she wrote.[11] While showing more of Dottie's setbacks on-screen could have added more tension to the plot, it would have distracted from the dichotomy that Nora was trying to showcase.

Dottie is brimming with the resilience echoed in *Heartburn*'s Rachel Samstat and *Silkwood*'s Karen Silkwood. Like Dottie, Nora herself was trying to stand out in a male-dominated field—but as a director. While she had experienced considerable success, Nora knew all too well the uphill battle that remained constant in Hollywood—and it was paralleled in Dottie's drive for comedy stardom.

In the years since its release, *This Is My Life* has been continually discovered and rediscovered by generations of women who see themselves in Dottie, Erica, and Opal. Along the way, it's also been reappraised as a heartwarming, hilarious tale and for its standout performance from character actress Julie Kavner, in what was notably her only leading film role.

Though Nora's next few films would launch her into rom-com stardom, *This Is My Life* is an important—albeit more obscure— project in her catalog, underscoring themes that have reverberated throughout her entire filmography. ◆

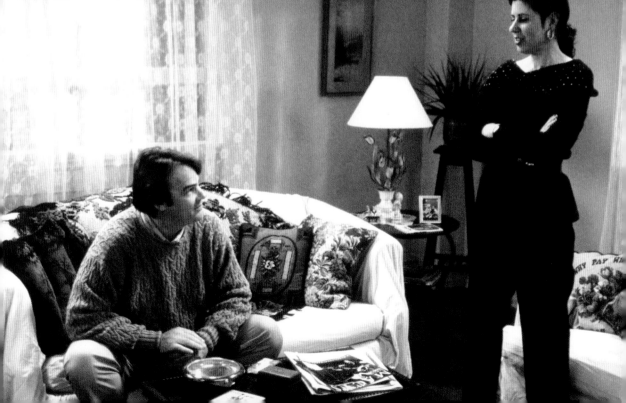

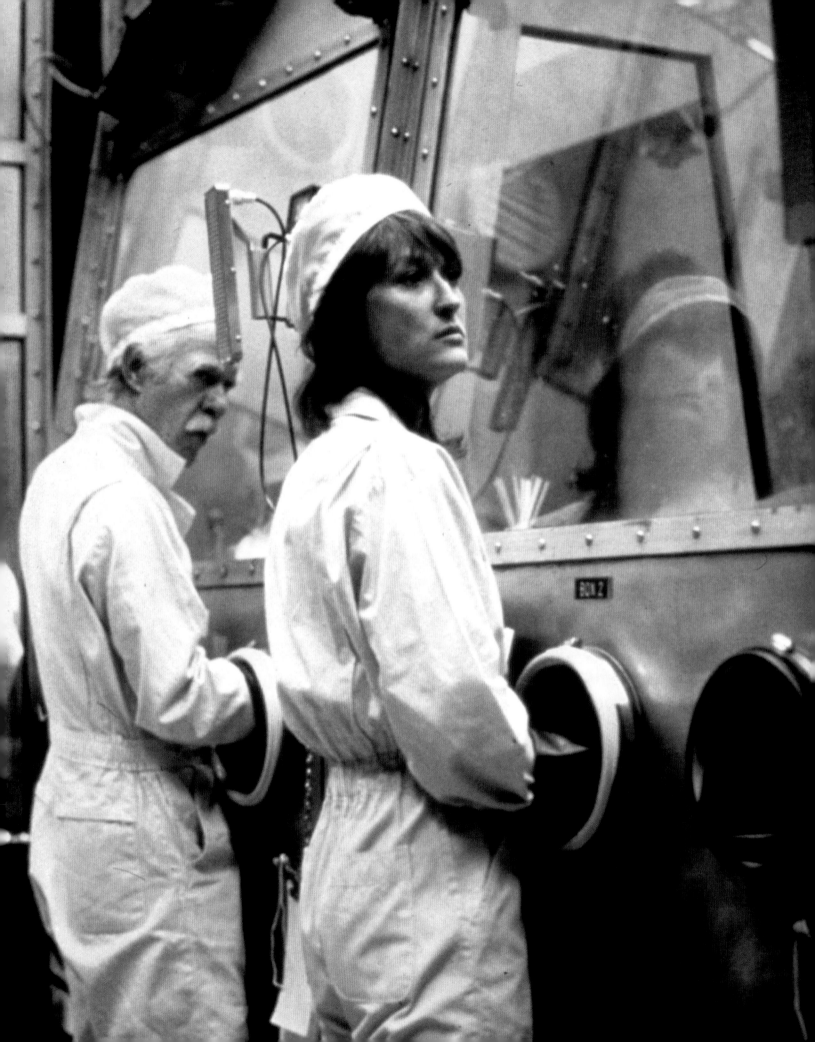

Silkwood

When Nora was approached to write a script about nuclear plant whistleblower Karen Silkwood, she was at a crossroads: newly divorced and with two young kids, she didn't know whether she could handle such a project at that time—one that had its roots in Oklahoma, the site of *Silkwood*'s heroic story and tragic ending. And she couldn't exactly travel to Oklahoma to do the research that she felt needed to be done.

She decided to do it anyway by enlisting the help of another screenwriter, her friend Alice Arlen. Nora approached Alice because she was familiar with Karen's story and had experience with the National Resources Defense Council, and other sociopolitical knowledge that could inform the narrative. Nora also thought that because Arlen was from Middle America she'd "surely know a lot about Oklahoma." She didn't exactly, but they researched together and wrote the script. Soon, Mike Nichols was directing and Meryl Streep, Cher, and Kurt Russell were

starring, and eventually came the Oscar nominations:[12] Nichols for Best Director, Streep for Best Actress, Cher for Best Supporting Actress, and Ephron and Arlen for Best Original Screenplay.[13]

From the beginning of her career, telling stories about determined, spirited women was the ethos of Nora's work—whether or not she was in the director's chair. So it suited Nora that her screenwriting debut was about someone like Silkwood, a charismatic nuclear worker–turned–labor activist spitfire played by Streep, who described her character as "full of contradictions. She loved her children and yet she left them. She was on about safety, yet sometimes she smoked dope and popped pills on the job."[14]

In adapting Howard Kohn's *Who Killed Karen Silkwood?*, Nora and Alice mined a real-life exposé and crafted a heartfelt film that also showcased the humanity of blue-collar America.[15] The story of Karen Silkwood is a tragedy, but it's also a triumph—something they

PREVIOUS SPREAD Karen (Meryl Streep) working at Kerr-McGee in *Silkwood* (1983)

BELOW Karen spying and looking at documents in the lab for Kerr-McGee

OPPOSITE Karen in bed with her boyfriend, Drew (Kurt Russell)

Karen stealing a bite of her colleague Winston's (Craig T. Nelson) food at Kerr-McGee

captured through the character's sheer determination to advocate for workplace safety with the same fervor present in today's labor rights movement.

Directed by Nichols—Nora's first collaboration with her longtime friend—*Silkwood* tells a story rooted in the American working-class struggle and how Karen Silkwood risked it all to advocate for safer conditions. Karen, her boyfriend, Drew (Russell), and her best friend, Dolly (Cher), all live in a ramshackle house and work together at the Kerr-McGee Cimarron Fuel Fabrication Site, where they make plutonium pellets. "[Mike Nichols] wanted the sense of family, and he wanted the house to look patched together with layers of seams and repairs," says Patrizia von Brandenstein, *Silkwood*'s production designer. "I think by then he knew that there was no easy way to make a family, and wanted to create the feeling that these people had tried to do it the hard way, and the struggle was showing." Karen realizes the plant, which could easily pass for the southern textile mill from *Norma Rae*, is cutting corners and compromising employee safety for corporate profit, so she begins investigating the company's practices and stealing classified documents.[16] While she's initially protected by the Oil, Chemical, and Atomic Workers Union, it's not enough to save her in the end. The plant exposes Karen and her peers to severe radiation and places the blame on Karen, who then dies in a car crash, right before she's about to expose Kerr-McGee's malpractice.

Yet *Silkwood* is bigger than its titular character's fateful end. The movie is rooted in the conspiracy at the plant and the egregious, ignored conditions of the working class and the men who were complicit in it all. Those conditions are echoed in a series of shower scenes that reveal the callousness toward manual laborers and how disposable these plant workers were to a corporate entity. Exposed to dangerous levels of radiation, women—including Karen—are scrubbed, prodded, held down, and essentially waterboarded to rid them of external contamination. Years later, that radiation scrub has lived on as the "Silkwood shower," as NPR Arts reporter Neda Ulaby notes, showing "Meryl Streep as a terrified worker at a nuclear power plant, being frantically scrubbed after exposure to radiation."[17]

When filming the scene, Streep had "jets of water shot up her nose."[18] It's uncomfortable to watch and that's the point—something

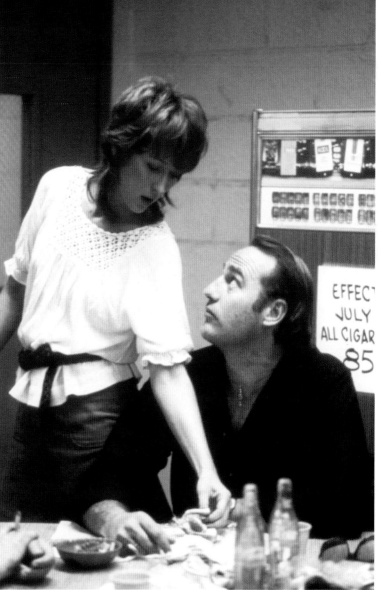

Drew and Karen having
a difficult conversation
about their relationship

enhanced by the way Nichols keeps the camera on Karen for elongated stretches. According to *Mike Nichols: A Life* author Mark Harris, the director "had become enamored of long takes" and began "to enforce, for no particular reason, a somewhat dogmatic principle that a movie should contain as few cuts as possible."[19]

Meanwhile, Karen's gradual journey of spinning out is gripping; she is a portrait of paranoia, confusion, and rage as she inches dangerously close to unearthing Kerr-McGee's sloppy practices. The obvious cost of Karen's dangerous journey is her life, but the intentional build toward her loss of sanity is what's most riveting—her insistence on using a pay phone because she believed her phone was tapped, the idea that someone purposefully poisoned her ("My urine sample container! Somebody put plutonium in my urine sample

container!" she shrieks), the raid of her home and belongings after she'd been deemed "cooked" or contaminated by Kerr-McGee, the belief—and later confirmation—that she was being followed in her white Honda.

Streep's take on the real-life activist was unfiltered, fiery, and full of contradictions: she sports a mullet shag, wears worn T-shirts without bras everywhere, and moves through life without a filter. Karen is the type of person who flashes a colleague when they tease her, who glides from table to table in the lunchroom stealing bites of other people's sandwiches, and who is never without a cigarette in hand. Karen also loves her three children and wants to spend time with them, but she puts in minimal effort to do so, other than a diner meal together once every few months. Being maternal almost seems more an act than an instinct.

She asserts she has a "moral imperative" to work with the union to reveal the dangers of the nuclear plant, but photos of her with union lawyer Paul Stone (Ron Silver) in Washington reveal she cheated on her devoted lover, Drew. But her belief in justice for blue-collar workers never falters, much to her own detriment. Drew can't be with Karen as her tunnel vision for whistleblowing takes over—he believes she's become two people. "I'm in love with one of them, but the other is just—" he says, before Karen interjects, "a pain in the ass." When Karen's boss, Hurley, tries to pay her off following the house raid, she metaphorically throws up two middle fingers and drives off in a getaway car with nothing left to lose.

Karen is the soundtrack to her own death, as the movie concludes with Streep singing "Amazing Grace" as her car crashes—a ploy to turn a restless social crusader into a martyr. As film critic Gary Arnold wrote in the *Washington Post*, "Her cry of distress, 'I'm contaminated!,' may express the feelings of true believers more honestly than the lyrics of 'Amazing Grace.' At bottom, the myth of martyrdom must be sustained by a fear that her contamination is everyone's contamination."[20]

It's those moments that marked *Silkwood* as a star turn for Streep, but it was also notably a turning point in Cher's acting career. Her pop-star sheen had prevented her from successfully landing a film role for eight years. But Cher's "vitality, humor and surprising depth" helped her land the role of Dolly. Karen's curmudgeonly roommate and coworker. Dolly was Cher's second serious role and a landmark for LGBTQ representation in commercial cinema, as Dolly was a lesbian.[21]

This is the eighties in Oklahoma, so Dolly's subsequent relationship with a hairdresser is met with overt and covert homophobia—even by Karen and Drew. Instead of being celebrated, her sexuality is merely tolerated. But stepping into Dolly's shoes helped cement Cher's place as a dramatic actress and helped her land later roles in classics such as *Mermaids* and *Moonstruck*. *Silkwood* was her golden ticket into Hollywood.

Following its release, *Silkwood* became a critical and commercial hit. The movie was made for $10 million and generated $36.5 million at the box office,[22] while earning five nominations at the 56th Academy Awards. "It's a little amazing that established movie stars like Streep, Russell and Cher could disappear so completely into the everyday lives of these characters," wrote film critic Roger Ebert. It was easy to forget about Cher's pin-straight hair and Bob Mackie gowns, because Nichols dressed the three leads down so completely that you believed they were really punching in and out at the factory every day and struggling to make ends meet. But *New York Times* film critic Vincent Canby, while largely praising the biopic, found that it couldn't decide whether to stick to the facts or opt for a dramatization: "We are drawn into the story of Karen Silkwood by the absolute accuracy and unexpected sweetness of its Middle American details and then, near the end, abandoned by a film whose images say one thing and whose final credit card another."[23] To Canby's point, the film seems to be uncertain about how much it should rely on fact versus fiction. The end feels abrupt, a dramatized and romanticized version of Karen Silkwood's fatal car crash to the tune of Streep singing "Amazing Grace," but then viewers are slapped with the facts of what followed, which makes its ending feel like a complete departure from the rest of the movie before it. The *Hollywood Reporter*'s Duane Byrge noted, "*Silkwood*'s strength is not in dealing with the abstract but the everyday."[24] The film's most compelling moments are the workers' collective frustrations with capitalism; the playfulness between Karen, Drew, and Dolly as roommates; and the primal relationship between Karen and Drew. The conspiracy fosters the plot, but it's the humanity behind the film's players that makes it so moving.

Streep, Russell, and Cher convincingly take on the roles of pot-smoking minimum-wage workers and create mesmerizing character portraits of the working class in rural areas. But it comes at the expense of elements of the film that haven't exactly aged well. There are racist punch lines, a giant Confederate flag in Drew's bedroom, and a couple of misogynistic jokes—though a lot of these cringeworthy lines and microaggressions reflect the Middle America of the time.

Silkwood, however, is remembered less for those and more for being a gripping tale of gumption. Nearly forty years later, not only the performances but also Karen's story arc have remained pertinent as ever, with anti-capitalist themes that can't be written off. Together, Nora and Alice added heart, humor, and depth to a conspiracy thriller that grappled with ethical dilemmas and the cost of survival. ♦

OPPOSITE Drew holding Karen

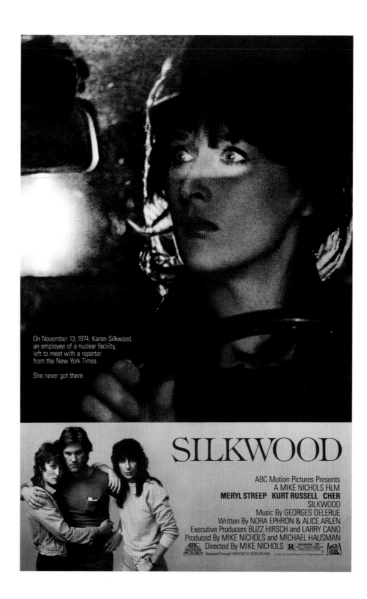

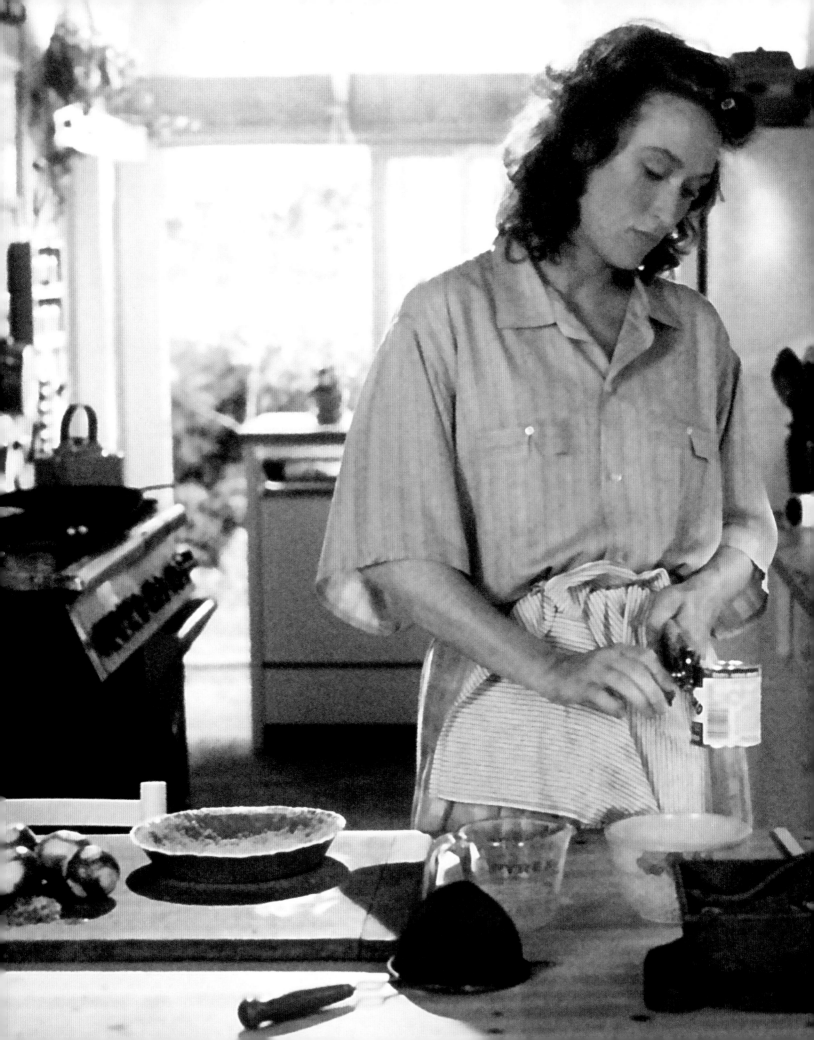

Personal Pain

Rachel making pie in
the kitchen in *Heartburn*
(1986)

71

Heartburn

The drama of Nora's divorce from celebrated *Washington Post* reporter Carl Bernstein didn't end when she signed the papers in June 1985—in fact, it was just heating up. After discovering Bernstein was cheating on her while she was pregnant with their second child, Max, in 1979, Nora turned her raw emotional reaction into the searing 1983 bestseller *Heartburn*, a "thinly disguised account" of their messy breakup.[1] Nora described *Heartburn* as her way of saying: "Look what happened to me and guess what? I have the last laugh because I get to be funny about it." Privately, Bernstein was less than thrilled at being portrayed as a man "capable of having sex with a Venetian blind,"[2] but publicly, he feigned support: "I've always known that Nora writes about everything that happens in her life," he said. "The book is just like her—it's very clever."[3] But when it turned out Nora's acerbic novel was going to become a film, his tune changed—suddenly *Heartburn* was "nasty . . . smarmy . . .

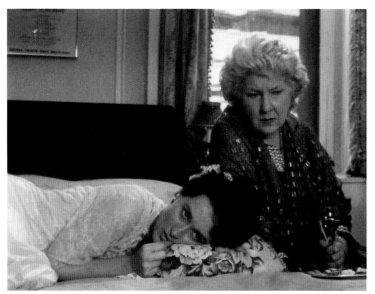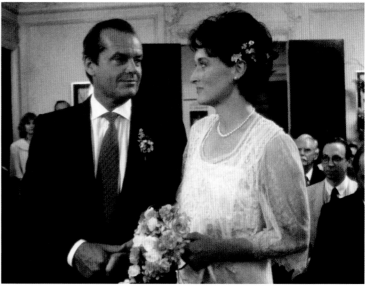

PREVIOUS SPREAD Rachel (Meryl Streep) showing off her engagement ring during her group therapy session in *Heartburn* (1986)

ABOVE Rachel getting advice from wedding guest Vera, played by Maureen Stapleton, about whether she should get married

Rachel and Mark (Jack Nicholson) getting married

prurient"—and it resulted in one of the "most unusual Hollywood divorce agreements in history." As specified in their divorce agreement, Bernstein was able to read the screenplay and its subsequent drafts and submit feedback, while Nora agreed *Heartburn* would never get a TV adaptation and Bernstein's on-screen counterpart would be portrayed in a "caring" manner.[4] Their two sons would have a trust that would hold the film's earnings.

Things were considerably less dramatic by the time the film went into production. Nora teamed up once again with *Silkwood* director Mike Nichols—who used original music from Carly Simon to convey the film's theme—and enlisted Meryl Streep to play cookbook author and food writer Rachel Samstat, Nora's alter ego.[5] Mandy Patinkin was initially cast to play her two-timing husband Mark Feldman, but was fired after the first day. Mandy and Meryl just didn't bring the dynamic Mike Nichols wanted on-screen.[6] After trying and failing to hire Kevin Kline, Nichols reached out to Jack Nicholson, who immediately took over the role of Mark. Streep wasn't pleased—she thought Patinkin embodied the neurotic Jewish role and that Nicholson was too charming: "This was a movie about a woman, which was even more unusual in those days than it is now. It was a unique opportunity to explore things from *her* perspective, from Nora's perspective," Streep asserted.[7] Luckily, their tension eventually led to a breakthrough—all thanks to a scene where they ate takeout in bed. And

considering the film was steeped in the messiness of marriage and divorce, it worked.

What transpired on the big screen is a dramedy about matrimony and fidelity centered on the relationship between Rachel and Mark as they meet, get married, have kids, and break up. But unlike Nora's other romantic dramedies, *Heartburn* is largely based on Nora's reality. She channeled her pain and rage into *Heartburn*, and in this case, art imitated life.

The writing is quite literally on the wall minutes before Rachel is set to walk down the aisle. She says it herself: "I'm never getting married again. I don't believe in marriage." Her nuptials are stalled as she languishes in bed, debating whether to tie the knot. While seemingly hours go by, a hilarious, rotating cast of characters enter the bedroom for armchair—or bedside—advice because she can't decide whether the marriage will just end in divorce.

She, of course, marries Mark; the scene both provides comic relief and reinforces a self-fulfilling prophecy of sorts. Her gut instinct turns out to have some merit. As Rachel and Mark navigate marriage, the cracks in their foundation are both literally and figuratively paralleled in the construction of their home, which was once destroyed by a fire. It gets messy, with no help from Mark's socialite mistress, Thelma Rice.

Along the way, the oddities of coupledom are revealed. There's a certain peculiarity that

Nora Ephron looking away as a guest sits on then husband Carl Bernstein's lap in 1977

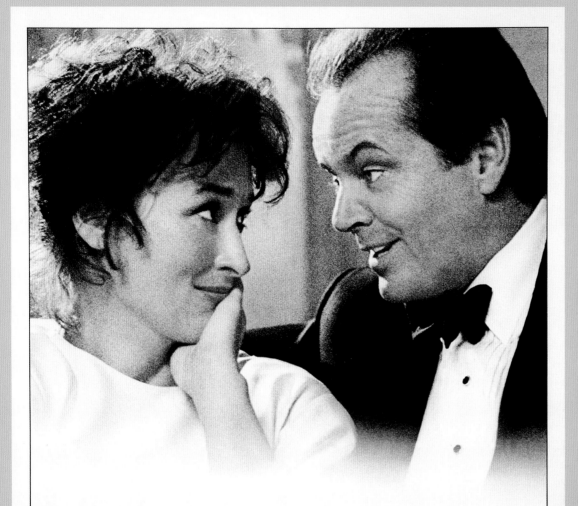

MERYL
STREEP

JACK
NICHOLSON

Sex. Love. Marriage.
Some people don't know when to quit.

A MIKE NICHOLS FILM

Heartburn

PARAMOUNT PICTURES PRESENTS HEARTBURN
MUSIC BY CARLY SIMON FILM EDITOR SAM O'STEEN COSTUME DESIGNER ANN ROTH PRODUCTION DESIGNER TONY WALTON
DIRECTOR OF PHOTOGRAPHY NESTOR ALMENDROS, A.S.C. SCREENPLAY BY NORA EPHRON BASED ON HER NOVEL PRODUCED BY MIKE NICHOLS and ROBERT GREENHUT
DIRECTED BY MIKE NICHOLS A PARAMOUNT PICTURE
RESTRICTED R UNDER 17 REQUIRES ACCOMPANYING PARENT OR ADULT GUARDIAN
READ THE PAPERBACK FROM POCKET BOOKS COPYRIGHT © 1986 BY PARAMOUNT PICTURES CORPORATION. ALL RIGHTS RESERVED.
NSS NO. 860001 HEARTBURN

comes with being in a long-term relationship with someone. When Mark finds out that he's going to be a father and is hilariously singing and prancing on the couple's bed for what seems like a solid portion of their night, it's a reflection of that intimacy. Perhaps the most memorable moment of the film comes when a disheveled Rachel emerges from the bathroom after a faked shower with receipts—evidence that Mark has been cheating on her. It's simply the most primal, overdramatic exclamation of unapologetic rage delivered by a completely frazzled woman with her hair half-done.

come back to her. He *has* to. When the phone rings, it's going to be him. If flowers are delivered? They *must* be from him.

Blinded by rage, she also spreads a vicious rumor that Thelma has an STI, merely unflattering gossip that she wishes were true. Her world revolves entirely around Mark and his mistakes. After cycles of missing Mark, hoping he dies, and even trying to reconcile with him, Rachel discovers he's restarted an affair with Thelma. It solidifies the true end of their relationship, and Rachel uproots herself and her two children to New York to start over. But this, of course, doesn't happen before he

BELOW LEFT Thelma Rice (Karen Akers), with whom Mark is having an affair, approaches Mark, Rachel, and their friends Arthur (Richard Masur) and Betty (Catherine O'Hara) at dinner.

Julie (Stockard Channing) and her husband, Arthur

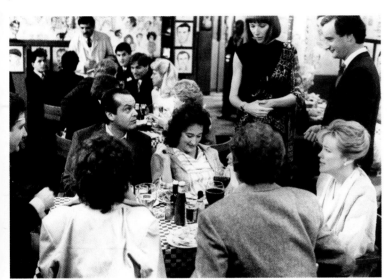

Through Rachel, Nora's real-life misery is rewritten with an irreverent sense of humor. What begins with a euphoric postcoital bowl of carbonara in bed ends with throwing metaphorical spaghetti at the wall. But *Heartburn* stands apart from the copious other run-of-the-mill dramedies of the eighties in its overdramatic monologues and a balance of dour moments (Rachel uprooting her kids to New York after she discovers the affair) and character quirks (her reminder to party guests to cook her lamb for twenty more minutes as she goes into labor).

But even though we're meant to empathize with Rachel, Nora writes her as complex and not easily likable. It doesn't help that Rachel is rather caught up in her own narcissism—she believes wholeheartedly that Mark is going to

(deservedly) gets creamed by a Key lime pie in the face in front of their friends.

Heartburn the book remains the bible for breakups, but the film adaptation, despite being a commercial hit and earning $52.6 million worldwide at the box office,[8] didn't garner the same widespread praise. Film critic Roger Ebert criticized how close Nora was to the material: "And she apparently had too much anger to transform the facts into entertaining fiction. This is a bitter, sour movie about two people who are only marginally interesting."[9] The anger is what fuels the quirks of Streep's Rachel, and she largely carries the most fascinating parts of the movie, but Nicholson's Mark could have had a bit more of a personality beyond womanizing and bed dancing. He's a *Washington Post* columnist, but you never really get the sense he is.

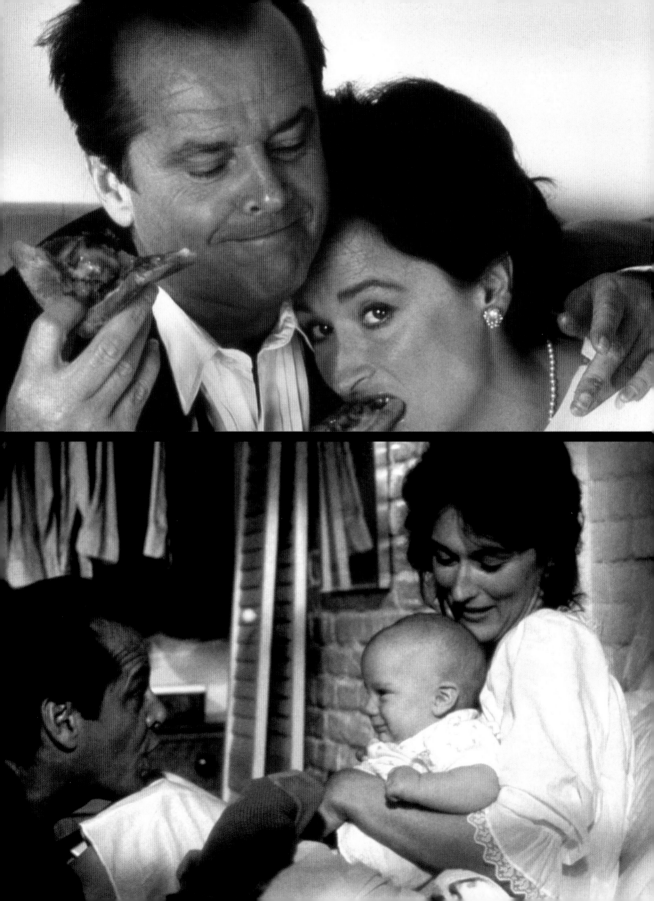

Whereas *New York Times* film critic Walter Goodman made a fair point about the disjointedness in the story: "The skits seem diversions from a plot that refuses to develop."[10] A robbery that takes place at a therapy group where Rachel's ring is stolen, for instance, feels like a misplaced *SNL* sketch. It largely feels like a cheap play for laughs. But *Washington Post* film critic Paul Attanasio gave it a rave review, noting that the intimacy of the film is what makes it so singular: "You feel as if you were there, and it happened to you, and its heroism, the heroism of everyday life, is yours."[11] Attanasio isn't wrong: the palpable terror and rage Rachel feels when she discovers the receipts that confirm Mark's affair and the look of insanity in her eyes could easily be yours—and the moment she decides to leave Mark and start her life over on her own is inarguably brave.

The heroism in Rachel's resilience is significant. For decades, divorce was taboo—it was expected that women would turn a blind eye toward their husband's dalliances. While some progress had been made, Nora tried to redefine and portray a real emotional reaction and what a life without the perfect nuclear family could look like. It's easy to relate to someone who is willing to compromise their self-worth for the idea of love or the hope of keeping their family together. It's a common choice people face. Ultimately, *Heartburn* reveals that this is the type of decision that can come at a very high cost if you don't choose yourself.

Nora could have opted for comfort or complacency, but she instead took the tougher road—one traveled alone. She fought for a happy ending without a prince to save the day. Being a single parent and starting over could be a strong choice and a good thing. And that was satisfying—just like a bowl of carbonara after sex. ◆

OPPOSITE, TOP Mark and Rachel eating pizza while Mark wraps his arm around her

OPPOSITE, BOTTOM Rachel holding their baby while Mark plays with her

ABOVE Mark sitting on a fountain

Hanging *Up*

It should have been a hit. The star power of Meg Ryan, Diane Keaton, and Lisa Kudrow as *sisters* was catnip. But *Hanging Up*, released in 2000, didn't exactly become a box office smash.

Originally a novel published by Delia in 1995 as a way to process her father's death, her relationship with her sisters, and middle-child syndrome, *Hanging Up* follows the fraught family dynamics among the three sisters—Eve, Georgia, and Maddy—and their dying alcoholic screenwriter father.[12]

This plotline didn't stray far from the Ephron sisters' reality. Nora, Amy, Delia, and Hallie were also the daughters of alcoholic screenwriter parents, and the siblings experienced varying degrees of success that tempered their relationships with one another. Their father, Henry, died in 1992 of natural causes, while their mother, Phoebe, died in 1971 of cirrhosis. Delia told the *LA Times* that the family was "very careful about ever saying anything about there ever being any problems when my parents

were alive."[13] Writing the book, she added, helped her "understand in a more in-depth way what my relationship with my father was about." As Delia and Nora's sister Hallie put it, their "father's endless crazy phone calls" essentially became the novel.[14]

When it came to crafting the film adaptation, it became a family affair when Nora stepped in to write the script with Delia—and to direct. It was the second time they worked together on a family drama, but it was not an easy collaboration. It was allegedly "too close for comfort." "What we found ultimately, over the years, was that there was stuff that was right for us to collaborate on and then there was the stuff that was too personal, like *Hanging Up*, which was too difficult for both of us to work on," Delia told *Vanity Fair*.[15]

It makes sense: Georgia is a less-than-subtle allusion to Nora's tenure as a food writer—she

PREVIOUS SPREAD Diane Keaton as Georgia in *Hanging Up* (2000)

BELOW Lou (Walter Matthau) caught in bed with Esther, played by Edie McClurg

Meg Ryan and Diane Keaton behind the scenes looking at a script

just happens to steal Eve's stuffing recipe and publish it in the *New York Times*, without ever having made it. (Nora would never do such a thing.) According to Delia, "Georgia both is and isn't Nora." She adds, "Nora is awesomely confident and has the effect of both terrifying you and comforting you at the same time."[16]

Ultimately Keaton took over when Nora was tapped to direct *You've Got Mail*, but Keaton was initially reluctant.[17] "Then the reality of the fact that somebody would have to play my part dawned on me," she said. "I knew I was going to be terrified, so why not just double-wham it."[18] It just happened to be the last time she directed a feature-length film.

In *Hanging Up*—a movie that could easily be mistaken for a Nancy Meyers flick for its chic California interiors—three sisters (played by Ryan, Keaton, and Kudrow) fight and bond while their father (Walter Matthau) falls ill. Nora's muse, Ryan, plays Eve, a perky event planner with middle-child syndrome who has become her father Lou's default caregiver; Keaton takes on the role of a self-absorbed Joanna Coles–type magazine editor; Kudrow plays Maddy, the baby sister who is a coddled soap opera actress. Unfortunately, the actual plot was half-baked despite the smart casting and character work.

Through a series of flashbacks and daydreams, the film unpacks the women's fraught relationships with one another as well as with their father, often amid the trappings of Eve's Spanish-style bungalow. Their connection—and disconnection—is demonstrated largely throughout a series of manic phone calls, which take up too much screen time. They recall the humor of his insatiable thirst for sex (walking in on him and a semi-regular hookup) and the worst of his alcoholism (how he ruined Eve's son's birthday party), while the present Lou delivers offensive one-liners about his Hollywood heyday from his hospital bed in what is Matthau's final role.

Those memories also reveal how easily Eve settled into the "daddy's little girl" role throughout her life. She is ignored and a chronic people-pleaser, always encumbered by caring for other people or their needs. She worries and takes care of her ailing father, suffering from dementia; plans a party at the Nixon Library; carts around her sister's giant St. Bernard puppy, Buck; and gets into a car accident because she's frantically on the

Meg Ryan

Diane Keaton

Lisa Kudrow

and

Walter Matthau

Hanging Up

Every family
has a few hang-ups.

COLUMBIA PICTURES PRESENTS
A NORA EPHRON AND LAURENCE MARK PRODUCTION
"HANGING UP" ADAM ARKIN
PRODUCED DIANA POKORNY MUSIC DAVID HIRSCHFELDER
DESIGNER BOBBIE READ EDITOR JULIE MONROE
PRODUCTION WALDEMAR KALINOWSKI
DIRECTOR OF HOWARD ATHERTON, B.S.C.
PRODUCED DELIA EPHRON · BILL ROBINSON
PRODUCED LAURENCE MARK · NORA EPHRON
BOOK DELIA EPHRON SCREENPLAY DELIA EPHRON & NORA EPHRON DIRECTED DIANE KEATON
www.sony.com/hangingup COLUMBIA PICTURES

LEFT Georgia, Eve (Meg
Ryan), and Maddy (Lisa
Kudrow) with their father,
Lou, as he lies in his hos-
pital bed

Eve trying to feed a pill
to Maddy's beloved
St. Bernard

Eve takes a phone call
while sitting on the floor
of her bedroom as Joe
(Adam Arkin) looks on.

phone—she's juggling so much that you're waiting for her to finally crack. And she does, entertainingly so.

One of the highlights of *Hanging Up* is also one of the most darkly comedic scenes in the movie. Eve jolts from her pristine white pillow from her sleep in a panic when the phone rings, shouting, "He's dead!" Clearly, Eve is overwhelmed, anxious, frazzled. The thought has been haunting her! Though she's relieved when she finds out he's not, the scene is one of the funniest in *Hanging Up*. It's sardonic in nature but also bittersweet—there is little

milking sympathy about the father about whom she couldn't be more ambivalent? Eve won't stand for it any longer. And finally, Ryan, Keaton, and Kudrow *really* deliver their best moments in the film—when they're together.

Despite earning $51.9 million at the box office,[19] *Hanging Up* didn't exactly win critics over. The *Guardian*'s film critic Peter Bradshaw said that *Hanging Up* was written "in a kind of gibbering therapy-speak, and structured in a series of evenly spaced emotional crises."[20] Bradshaw's harsh critique was somewhat warranted—Eve's outbursts seem like a

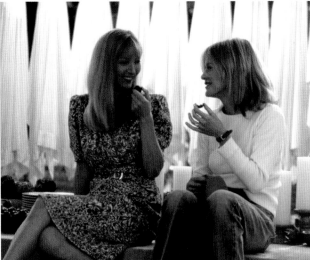

comedy in caring for an unwell parent, especially one you have a fraught relationship with. But Eve delivers a line that emanates the signature Nora neuroses that burst from her films. However, that one scene did not in fact save *Hanging Up*.

Though the point of the movie is to show the complex familial relationships between Eve and her father as well as her sisters, much of it is nothing more than entertaining meltdowns as Eve loses her sanity amid the chaos and grapples with the emotional roller coaster of grief. By the end of the film, *Hanging Up* feels like merely a character study—the plot an afterthought.

At that point little has happened, and all you've seen is Eve getting saddled with responsibility after responsibility. So when Georgia gives a sob-story speech at the Nixon Library about how her father's dying—as if she cared—you can feel Eve's rage. Georgia

way to pad out the plot because the movie is rather anticlimactic.

New York Times film critic Stephen Holden was equally harsh: "Frustrated cell phone communication among the major characters is such a naggingly unfunny recurrent gag in the film that by the time it's over, you wish that dog had devoured every telephone on the set ahead of time."[21] It's true—the gag doesn't land, and it's a nice reprieve when Eve disconnects all the phones in her house. The movie seems to rely on the barrage of constant phone calls to provide conflict.

While Roger Ebert was largely in agreement with the others, he did find a silver lining in the film: "The best scenes are the ones in which the daughters are performing as themselves—projecting the images they use in order to carve out psychic space within the family."[22] Eve, Georgia, and Maddy, in all of their chaos, are larger-than-life characters

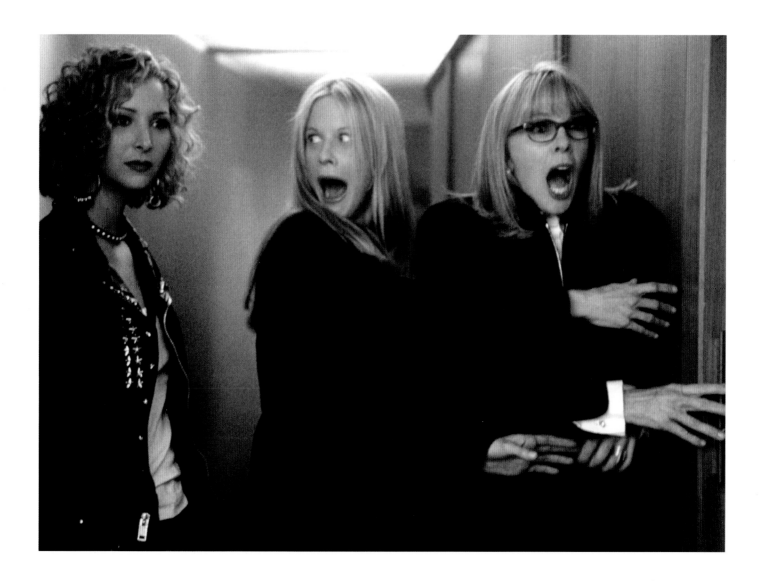

filling up the white space, but their performances aren't enough to save the movie.

With such a star-studded cast and the personal nature of the material, *Hanging Up* lives on with a lot of untapped potential. It intends to show the depth of sisterly bonds and grief, but it ultimately feels like a one-dimensional glance at a family's memories. Its personal nature may have contributed to the unevenness of the film. While Nora didn't direct it, the complex issues at the center of the movie that mirrored the sisters' own lives seemed to stunt its success and Keaton's directing career. We are left with an hour and a half of nervous breakdowns, heated phone calls, and enviable interiors. ◆

OPPOSITE Georgia giving a speech about her magazine

Maddy and Eve sitting on a countertop, eating candy and laughing

ABOVE Maddy, Eve, and Georgia shocked in an elevator

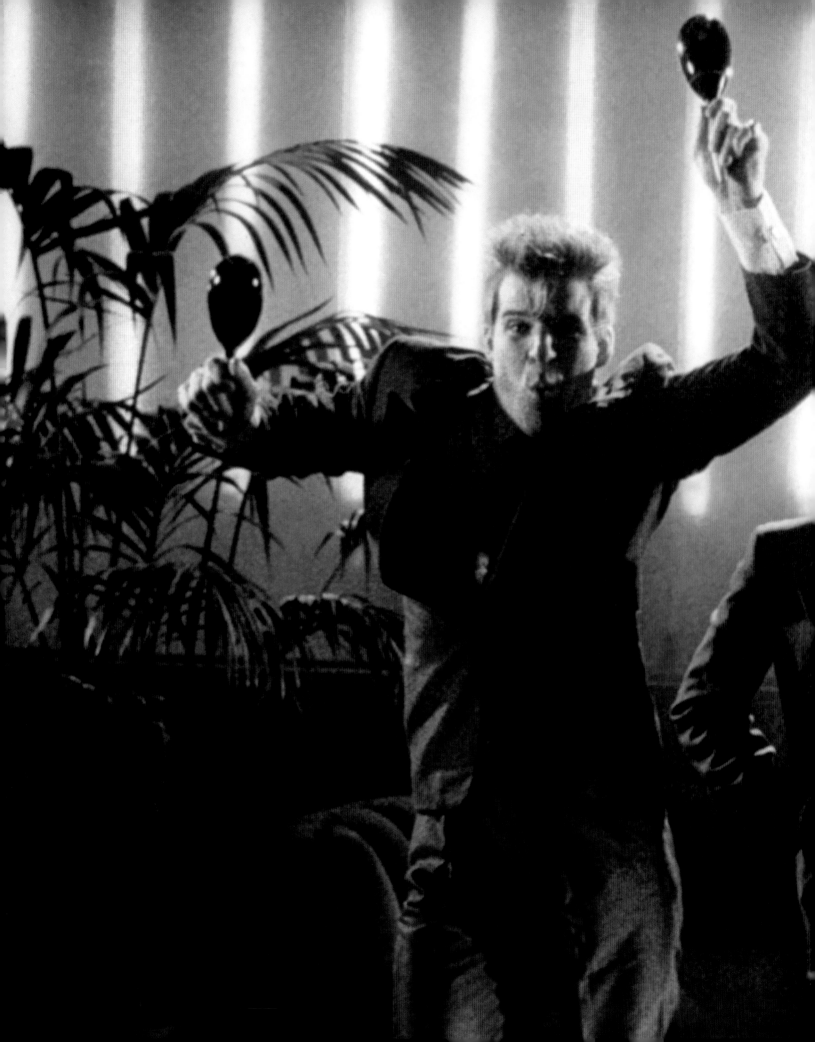

Under the Radar

Vinnie (Steve Martin) and Barney (Rick Moranis) dancing with maracas in *My Blue Heaven* (1990)

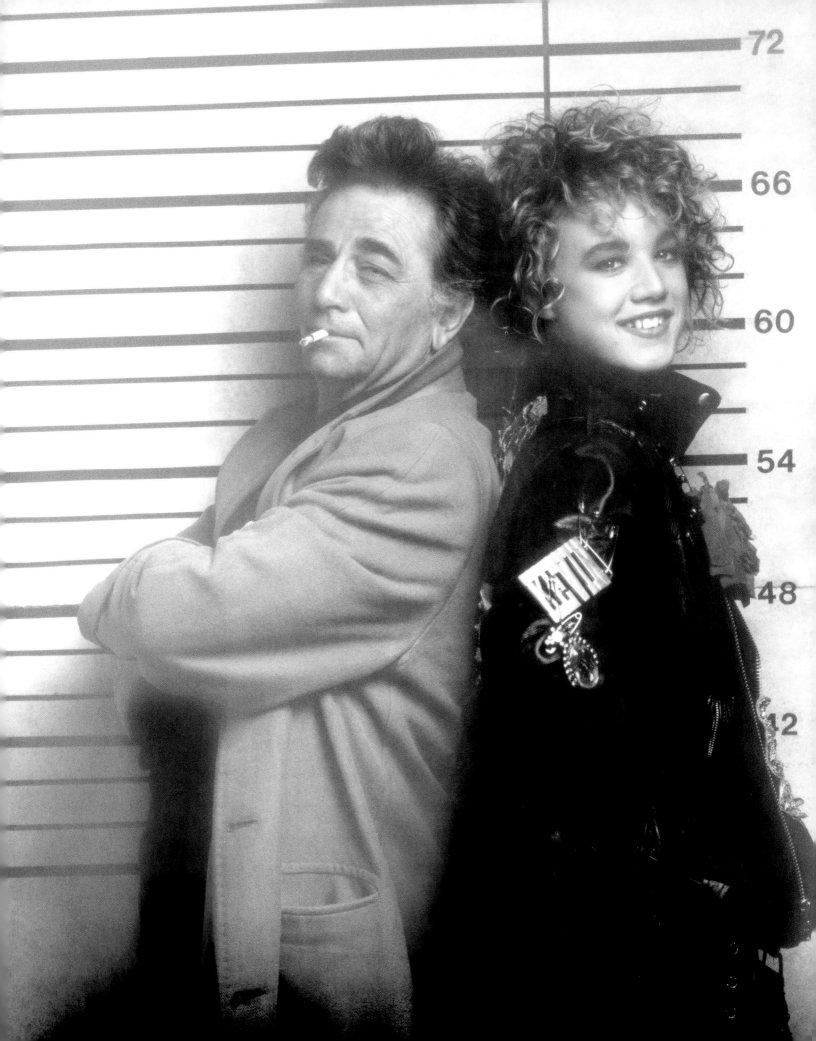

Cookie

The eighties were teeming with classic gangster movies: *Scar-face*, *Married to the Mob*, *Harlem Nights*—the list goes on. *Cookie* isn't one that generally surfaces near the top of that list. And it's not one you necessarily think of Nora being a part of when combing through her filmography. But she was.

Following their successful collaboration on *Silkwood* (1983), Nora and Alice Arlen teamed up again for the screenplay for *Cookie*. It would be years before Nora herself would sit in the director's chair; instead, Susan Seidelman took on that role. She admired Nora's reputation as sharp-witted and was drawn to the screenplay "because it's a gangster film told from a girl's point of view." "Actually, this is a father-daughter story," Seidelman told the *New York Times*. "You have this young, modern girl thrown together with her very old-fashioned macho father, and they have to work out their problems by the end of the movie."[1]

It also spoke to Seidelman's own "bad-girl fantasies" growing up in Philadelphia. "There was always a side of me that would

watch gangster movies and think, 'Ooooh, that looks like fun. I wish I was the guy driving the getaway car,' as opposed to, 'Oh, I wish I could be washing the dishes,'" she added.[2] So the idea of *Cookie* resonated with her.

Cookie is the story of paroled racketeer Dominick "Dino" Capisco (Peter Falk), who tries to reconnect with his rebellious, illegitimate daughter—the titular Cookie (Emily Lloyd)—when he's released from prison after thirteen years. Dino wants to get out of the business, and Cookie's mom, Lenore (Dianne Wiest), wants him to get to know her, but things don't go as planned.

As Cookie and Dino team up and butt heads along the way, the parolee is the target of a duplicitous former partner and the Feds who want him back in jail. And Cookie, who is initially reluctant to the mob boss's lifestyle, eventually comes to enjoy the thrill of it all.

Cookie is quick-tempered, curious, and headstrong—not about to let a little thing like

the mafia frighten her. She and Lenore navigating the mob as misfits is particularly entertaining—for example, showing up to Dino's safe house in giant stolen furs, as if it's an Atlantic City casino.

The dynamic between Cookie and Dino is simply enjoyable because they are both too stubborn to see how alike they are, and it's in their bickering that this comes to light. When Cookie questions what Dino is doing while she's driving him around, he hands her calamari and dryly retorts, "Shut up and eat some fish."

But beyond the vivacious characters, what decidedly makes *Cookie* a Nora story is that it is also a tale about tough women. Cookie doesn't let anyone—let alone her mobster father—put her in her place. When she meets Dino for the first time since she was a kid, he tells her to stop chewing her gum and she puts it on the call window between them at the prison. She isn't about to take orders from someone who

hasn't been a parent to her. She also refuses to stand down after he slaps her across the face and then goes on to tell a joke about a fellow racketeer prisoner who put a hit on his own kid. Lenore, who owns a clothing store, has raised Cookie completely on her own.

Then there's Bunny (Brenda Vaccaro): she refuses to divorce Dino—savvy enough to know that the marriage of two crime families protects her. And while he was in prison, she took control of her own life by opening a pet-grooming business in her home. None of these women rely on men in the film.

These female characters also turn the film into a stylish feat—ninety-four minutes of pure eighties camp. "The little mafia princess" Cookie is a cigarette-smoking, gum-chewing, leather jacket–wearing spitfire who flaunts big, teased curls and sticks out like a sore thumb among the mafioso crowd. Lenore's style is also antithetical to the gray suits and trench coats of the mob's elite—she's spotted donning power suits or oversized fur coats, or wearing a feather duster in her pink-stained room. Then there's Bunny, who, after a car blows up in front of her house, goes on TV wearing a fabulous getup with a fuchsia T-shirt advertising her pet-grooming and -selling business scam.

It's Seidelman and Nora who dial up the delight. Seidelman, for one, is an expert on camp. Between *Desperately Seeking Susan* and *She-Devil*, her aesthetic is cemented in her films and is mirrored in *Cookie*—from the tacky costumes to the gaudy Italian restaurants. Where Nora shines is in the humor, the quippy dialogue that carries the film. When Cookie walks into the house as her mother is preparing to see Dino for the first time in years and scoffs, "It smells like a bordello in here," you can practically hear Nora shouting. Lenore, though a completely different character from *Heartburn*'s Rachel Samstat, parallels her theatrics.

Cookie wasn't well reviewed and made roughly $1.9 million at the box office.[3] Roger Ebert said, "All of this stuff is just atmosphere, but in *Cookie* it's made to count for a lot, because the characters don't seem to vibrate with lives of their own. They all seem in service of the plot."[4] The atmosphere is what makes *Cookie* charming. It's the mafia-chic attire, the grit of New York City, and the *Sopranos*-like caricatures that make *Cookie* a sassy, quirky ride.

While *LA Times* film critic Sheila Benson said, "It's a plot-heavy story of elaborate

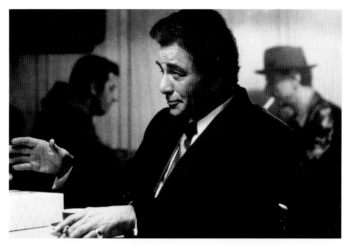

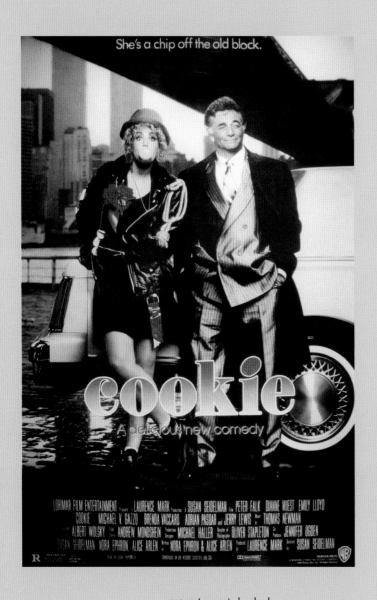

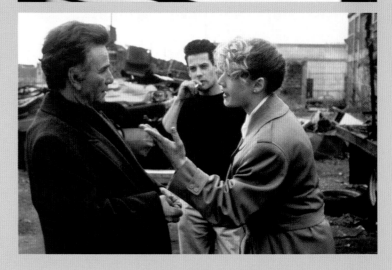

RIGHT Lenore in her bed yelling at Dino

Cookie looking out the car window in a black veil

Cookie arguing with Dino while young gangster Vito, played by Adrian Pasdar, smokes a cigarette behind them

Lenore, Cookie, and Dino in front of a plane

double-dealing as Dino schemes to get even with his cheating ex-partner, Carmine Tarentino (*Godfather II* icon Michael V. Gazzo), while avoiding a tail that the politically ambitious D.A. Segretto (Bob Gunton) has on him."[5] To its detriment, the layers of plot and subplot make *Cookie* feel more like an overstuffed sitcom, uncertain whether it's about a heartwarming father-daughter reunion or about dodging various types of dangers.

Though it's full of wisecracks and has the key elements that make a memorable mafia movie—a street-smart protagonist, a law enforcer, a rivalry, a revenge plot—the Seidelman flick blended in with the mafia-movie mayhem of the eighties and was saddled by its layered plot. Nora and Alice helmed a very different film from *Silkwood* and they just couldn't re-create the magic of it. *Cookie* is not the most notable part of Ephron canon, but it has the hallmarks of her most beloved work. It's the strong-willed, independent women, hysterical breakdowns, and witty dialogue that make *Cookie* worth watching. ◆

My Blue Heaven

Just one year after the release of *Cookie* and following the success of *When Harry Met Sally*, the prolific multihyphenate was on to her next mobster tale with *My Blue Heaven*—an unexpected misfits comedy that showcased the execution and enduring charm Nora strived for with her previous gangster flick.

When she was penning the script, Nora was immersed in the mafia world—her then husband, Nicholas Pileggi, was working on the nonfiction book *Wiseguy*, later produced as *Goodfellas*. She found herself inspired in the midst of his process, and the real mobster Henry Hill became source material for *My Blue Heaven*.[6] However, she wrote her own signature comedic twist into the script, turning the real-life Henry Hill into Vinnie. Throughout Pileggi's time working on *Wiseguy*, he and Nora would often receive collect phone calls from Hill asking for bail money and help, so she naturally got to know him.[7] "He was always getting into trouble, and it was for things like jaywalking, which

are not crimes in New York, you know," she added. In Hill's memoir, *Gangsters and Goodfellas: Wiseguys . . . and Life on the Run*, he recalled, "At night, I'd get half-gassed and call Nick in New York just to bullshit. It was like therapy for me. Sometimes Nick's wife, Nora, would answer the phone and tell me, 'Hey, Nick is sleeping. What's the matter, Henry? This is Aunt Nora.' Meanwhile, she was picking my brain for a script she was writing. I had no idea. She was on the other end taking notes. She was a piece of work."[8]

In the fall of 1987, Nora pitched the idea of *My Blue Heaven* to Anthea Sylbert, her future cowriter, and actress Goldie Hawn, who was interested in the DA role. But after Nora began writing and revising the script, it seemed like the role might not be a fit for Hawn.[9] By early 1989, she left the project due to "family reasons," though she stayed on as executive producer. But *My Blue Heaven* needed a well-known actor attached to it.[10] "I sent the script to Steve Martin, who responded very quickly," Ephron said. Martin was interested in playing the FBI agent, but she asked him to take on the mobster role. Martin's agent recommended *Honey, I Shrunk the Kids* star Rick Moranis for the FBI agent part, and Joan Cusack took on the DA character. They needed a comedy director, and Herbert Ross "was available immediately" to direct.[11]

Goodfellas was a Scorsese crime epic, almost like a more earnest take on made men, while *My Blue Heaven* was a spoof of caricatures that has largely fallen into a cinematic black hole—banking on the star power of Martin, Moranis, and Cusack to elevate the film.[12] It follows mob informant Vincent "Vinnie" Antonelli, played by Martin, who has been reluctantly relocated to the doldrums of California suburbia in witness protection, where he's supposed to cut ties with his old ways while he waits to testify against mafia kingpins.

For him, old habits die hard, but along the way, he forms an unlikely bond with the bookish FBI agent on his case, Barney (Moranis). "The idea, of course, that you could set these people down in, say, Wichita, and expect them to be model citizens, is ludicrous," Nora said in the production notes for *My Blue Heaven*. "And there they are, suddenly in pineapple-and-cottage-cheese-land. It seemed like a funny idea to explore."[13] Together, Martin and Moranis bring their own brand of buddy-comedy magic to the screen.

The unlikely friendship that forms between Vinnie and Barney makes for some of the most enjoyable moments of *My Blue Heaven*. While Vinnie is in need of rules and structure, Barney desperately needs to loosen up. A little lesson from Vinnie on merengue—after he bamboozles Barney into a night out right before he testifies—does just the trick. The duo ends up in a dance sequence that doubles as a physical comedy lesson in confidence and character development for Barney.

Meanwhile, their characters are notably weighed down by stereotypes. Moranis is a typical nerdy workaholic, while Cusack's role as Hannah, the assistant district attorney, is no different. She's a matronly divorcée who is essentially depicted as sucking the fun out of the air. As Megan Garber of the *Atlantic* wrote, "The characters here read more as caricatures

PREVIOUS SPREAD Steve Martin as Vinnie posing with a lawn mower in *My Blue Heaven* (1990)

OPPOSITE Vinnie, Hannah (Joan Cusack), and Barney (Rick Moranis)

Rick Moranis as Barney

Vinnie takes Barney suit shopping

Vinnie and Barney dancing the merengue

than as people, and the ethnic stereotyping, in particular, is blithe and unapologetic."[14] It's Martin's Vinnie that is undoubtedly the most offensive: he's a caricature of Italian Americans, with hair that looks like it was shocked by a light socket. Still, he manages to charm mostly everyone on-screen as this cartoonish mobster, wielding a cigar and teaching the grocery store employees what "a-ru-ga-la" is.

Throughout *My Blue Heaven*, even as Vinnie attempts to pull off the illusion he's changing, he's still up to his old tricks on new stomping grounds. Vinnie is secretly (and not so secretly) committing petty crimes—stealing cars, scamming grocery stores, starting a new mafia chapter with former mobsters placed by the FBI in the same town, and setting up fake donations. And yet, he still has a conscience. As Vinnie grows closer to Barney, he finds himself playing Cupid between him and Hannah, who is not convinced by his charms and puts a target on his back.

Still, Vinnie takes Hannah and her two kids to a baseball game in a limo just so he can ignite a spark between her and Barney. While these altruistic matchmaking moments are few and far between, Vinnie does end up making a sizable donation to the local baseball team—but only after he's caught in the midst of a scam. He's a softie at heart, but still a mobster.

Beyond Martin and Moranis, Cusack is a scene stealer in her own right for the way she executes her outbursts. It's embedded in Hannah's character that we see Nora's work of messy, complex women—including bits of Rachel Samstat's breakdowns.

Cusack, whose melodramatic flourishes made *Addams Family Values* and *In & Out* memorable, is a master of the on-screen meltdown. In *My Blue Heaven*, thanks to Nora's script no doubt, she channels that same energy, making Hannah feel fully formed despite being in a supporting role. It's how she turns a scene in *My Blue Heaven* where she finds out she accidentally flushed her son's turtle down the toilet into a one-woman show.

My Blue Heaven did somewhat decently at the box office, but the reviews were conflicting. *New York Times* film critic Caryn James said, "Such comic moments are scattered throughout 'My Blue Heaven,' which is a truly funny concept and a disappointment on the screen."[15] To James's point, Nora's quest to turn Hill's story into a gag-filled buddy comedy

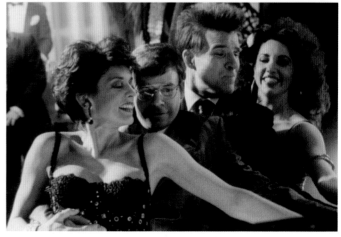

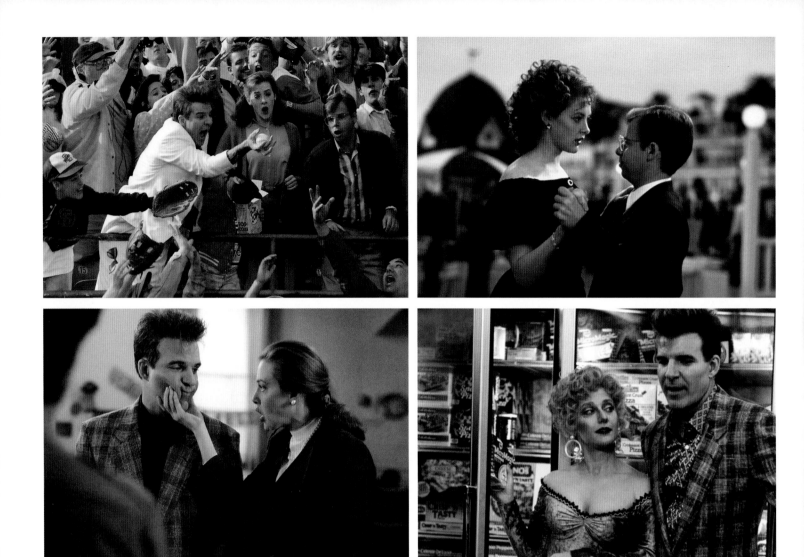

ABOVE Vinnie catching a
baseball at a game he's
attending with Hannah
and Barney

Hannah and Barney
dancing together

Hannah grabbing Vin-
nie's cheeks

Vinnie tries to charm
Shaldeen, played by
Carol Kane, in the
supermarket

OPPOSITE Hannah hold-
ing a rose

was inventive. And it isn't true that Martin,
Cusack, and Moranis don't provide laughs
with their hijinks. But the movie gets lost in
its own shtick.

Meanwhile, *Entertainment Weekly*'s film
critic Owen Gleiberman took aim at the writ-
ing: "The script, by Nora Ephron (*When Harry
Met Sally*), is tame, predictable, and mostly a
skeleton for the performers."[16] It never seemed
like Nora believed the script wasn't anything
but predictable, but she seemed to rely more
heavily on the larger-than-life gags that the
film's leads could provide than taking risks.

LA Times film critic Sheila Benson noted
that "the idea of a community of relocated
gangsters, desperate for a little decent mari-
nara sauce, but consigned to the land of pop-
overs and sunflower seed salads is a funny one,
but screenwriter Nora Ephron doesn't flesh it
out properly."[17] For all of the creativity poured

into the script—and the inconceivable notion
that a community of quirky criminals would
be relocated to the same purgatory of subur-
ban monotony—the story, like *Cookie* before it,
remains scattered.

As with *Cookie*, *My Blue Heaven* isn't meant
to be self-serious, but the frivolous concept of
the film doesn't quite cut it. The idea that all of
these former mob informants would be sent to
the same town by the FBI, the DA would be so
naive as to think a hit wouldn't be put on this
mob informant if news leaked of his where-
abouts in the paper, and that he would become
"Man of the Year" in this town for refreshing a
baseball field is beyond absurdity—asking too
much suspension of disbelief from the audi-
ence. But the pairing of Martin and Moranis,
the playful character work, and the creative
spin on a mafia movie still earned the film
some die-hard fans. ♦

Mixed *Nuts*

After the whirlwind success of her rom-com trio, Nora wasn't interested in another Hollywood romance: "The last thing I wanted to do was a love story about two people who think they're destined for one another," Nora said.[18] So the idea of working on a black comedy based on 1982 French farce *Le père Noël est une ordure* (*Santa Claus Is a Stinker*) was more than appealing. "I loved this and Delia loved it because the premise just killed us: people at the suicide hot line who were more neurotic than the people calling." Released in 1994 as *Mixed Nuts*, the film was named after one of the most beloved snacks at Nora's famed dinner parties.[19] She wanted the film to show "just how complicated" Christmas could be.[20]

Despite *My Blue Heaven*'s critical failure, Martin was the first to join the cast: "I just trust Nora, and I know that when we get there on the set, it's going to end up funny somehow," he said. Unlike Nora, Martin was coming off two films that hadn't

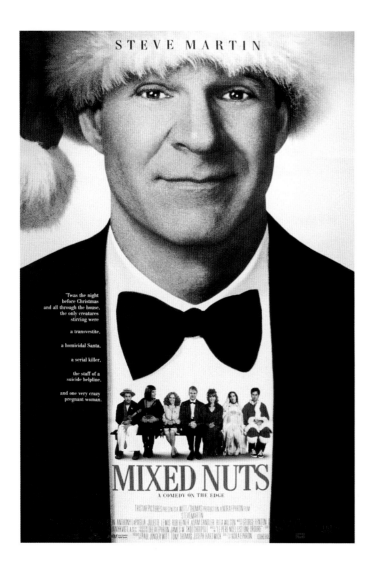

STEVE MARTIN

'Twas the night
before Christmas
and all through the house,
the only creatures
stirring were

a transvestite,

a homicidal Santa,

a serial killer,

the staff of a
suicide helpline,

and one very crazy
pregnant woman.

MIXED NUTS

A COMEDY ON THE EDGE

PREVIOUS PAGE Louie
(Adam Sandler) playing
the ukulele in *Mixed Nuts*
(1994)

OPPOSITE Nora Ephron
talking to Sandler and
Martin on set

Nora standing behind
her director's chair on
the set

Nora on the set

performed well—a hit was important to him. But Nora knew *Mixed Nuts* wasn't going to have the mainstream appeal of *Sleepless in Seattle*. "My hope is that it finds that 'Fish Called Wanda' niche," she said. She hoped that like *A Christmas Story* or *National Lampoon's Christmas Vacation*, it might become annual viewing on TV during the holidays.[21]

Written by Nora and her sister Delia and directed by Nora herself, *Mixed Nuts* uses the tackiness of Venice Beach bodybuilders and tourist traps as a stage for a chaotic Christmas Eve full of twists, turns, and accidental murder.

The ensemble is teeming with talent: Steve Martin, Madeline Kahn, Rita Wilson, Adam Sandler, Rob Reiner, Juliette Lewis, Garry Shandling, Parker Posey, Jon Stewart, Steven Wright, Joely Fisher, Victor Garber, Haley Joel Osment, and Liev Schreiber, in his first film role. On the surface, that alone should have guaranteed success.

Martin leads the slapstick production as Philip, the well-meaning head of a suicide prevention hotline called Lifesavers, who is having a tough time that only continues to get worse. Philip's business Lifesavers hasn't made any money in three years, he's getting evicted by his landlord Stanley (played by Shandling), his fiancée has been cheating on him with a psychiatrist for four months (she wanted to fax him a breakup instead of calling him, but he didn't have a fax machine), and he seems more exasperated by the idea of helping people than passionate about it. In fact, the irony of him running this so-called business is that he's not much better off than the people calling in to his hotline—he doles out advice to callers such as: "In every pothole there is hope."

Working alongside him are the curmudgeonly Mrs. Munchnik (Kahn) and the kindhearted, wide-eyed Catherine (Wilson), who has been pining for Philip for what seems like forever. The former kicks off the character mingling in a shtick where she's stuck in an elevator shaft while the building's tenants ignore her—even a fruitcake hurled at the ukulele-playing neighbor Louie (Sandler) doesn't work. The rest of the cast is made up of Catherine's best friend, Gracie (Lewis), a pregnant shop owner; and Felix (Anthony LaPaglia), the "loser" ex-con father of her unborn baby. Lurking in the backdrop is a seemingly hysterical fear about a serial killer called the "Seaside Strangler."

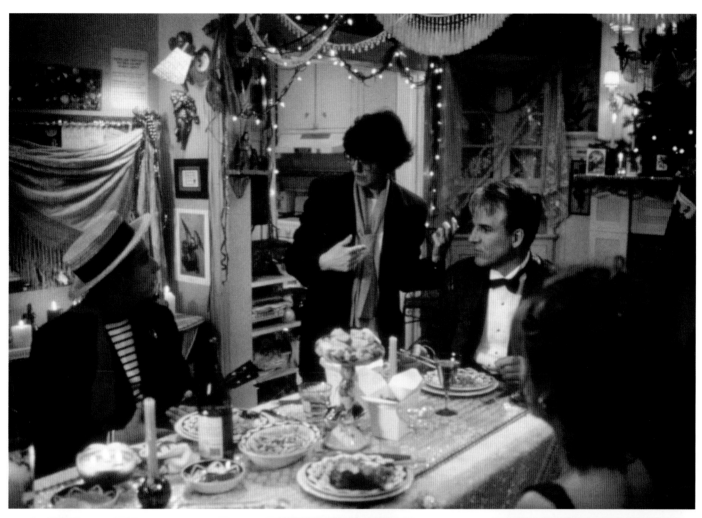

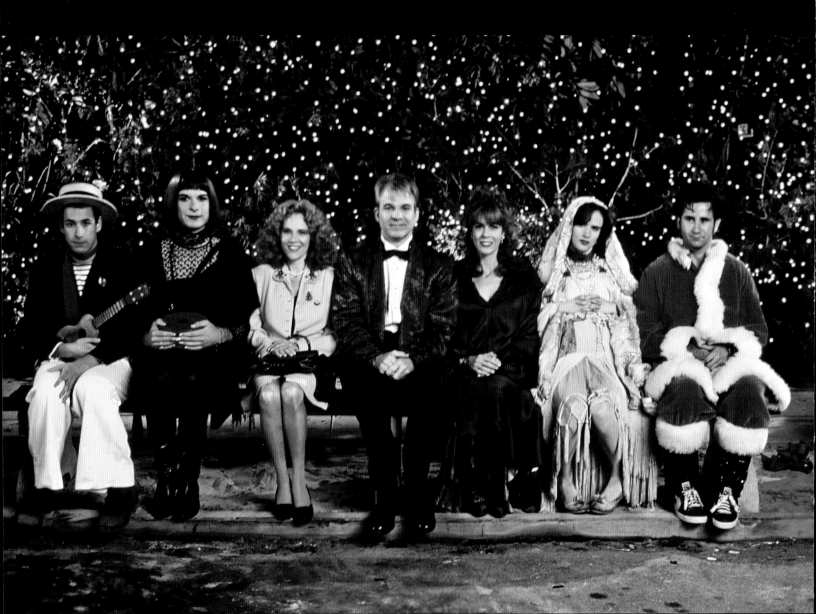

To add to the mayhem, Philip breaks the rules and gives out the address of Lifesavers to Chris (Schreiber), a trans woman, played by a cis man, whose loneliness has escalated on this particular holiday as she is surrounded by family members who harass her by calling her "Arnold"—as in Schwarzenegger—much to her disdain.

When Chris eventually shows up at the office, she is depicted as being tragic, innately sexualized, and self-loathing. When the lights turn out in the Lifesavers office, she's suddenly caressing Philip on the couch, terrifying him. Chris asks Philip to dance, and he is visibly jilted by dancing so closely with a trans person. The movie reeks of transphobia—it's painful to see Chris as this cliché, and having a bigger man like Schreiber portray her seems to not-so-subtly show her presence as unnatural.

The chaos of the day all comes to a boiling point by dinnertime, and the plot is completely off the rails. As a gun-wielding Felix

OPPOSITE Louie, Chris (Liev Schreiber), Mrs. Munchnik (Madeline Kahn), Philip (Steve Martin), Catherine (Rita Wilson), Gracie (Juliette Lewis), and Felix (Anthony LaPaglia) on a gondola

ABOVE Gracie standing with the Christmas tree

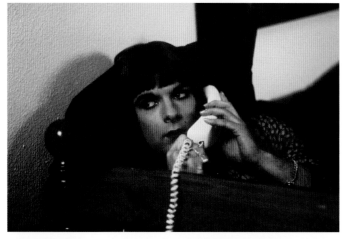

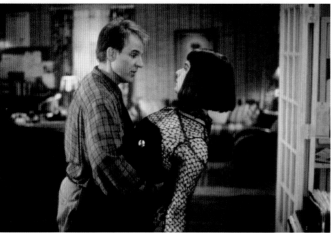

shows up to the Lifesavers office where Gracie, Catherine, and Chris are all congregating for an already manic Christmas Eve dinner, things go haywire. While Felix doesn't seem to want to use the gun, he accidentally shoots Chris in the foot while she's trying to take it away from him.

Gracie eventually wrestles the gun away from Felix, only to empty the remaining ammunition by shooting it in different directions—accidentally killing Stanley while he's buzzing up to the apartment. While they panic over how to cover up a homicide—eventually wrapping him up in the office's Christmas tree—it turns out that no one will get in trouble for this insane crime because Stanley was, in fact, the Seaside Strangler. Gracie then receives a $250,000 reward and Philip will get his $5,000 to save the Lifesavers office. And finally, Philip successfully saves someone from suicide—Felix—who tries to jump off a building in town. A messy Christmas miracle.

As in much of Nora's filmography, the eccentricity of the characters in *Mixed Nuts* is what makes it so charming. Kahn, in particular, channels the same energy she brought to *Clue*, where she plays tragic widow Mrs. White, screaming about flames on the side of her face. Mrs. Munchnik, also a widow, is a much more uptight, eye-rolling stickler for the rules. But she does steal scenes when she's holding in an emotional explosion over a regifted fruitcake from Philip. "A fruitcake?" she scoffs at Philip. "Remarkably like the one I gave you last year."

Catherine is a largely likable oddball who has regular meltdowns in an empty tub at work—Wilson does an excellent job of making her a sweet wallflower. Gracie might just be the most annoying, oblivious character, but Lewis is a savant at on-screen theatrics—casually shoveling peanut butter into her mouth while telling Felix she doesn't want to be with him, or downing ribs while being held at gunpoint.

But *Mixed Nuts*, which is now somewhat of a cult classic, was a miss for both the box office and the critics. One critic at *Variety* said, "Director/co-scripter Nora Ephron pitches the humor at a cacophonous level and displays the comedic equivalent of two left feet in evolving an absurdist, slapstick yarn."[22] While *Mixed Nuts* is undeniably full of shlockier wannabe *SNL* skits—Sandler's gondolier player basically is one—the stellar cast turns it into

colorful chaos. Still, it makes the movie feel overstuffed. Roger Ebert of the *Chicago Sun-Times* added, "Maybe there's too much talent. Every character shines with such dazzling intensity and such inexhaustible comic invention that the movie becomes tiresome, like too many clowns."[23]

The sheer power of Steve Martin, Rita Wilson, Madeline Kahn, Adam Sandler—the list goes on—is illuminating but also deeply chaotic. It's as if the characters spend the film just trying to outshine one another. *New York Times* film critic Janet Maslin said, "Staged as pure fluff without an ounce of ballast, 'Mixed Nuts' succeeds only in getting its cast into Halloween-caliber crazy costumes by the time it's over."[24] Maslin is right—the film isn't meant to be

deep, but the sheer inexplicability of what could appear next on-screen at least inspires curiosity.

With *Mixed Nuts*, the slapstick humor often comes at the expense of its characters and erupts in a torrent of gags. Much of the value of the movie stems from its standalone moments—brief character-driven scenes and silly character traits from a star-studded cast with infinite material. It bets on its absurdity, which is a risk worth admiring. Decades later it might not be appointment viewing on Christmas for most, but it remains an overlooked gem in a sea of lesser-known Ephron films—and maybe the holiday version of *A Fish Called Wanda* that Nora always wanted. ◆

OPPOSITE Gracie and her baby daddy, Felix, in shock

Philip and Catherine on the bathroom floor, staring into each other's eyes

Liev Schreiber as Chris, a trans woman who calls the helpline

Philip and Chris dance together

BELOW Rob Reiner as Dr. Kinsky

Rita Wilson as Catherine

Madeline Kahn as Mrs. Munchnik

Michael

John Travolta had been amid a career high for the first time since the 1980s when he received the script for *Michael* in the late spring of 1995. The success of Quentin Tarantino's 1994 movie *Pulp Fiction* catapulted him back to the forefront of Hollywood, and his crime satire *Get Shorty* was set to hit theaters soon. So the Nora Ephron script piqued his interest. "I saw this angel with extremely contradictory qualities, an angel that drank, smoked, womanized, and I felt that I could make it funny," Travolta said of his initial response.[25]

Once they were hired to rewrite the script, Nora and Delia immediately pictured Travolta for the titular role. The New Jersey–born actor, Nora thought, had a talent for being "both completely innocent and deliciously sexy at the same time."[26] She had some time to think about it: Nora had been eyeing the project since 1992, before *Sleepless* was released and became a hit. For her, *Michael* was also a love story: "I always saw it as a story that

JOHN TRAVOLTA
ANDIE MacDOWELL WILLIAM HURT

He's an angel.
Not a saint.

A NORA EPHRON FILM

MICHAEL

and BOB HOSKINS

TURNER PICTURES PRESENTS AN ALPHAVILLE PRODUCTION A NORA EPHRON FILM JOHN TRAVOLTA
ANDIE MacDOWELL WILLIAM HURT BOB HOSKINS "MICHAEL" ROBERT PASTORELLI JEAN STAPLETON
MUSIC BY RANDY NEWMAN EDITED BY GERALDINE PERONI COSTUME DESIGNER ELIZABETH McBRIDE PRODUCTION DESIGNER DAN DAVIS DIRECTOR OF PHOTOGRAPHY JOHN LINDLEY
PRODUCED BY G. MAC BROWN EXECUTIVE PRODUCERS DELIA EPHRON JONATHAN D. KRANE STORY BY PETE DEXTER & JIM QUINLAN
SCREENPLAY BY NORA EPHRON & DELIA EPHRON AND PETE DEXTER & JIM QUINLAN PRODUCED BY SEAN DANIEL NORA EPHRON JAMES JACKS
DIRECTED BY NORA EPHRON

is really about modern love. That's what angels are about, that's what romantic comedy is about. It's about seeking love."[27] And Michael does all this while sporting a trench coat, a flourish Nora added in because her "favorite boyfriend in high school" wore a trench coat.[28]

Like Travolta, Nora and Delia had a gut feeling about Andie MacDowell when it came to casting the role of "angel expert" Dorothy. "When Andie came into read, we knew she was this character," Nora said. "She's so real and true as a human being and is so natural as an actress and a comedian." Plus, MacDowell was very excited by the script, claiming it was "one of the best" she ever read.[29]

Travolta and MacDowell became the main ingredients for the fantastical *Michael*, an eccentric film about a whimsical, cigarette-smoking, beer-drinking, womanizing, sugar-loving archangel who is on his last hurrah to Earth with a mission to warm some hearts and change some lives. His mark? Bitter Chicago tabloid reporter Frank Quinlan (William Hurt), whom he lures to Iowa—alongside his reporting colleague Huey (Robert Pastorelli) and Dorothy—thanks to a letter sent to his office from the Milk Bottle Motel.

While Michael's intentions are largely masked for the duration of the movie, his end goal is to guide Frank and a thrice-divorced Dorothy to fall in love. So, embedded in the fantastical nature of *Michael* is that love story Nora envisioned.

While Nora's most notable work takes place in New York City, *Michael* is based in

Chicago—it's also an Iowa movie and a road trip movie. It's also an offbeat Christmas movie à la *Mixed Nuts*, as Frank and Huey need to bring an angel back to their fickle boss, Vartan Malt (Bob Hoskins), by Christmas—but that's mostly a backdrop timeline. Still, it makes the prospect of life-affirming miracles even juicier as Frank, Huey, and Dorothy hem and haw about whether or not this scruffy guy with wings is an actual angel while they drive him back to Chicago.

It's Michael who brings the real charm. He's as hedonistic as he is earnest, with a cotton candy–like scent that is seemingly irresistible to women. He can make an entire bar of women swoon for him while he struts through a choreographed dance number to Aretha Franklin's "Chain of Fools." He may or may not be telling the truth. He claims he invented something or other—Psalm 85, pie, or standing in line. And while Michael touts a Beatles-coined "All you need is love" mentality, he does love a bar brawl. But he's also an angel who just wants to see the world's biggest ball of twine and the world's largest nonstick frying pan. Plus, he *loves* pie.

So does Nora, and she's able to wax poetic about the humble dessert. Gathered around the table at a motel restaurant with Dorothy, Frank, Huey, and a waitress named Anita, Michael ponders, "What is it about pie?" Everyone at the table, at a motel restaurant known for its homemade pies, shares a different answer—it's pretty; it reminds you of home; "it gives you the sense that you're a foursquare person living in a foursquare country." The table *has* to have two of every flavor—with a scoop of vanilla ice cream—according to Michael. Soon, Dorothy, who also moonlights as an aspiring country singer, bursts out into a song about pie—"Pie, pie, me oh my."

This scene functions as a delightful detour in the film, but in between pie stops, pit stops, and bar fights, Michael helps Frank, Dorothy, and Huey realize they need to stop worrying about the big picture and start appreciating small miracles. Eventually, he proves his angel status by resurrecting Sparky, Huey's dog and the tabloid's mascot. The reporters can no longer deny it—Michael is an angel, an unconventional one.

Released on Christmas Day, *Michael* was a box office success, raking in $119.7 million,[30] roughly as much as the sports dramedy *Jerry Maguire*. But critically, reviews varied—in

PREVIOUS SPREAD Michael (John Travolta) and his wings charging through a field in *Michael* (1996)

OPPOSITE TOP Michael, Huey (Robert Pastorelli), Dorothy (Andie Mac-Dowell), and Frank (William Hurt) in court

Michael dancing at a country bar to "Chain of Fools" by Aretha Franklin

ABOVE Nora talking to John Travolta on set

Nora behind the scenes during filming

a sea of nineties "angel" films, *Michael* was ambling, lacking clarity in its plot, and over-burdened by a lot of cinematic fanfare.

Variety film critic Emanuel Levy found many allusions to *Michael* in *Mixed Nuts*. "New pic also suffers from the same vignettish structure and lopsided tempo that marred Ephron's 1994 comedy," he wrote.[31] While diversions like Michael gyrating at a country bar and a scene all about pie deliver the signature eccentricities of Nora, they're more fun than substantive. Ultimately, it's Travolta's acting that provides consistency in a scattered narrative.

On the other hand, *LA Times* critic Kevin Thomas praised the mood of the film: "Ephron knows how to make every element of the film work for her, for on one level 'Michael' is an appealing homage to roadside Americana."[32] To his point, Nora is a master of world-building. The movie's aesthetic is bridged by a score from Randy Newman, with songs such as "Heaven Is My Home" that are teeming with the simplicity of America's heartland and fitting of Michael's angelic presence.

But with the film's quirky mood, the character work suffered. MacDowell does her best with Dorothy, but she's full of contradictory traits—she's sweet but quietly conniving, and seems to just serve the purpose of being a love interest for Frank. And when it comes to Frank, it's challenging to empathize with him since his curmudgeonly demeanor stems from being miserable at his tabloid job after losing his last job for drunkenly punching the managing editor.

Between *Mixed Nuts* and *Michael*, Nora definitely opted for a more eccentric atmosphere, pushing out of her comfort zone with risk-taking stories to supplement a more oddball tone. While neither film really landed, *Michael* remains a charming nineties rom-com-esque piece of cinema, and like Michael himself, the movie is a little rough around the edges, but its underlying moral is sweet as pie. ◆

OPPOSITE Michael saving Huey's pet dog, Sparky

Michael pushing the world's largest ball of twine

RIGHT Michael looking at the sky with Frank

Frank and his boss, Vartan, played by Bob Hoskins

Frank, Dorothy, and Huey sitting on the edge of a field

Dorothy kissing Frank at the motel

Lucky Numbers

Nora spent much of the nineties penning an array of love stories, but the 2000 dark comedy *Lucky Numbers* was not the romantic kind. "This is a movie about people who are in love with only one thing, and that is money," Nora explained.[33] And this time, she wasn't behind the screenplay.

Originally called "Numbers," the Adam Resnick–helmed script was inspired by a 1980 Pennsylvania lottery scam dubbed the "Triple Six Fix" where the host of the nightly program *Daily Number*, Nick Perry, allegedly orchestrated a fixed drawing. To ensure the lottery's outcome, paint was injected into the balls so that they were too heavy to come out of the machine. The pay-out, which was a then-high sum of $3.5 million, had $1.18 million go to eight people allegedly involved in rigging the lottery. In the end, Perry was convicted but maintained his innocence.[34]

Resnick claimed the screenplay was not meant to be an adaptation of the real-life scandal, saying, "I was mostly interested in the

launching point—a lotto announcer and his cohorts who tried to rig the state lottery. The characters weren't based specifically on anyone involved with the crime." Much to his chagrin, Paramount wanted to make the film a "lighter comedy," so the script went through rewrites. The lead role, eventually given to John Travolta, went from "weatherman slash lotto announcer" to solely a weatherman whom Resnick found cartoonish: "I hate that goofy weatherman stuff. It was a hack cliché even back in 2000," he said.

Paramount brought on Nora to direct—she was supposed to make the film a hit. Among many changes, she reshaped Harrisburg, Resnick's hometown and the setting of the scandal, into something "beautiful" instead of embracing its "shabby realism."[35] As in *Michael* and *Mixed Nuts* before it, Christmas is the backdrop of the movie but it's more about the atmosphere, with an air of Nora sentimentality.

Resnick wasn't happy. "Nora was good at her thing, romantic comedies, but this just wasn't something for her. I guess she wanted to try something different," he said. And even though the studio wanted a lighter comedy, Resnick says Nora "was determined to make a dark comedy."[36]

John Travolta had just come off playing Michael, the titular schlubby archangel in Nora's film a few years prior, before starring in *Lucky Numbers* as a local celebrity weatherman and snowmobile dealership owner Russ Richards. "My character is the only one who is not completely money-oriented, although at first glance you think he is because he actually wants a career in game shows. His real deal is to hopefully one day bypass this local celebrity and become a major celebrity," Travolta said.[37] Nora thought John was one of the few people who could make Russ endearing. "John's characters never lose their innocence no matter what kinds of things they get themselves into," she says. "He brings that to every movie."[38]

Initially, Russ is a small-town golden boy with a game show–hosting dream—determined to be perceived as "nice." The big fish of Harrisburg, he has his own private, roped-off Denny's booth and makes sweet small talk with anyone who comes his way. As the film progresses, Russ reluctantly slips into bad behavior as he runs into financial troubles with his failing snowmobile business during a Harrisburg heat wave. What begins as a bungled insurance fraud con with strip club owner Gig, played by Tim Roth, turns into a plot to rig the lottery by injecting paint into the lotto balls.

Eventually, they enlist Crystal (Lisa Kudrow), an amoral lotto ball girl and Russ's conspiring coworker, to help them pull it off. But then, everyone wants their share of the

PREVIOUS SPREAD Crystal presenting lotto numbers in *Lucky Numbers* (2000)

BELOW A billboard of Russ (John Travolta)

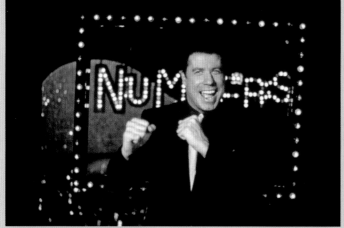

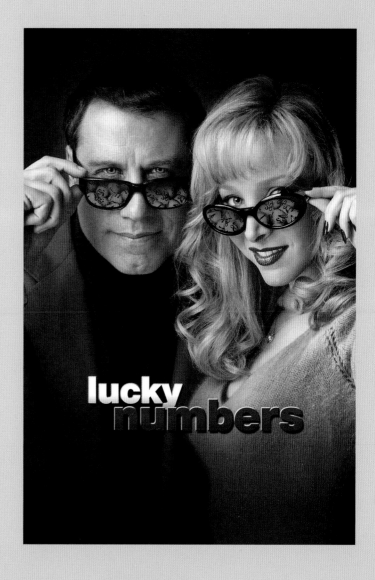

lucky
numbers

LEFT Russ speaking to a
kindergarten class

Russ in a celebratory
mood

Russ and Crystal, played
by Lisa Kudrow, injecting
paint into lotto balls

Russ stressed about the
lotto ball situation

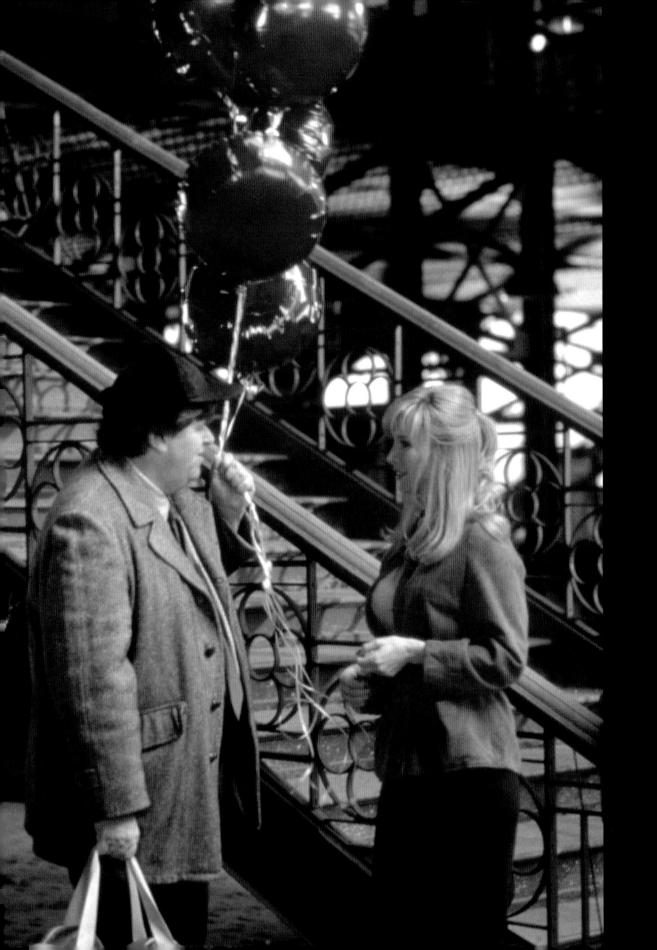

millions once they discover what Russ and his accomplices are up to. What follows is an amalgamation of hitmen, accidental murder, and too many side characters with their own agendas that don't contribute much to the storyline. That said, the cast also features Bill Pullman, Michael Rapaport, and a small but memorable feature from Maria Bamford.

While Travolta has top billing, Kudrow, who had carved out a lane for playing ditzy characters like Phoebe on *Friends*, is the true star of the film. Through the film's jarring tone shifts and setbacks, she delivers the most compelling scenes with hair that would make Michele Weinberger proud, touting one-liners about the joys of sleeping with Russ compared with her married station manager (Ed O'Neill)— "Boy, that is always such a treat. Oh, with Dick it's like having sex with a sloth"—or hurling insults at someone who can't make a proper drink: "What is this? Schnapps? What am I, in third grade? Can I have a drink, please?"

She ultimately fires off some of the best dialogue in the movie—between her realizing the meal she wants isn't on the bar menu ("Fuck me, no fried clams?") and berating Dick in a slutty Santa outfit after he chooses to take his wife on a Hawaii trip meant for Crystal, his mistress.

While Crystal knows she's objectified by the men around her, she uses it to her advantage at every turn. She's an expert at playing dumb, but even better at making a fool out of those around her. She murders her leering asthmatic cousin (Michael Moore), whom she hired to purchase the lottery ticket with prearranged numbers for their scam, by bouncing on him and denying him his inhaler because he wants a larger cut. All the while, she's gleefully watching *Happy Days* in the background.

With a $63 million budget, *Lucky Numbers* only earned $10.8 million.[39] It was not only a box office bomb but a critical miss, too. Roger Ebert of the *Chicago Sun-Times* took aim at the confounding storylines, saying, "Here we got the curious sense that the characters are racing around Harrisburg breathlessly trying to keep up with the plot."[40] Because of that, the tone of the film is skewed—uncertain whether it's trying to be a comedy or something more sinister. It essentially makes it appear as if the stars of the film are acting in entirely different movies.

New York Times film critic Elvis Mitchell, however, praised Kudrow as a standout of *Lucky Numbers*: "Her Crystal has a peevish, greedy streak and blurts out whatever angry remark is rattling around in her almost empty head. When she sits in bed preening after sex, she's basking in her own afterglow; she doesn't need anyone else."[41] Kudrow does quite literally position herself as the star of the film by flaunting the signature ditziness that cemented her role as Phoebe on *Friends* with a side of cunning.

On a broader scale, *Washington Post* film critic Michael O'Sullivan praised Nora for abandoning her "insufferable cuteness," but he ultimately didn't think she was able to take the material in the dark direction it was meant to go in: "Time and time again, she keeps pulling back from the abyss just when [Adam] Resnick's story lets us know that it's ready to abandon all social decency and hurl itself over the edge."[42] For its duration, it aspires to be darker than it lands, and in turn, she sacrifices attempts to take risks. Nora had attempted black comedy in *Mixed Nuts*, but, as in *Lucky Numbers*, it came with a saccharine ending after all the scheming—a ploy to pull off what the Coen Brothers have turned into a cinema empire.

To Nora's credit, *Lucky Numbers* was a gamble. Resnick said it himself when speaking with *Vulture*: "[It] was not an Ephronesque script. And the movie was expensive, so the losses were great."[43] ◆

OPPOSITE Walter (Michael Moore) holding balloons while talking to Crystal

BELOW Russ looking back, smiling, in the convertible

Bewitched

After a string of harsh reviews and box office flops, things started to look up in early 2003 when Nora picked up a call from Amy Pascal, the head of Columbia. "Nora, please help!" Amy said. "Nicole Kidman is coming to meet about doing 'Bewitched' tomorrow morning and we don't have a plot."[44]

The film had been in development for thirteen years with nine screenwriters who had tried their hand at it. Names such as Gwyneth Paltrow, Jennifer Aniston, Cameron Diaz, and Alicia Silverstone had come up for the role of Samantha.

When Nora came into the picture, the film suddenly gained direction. She saved the day, agreeing to direct and enlisting Delia to help write the script with her. Will Ferrell's longtime collaborator Adam McKay (*Anchorman*, *Step Brothers*) also signed on to the project to help shape the script. Nora's story would be a reboot of the 1960s ABC fantasy sitcom *Bewitched*. And in this version, the actress playing TV witch Samantha would actually be a witch in reality.[45]

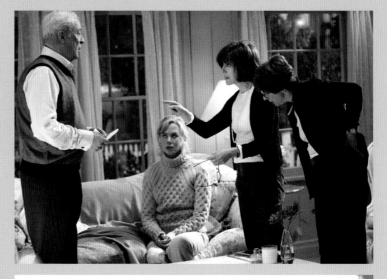

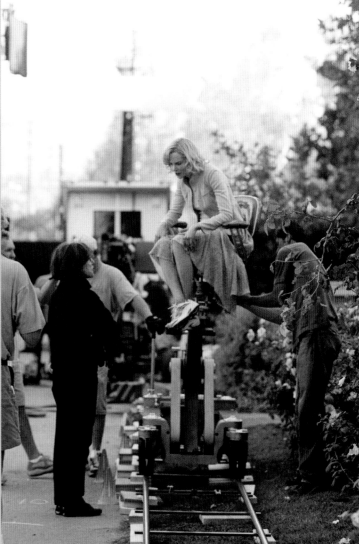

PREVIOUS SPREAD Isabel (Nicole Kidman) with her aunt Clara (Carole Shelley) in *Bewitched* (2005)

RIGHT Nora Ephron on set with Michael Caine and Nicole Kidman

Nora talking to Nicole Kidman while filming

Isabel and her black cat, Lucinda

Kidman, on the heels of successful Hollywood dramas such as *The Hours* and *Cold Mountain*, seemed like perfect casting, in Nora's eyes, for Isabel, who plays Samantha in the movie's TV show. "I became transfixed by the fact that Nicole's nose and Elizabeth Montgomery's nose were the same," she said, later adding that the plot of this movie "is built entirely on that nose."[46] Kidman was thrilled to play a character like Isabel because she was a witch, but also because she "loved that she was so wide-eyed and such a believer in love."[47]

Ferrell, who portrays Jack Wyatt—the actor playing Darrin Stephens in the movie's TV show—was looking to leave TV. He was attracted to Nora's spin on the *Bewitched* story. "I appreciated the premise as opposed to the straight remake of the TV show," he said. "I don't think I would have been interested in just doing *Bewitched* as a movie." The rom-com genre was a change for both Kidman and Ferrell. "Neither of them had ever quite been in a movie like this, so they weren't sick and tired of doing them, so that is always a refreshing thing," Nora told Charlie Rose in 2005.[48]

In Nora's spin on the 1960s classic, narcissistic movie star Jack has hit rock bottom in his career but is trying to reclaim his reputation by starring in a remake of the show *Bewitched*. As the crew struggles to find a witch who can convincingly twitch her nose, Jack discovers Isabel at a bookstore and insists she is perfect for the part, claiming she'll make him look better on-screen. Not only does she have an adorable, twitchy nose but she's actually a real witch—one who can make magic happen by pulling her ear.

She can rewind time, make Jack speak Spanish on command, sell herself a house, and see her dad magically appear on cereal boxes. Of course, beneath the fantasy is a classic Nora rom-com between Jack and Isabel, who are initially repelled by each other à la *When Harry Met Sally* and *You've Got Mail* but eventually—by the power of a little bit of magic, but mostly chemistry—begin to fall for each other.

Kidman (and her nose) are the draw for *Bewitched*. It's the whimsicality of Isabel that makes the film so entertaining—her put-on airy voice, her mischievous way of rewinding time, and the charm of a wayward witch. Her determination to live as a mortal, and not as a witch, is quite predictable indeed, and

watching her try and fail to do so is as fun as it is depressing. She repeatedly remarks some version of "That was my last thing as a witch!"

Despite Kidman's allure, Ferrell, much like Jack, doesn't quite stick the landing as a costar. Jack is meant to be washed-up and egotistical, but he ultimately becomes insufferable not only to Isabel but to viewers—to the point that by the time he demands the crew make him twenty cappuccinos, the fast-forward button can't come soon enough.

It also doesn't help that the chemistry between Ferrell and Kidman is lacking on-screen. They are seemingly polar opposites, acting in two very different movies. Because there is much more screen time spent with each character alone, Jack and Isabel feel self-contained. As a result, the buildup to their romance feels anticlimactic, and it ultimately jilts the narrative.

The casting of the supporting roles in *Bewitched*, however, is largely stellar. Kidman and Ferrell are joined by a laundry list of stars, including Shirley MacLaine, Michael Caine, Steve Carell, Kristin Chenoweth, Jason Schwartzman, Stephen Colbert, David Alan Grier, and Amy Sedaris.

Caine, playing Isabel's mischievous father, Nigel, is a delight whenever he makes surprise appearances on grocery store products. Chenoweth adds campy flair to the flick as Isabel's WASPy but loyal neighbor Maria. Even with only a handful of scenes, MacLaine, who takes on the role of Samantha's diva mother, Endora, on the show, shines as a cape-wearing Hollywood starlet who also claims she's a witch (we

never really know for certain whether she actually is one, but all signs point toward yes).

Despite the deliberate callback, Carell's appearance as a version of Uncle Arthur from the original *Bewitched* series doesn't quite work. Carell's role is a fleeting plot device used to bring Jack and Isabel together, which ultimately appears contrived.

For viewers, *Bewitched* was a mainstream hit. It grossed $131.4 million at the box office with an $85 million budget[49]—charming some critics but not others.

New York Times film critic Manohla Dargis praised the casting of Kidman as a witch: "It's pleasant just to watch Ms. Kidman float through the movie's sets like a visitor from another land; she's as adorable as E.T., though her voice is as baby-breathy as that of Marilyn Monroe."[50] It's true: Kidman's bubbly presence makes it seem like she was born to play a supernatural being, making her undeniably magnetic. However, the overall structure and casting of *Bewitched* gave critic Brian Lowry of *Variety* pause. "Burdened by its show-within-a-movie-about-a-show structure, *Bewitched* suffers from its sheer peculiarity as well as a lack of chemistry (or alchemy, for that matter) between leads Nicole Kidman and Will Ferrell."[51]

The structure did prove to be a clever twist on a beloved classic—a departure from a typical remake. But the chemistry seems forced between Kidman and Ferrell, and the former carries the load on the silver screen. Roger Ebert referred to the movie in the *Chicago Sun-Times* as a series of scenes: "It's one of those movies where you smile and laugh and are reasonably entertained, but you get no sense of a mighty enterprise sweeping you along with its comedic force."[52] Films such as *Mixed Nuts* and *Cookie* had received similar criticism, but the plot of *Bewitched* was much more conceptualized and the scenes fostered character growth for Isabel as she learns self-acceptance.

Nora's offbeat projects such as *Mixed Nuts*, *Michael*, and *Bewitched* were disparaged by critics upon release and then reappraised later on. When Nora opted for quirkiness as a mood, the storyline often suffered. But it's easy to see why Nora wanted to be involved with this project. *Bewitched*, the TV sitcom, was a male fantasy that depicted what happens when patriarchal control disempowers women. Rather than moving the needle, it serves as a cautionary tale. In Nora's take, Isabel fights

OPPOSITE Jack (Will Ferrell) holding Isabel's broomstick

Jack chasing Isabel around her house with a lobster claw

Jack's agent, Ritchie (Jason Schwartzman), chasing him while he's riding a bike on the *Bewitched* TV series set

Isabel, Jack, and Iris (Shirley MacLaine) filming the *Bewitched* TV show

ABOVE Isabel revealing her magical powers to Jack

LEFT Nora Ephron at the premiere of *Bewitched* in 2005

ABOVE Iris walking away
from Isabel on the set of
the TV show *Bewitched*

OPPOSITE Nina (Heather
Burns) and Maria (Kristin
Chenoweth) talking to a
frustrated Isabel on the
Bewitched TV show set

back when sidelined; she teaches Jack several
lessons with magic when she finds out he only
hired her to make himself look better, and it's
inarguable that both Jack and Nigel are no
match for her spells. There's a lesson on the
powers of the divine feminine at the heart of
Nora's *Bewitched*.

In many ways, the movie was also ahead of
its time. *Bewitched* is meta—a real witch being
cast to play a witch on a reboot of a nostalgic
show about a witch. It's a rather on-the-nose
perspective on society's consumption of pop
culture. It also—whether intentional or not—
showed the absurdity of reboot culture and the
catnip draw of nostalgia. ◆

CHAPTER 5

The Final Film

Paul and Julia giving
a toast in *Julie & Julia*
(2009)

129

Julie & Julia

The first collaboration between Nora and Meryl Streep in nearly twenty-five years began with a Julia Child impression. It was the summer of 2005 and Nora and Meryl ran into each other in Central Park during a Shakespeare in the Park performance. It was common for them both to be there enjoying the productions. When they ran into each other that day, the friends began talking shop. Nora revealed she was working on a script based on Julia Child's life in France. "I felt my entire life had prepared me to write this screenplay—my obsession with food," Ephron said.[1] It wasn't long until Streep whipped out her signature Julia Child impression. "*Bon appétit*," she mused with a high-pitched lilt.

Before long, Streep read the script for what would become *Julie & Julia*, and she was instantly moved. "I thought it was absolutely beautiful," Streep recalled. "It made me cry, the idea that what you put in front of your family, that love, those connections between people, are the real important things."[2]

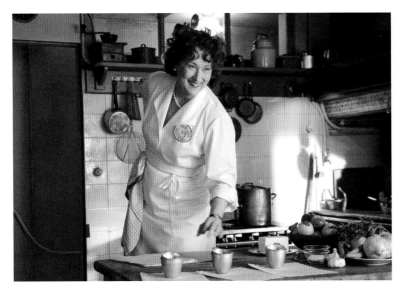

PREVIOUS SPREAD Julie
(Amy Adams) posing
with a portrait of Julia
Child in *Julie & Julia*
(2009)

ABOVE Meryl Streep
as Julia Child in the
kitchen

Stanley Tucci as Paul
Child giving a toast
at a Valentine's Day
celebration

As Streep was set to step into Julia's shoes, she suggested Stanley Tucci for the part of her on-screen husband, Paul Child. The duo had recently starred in the *Vogue*-coded dramedy *The Devil Wears Prada* together. Tucci was thrilled at the prospect of reuniting with Streep on-screen and working with Nora. As someone who loves food and cooking, he grew up watching Julia Child. "She so loved what she did, and you saw it in every gesture and in every inflection," he said.[3]

The film was based on Julie Powell's experience cooking 524 of Child's recipes. Nora eyed Amy Adams for the role of Julie because she believed Amy was quite funny and "smart enough to be a writer."[4] The actress was drawn to how "gentle" the script was.[5]

For Nora, *Julie & Julia* was the ultimate passion project. Julia Child had been a part of her life for a long time. She had first bought a copy of Child's 1961 cookbook *Mastering the Art of French Cooking* when she moved to New York in 1962.[6] Nora believed that Julie Powell had the same unspoken bond with the famed chef.

Julie & Julia, which would end up being Nora's final film before her death in 2012,[7] was the ultimate send-off: a love story within a love story, about food and marriage, two of the topics that were a throughline of decades of her oeuvre. No one but Nora's inner circle really knew that the writer-director was sick during the filming of *Julie & Julia*.[8] But whether or not she intended it to be, *Julie & Julia* was a poetic ending for her career: a love letter to food and to women who have the courage of their convictions to relentlessly pursue their passion

projects. It was also a nod of appreciation to her husband, Nick.[9] A fitting ending to a storied career.

Based on two books, Julia Child's autobiography *My Life in France* and Julie Powell's buzzy 2005 memoir, *Julie & Julia: 365 Days, 524 Recipes, 1 Tiny Apartment Kitchen*, Nora's *Julie & Julia* chronicles Julia's early years in France in her pursuit of a culinary career and aspiring writer Julie's frustration with her post-9/11 cubicle job and her challenge to cook all 524 recipes in *Mastering the Art of French Cooking* within a year. This format returns to the writer-director's affinity for dual storylines with a nonlinear parallel between timelines—something that has shaped some of her best work, including *When Harry Met Sally*, *You've Got Mail*, and *Sleepless in Seattle*.

While Julia gets her cooking career off the ground, struggles to get her book about French cooking for housewives published, and grapples with her diplomat husband's regular reassignments, Julie struggles with balancing the success of her cooking blog (and mastering boeuf bourguignon) with her marriage. Though there are stark differences between Julie and Julia—the time periods, the rationale behind their culinary pursuits—Nora games out a movie where there is more common ground for them than just the kitchen. The parallels surface in their ambition, love for their husbands, and a certain desire for more.

As Julia and Paul's sweet storybook romance unfolds—filled with Valentine's Day bathtub photo shoots, taste-testing, and unwavering support—Julia grapples with balancing her personal and professional ambitions, delivering an unfiltered look at what it takes to sustain a marriage.

Julie's husband, Eric (Chris Messina), is equally supportive of his wife's rabbit-hole journey into Julia's recipes, from setting up her blog to gleefully eating his way through his wife's foray into French cooking, but Julie's obsession with combing through the recipes and also being seen as a writer takes a toll on their relationship. At one point, Eric briefly leaves her as her self-obsession hits an all-time high. Which is understandable. But Eric's patience and Julie's ability to acknowledge her ego—that she can be a "bitch"—help them work things out.

Streep plays Julia as more of a concept than a person—an over-the-top, beloved caricature that no one can resist. It's so enthralling

ABOVE Nora Ephron on set with script supervisor J. J. Sacha, coproducer Dianne Dreyer, and Meryl Streep

Nora and Meryl Streep behind the scenes

Julia in cooking school
with two men who
are surprised at how
efficiently she chopped
her onions

to watch her mimic Julia's mannerisms and go all in on becoming who the public perceived Julia to be. Streep was somehow able to master Julia's unique California-meets-mid-Atlantic voice, or what's referred to as "the upper-class American accent," an aristocratic tone that largely slipped away but that the famed chef held on to. And Tucci's quiet but dedicated presence complemented her stride.[10]

Unlike Julia, Julie is not necessarily the most likable character—she's deeply narcissistic and pessimistic—yet Adams finds a way to make her endearing even when she's insufferable. Messina adds his rugged humor into the mix, grounding their dynamic—though it can be a struggle to watch him through "the Julie show" at all hours of the day.

The most standout moments come when Nora writes herself into the script.[11] Julie endures what she refers to as the dreaded ritual Cobb salad lunch, where she and her three equally insufferable friends all order different versions of a Cobb salad. She admittedly hates her friends and seemingly hates Cobb salad, and yet Julie continues to participate in this cringeworthy charade.

Both critics and audiences loved *Julie & Julia*. With a $40 million budget, the film earned $129.5 million.[12] Streep's role as Julia was praised by Kenneth Turan of the *LA Times*: "She outdoes herself here in a comic-dramatic role that is not only enormously funny but also trickier than it may seem at first."[13] From her old-money vocal lilt to her mannerisms, it was easy to forget it was Streep playing the chef and not Child reincarnated. She ultimately crafted a caricature that was endearing without being insulting. However, Owen Gleiberman of

Julie presenting her boeuf bourguignon to a group of friends at dinner

Entertainment Weekly noted the Julie half of the storyline didn't completely stick the landing. "Yet the movie wants to make Julie an edgy 'bitch' and soften her at the same time, which doesn't exactly jell. What does jell is the drama of two women, hungry for recognition, sharing their earthy love of the kitchen across the decades and the generations."[14]

To his point, Adams's Julie doesn't charm quite like Streep's Julia, almost as if the movie itself is uncertain whether we're supposed to be rooting for Julie. But the generational culinary love story makes it an afterthought—you're already in a foodie's wet dream. Slate film critic Dana Stevens noted the rare—and powerful—feminist narrative that makes *Julie & Julia* innately special: "Still, the relationship at the heart of this movie—between a female mentor and pupil who never meet but who share a common passion and a drive to reinvent themselves—is one you don't often see depicted in the movies. *Julie & Julia* makes deboning a duck a feminist act and cooking a great meal a creative triumph."[15] Stevens is right: what makes *Julie & Julia* so refreshing is the parallel narratives of two women who are determined to rewrite their own stories, while showing how your heroes can become your biggest teachers.

No one could make a better food movie than Nora; her passion for cooking, hosting, and buttery mashed potatoes was no secret. Nora hosted dinner parties for everyone she knew, was a prolific food writer, and even had a secret self-published cookbook she left behind.[16]

But at the heart of *Julie & Julia* is a feminist tale that captures the essence of both Julia Child and Julie Powell. Their stories grapple

with a woman's ambition and the power of reclaiming your destiny through food when in the midst of a rut. As Collider writer Rhianna Malas explains: "*Julie & Julia* makes the case that cooking is the perfect escape. In a world full of chaos, you can have almost complete control over something."[17] It's what makes the payoff of their success so rewarding. So *Julie & Julia* is an ode not only to cuisine but also to women who take control of their lives and who understand, like Julia, that every dish is made better with butter. And, as Julie says in the film, "you can never have too much butter." ♦

ABOVE Julia frosting a cake in her kitchen

Julie and Eric (Chris Messina) making mousse

OPPOSITE Julia holding up a raw chicken

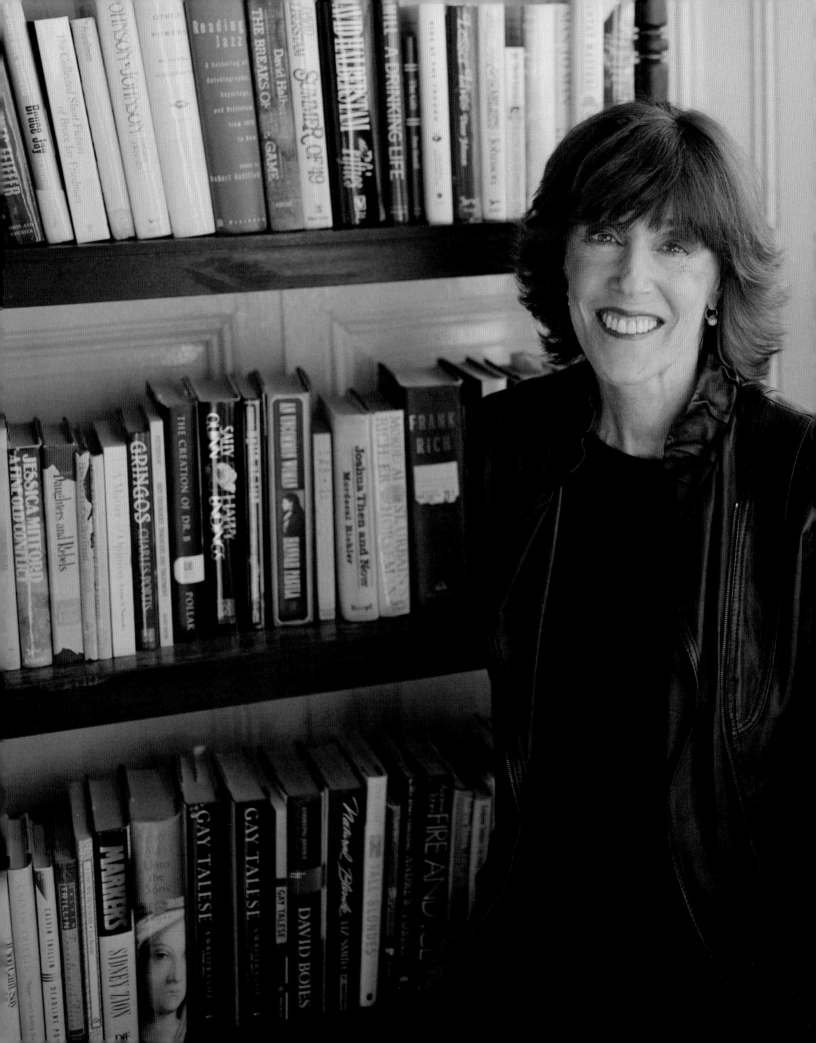

CHAPTER 6
Books and Essays

Nora Ephron in front of
a bookshelf at her Upper
East Side apartment

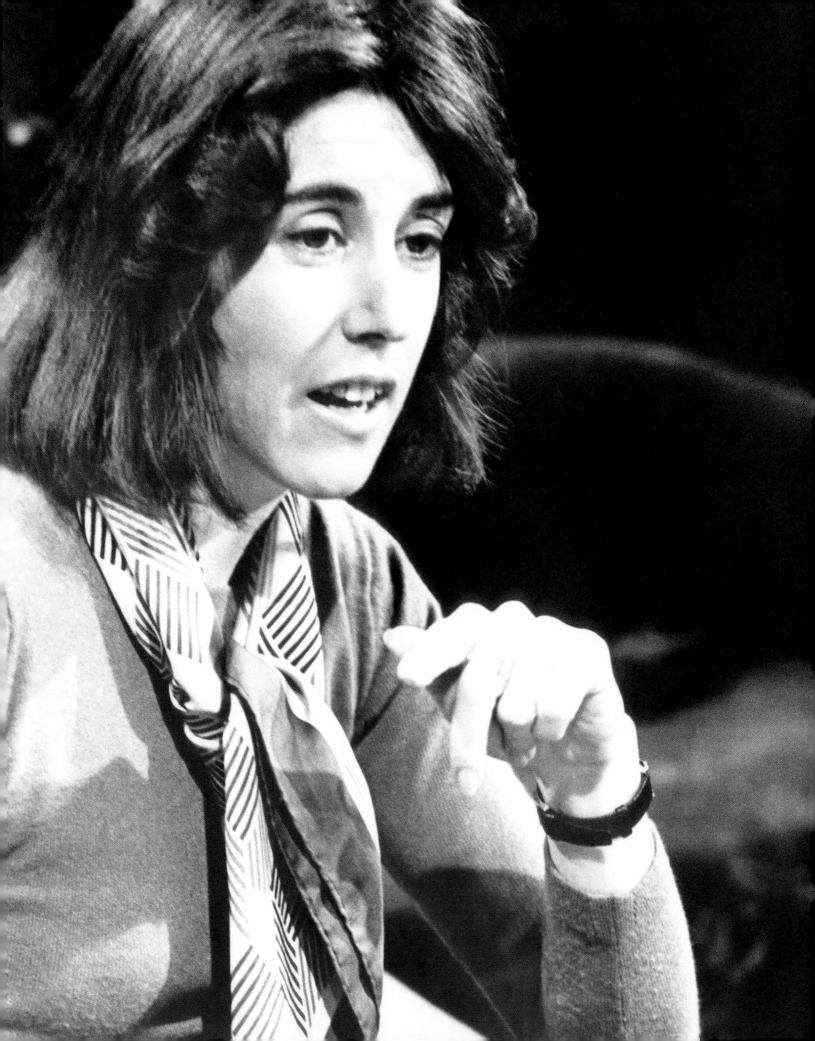

Nora was her words. Copy was her currency—whether consumed on the page or on the screen. Every sharp, witty line is delivered with the brutal honesty of a best friend. It's what made her writing so relatable, so human. Even if you didn't know Nora, she *knew* you.

Still, it's easy to conflate Nora's work with the writer-director herself. Because of Nora's impact in the literary and film industries, there's an unshakable sentimentality that surrounds her work. It's crystallized by her rom-com legacy with *When Harry Met Sally*, *Sleepless in Seattle*, and *You've Got Mail*. Though her on-screen oeuvre was emblematic of this magical Old Hollywood ethos, her prose was quite the opposite. Nora didn't spare anyone's feelings—least of all her own. Whether she was delivering anecdotes about aging or her early career, she was going to tell the truth no matter how messy and meandering it was. She insisted on sharing every humiliation in overdramatic

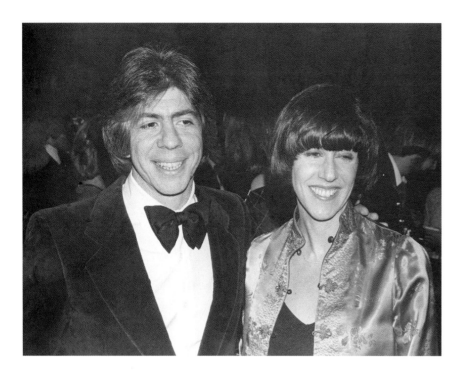

PREVIOUS SPREAD Nora Ephron in 1976

ABOVE Nora and then husband Carl Bernstein in 1978

husband in a book of children's songs she had given him. *Children's* songs. 'Now you can sing these songs to Sam' was part of the disgusting inscription, and I can't begin to tell you how it sent me up the wall, the idea of my two-year-old child, my baby, involved in some dopey inscriptive way in this affair between my husband, a fairly short person, and Thelma Rice, a fairly tall person with a neck as long as an arm and a nose as long as a thumb and you should see her legs, never mind her feet, which are sort of splayed."[5]

While she was expressing her devastation, there was levity. It came not only in her blunt descriptions but in the colorful recipes scattered throughout her fictionalized divorce narrative. There were toasted almonds (to be served with a "stiff drink"), Key lime pie, lima beans with pears, four-minute eggs, and a vinaigrette recipe that has become legendary in and of itself.[6]

In her essays, she brings the same immersive realness. At times, Nora's voice can come off as narcissistic and delusional, but she's also extremely self-aware, brave, and honest to a fault. Her wry and often humiliating storytelling serves a greater purpose—to help other women, for better or worse, not repeat her "mistakes."

Nora's 2006 tome *I Feel Bad About My Neck: And Other Thoughts on Being a Woman* epitomizes this as she grapples with the emotional and physical pitfalls of aging. In the titular essay, Nora laments the neck she once had when she was younger, the one she "took for granted." She could get plastic surgery, but she doesn't; instead, she'll try any kind of treatment and avoid looking at mirrors. As she rattles off the types of neck you can have—stringy, saggy, wrinkled, flabby—her beauty obsession is hilarious, but also surfaces a sad truth: that no matter what age you are, you will mourn your youth: "Oh how I regret not wearing a bikini for the entire year when I was twenty-six. If anyone young is reading this, go, right this minute, put on a bikini, and don't take it off until you're thirty-four."[7]

I Feel Bad About My Neck is a page-turner, rife with frivolous anecdotes and sage wisdom for women of a certain age, as it touches on maintenance, parenting, empty nests, death, and a lifelong cooking obsession. Not all of Nora's ramblings have a destination; some exist as opportunities for her to wrestle with her innermost thoughts and insecurities.

color through a stream-of-consciousness that mimicked what one might imagine to be a stroll through her brain.

While a buttoned-up austerity echoes through the lines of Joan Didion, Nora's more casual tone is teeming with wry cynicism. She believed wholeheartedly in using the most aching traumas and turning them into prose.[1] Her mantra, "Everything is copy," communicates her belief that frustrations, heartbreak, and disappointment could translate into something meaningful, something that you could laugh about one day.[2]

Heartburn is a great example of this approach. Before the Streep-led movie, there was the eponymous autobiographical novel, published in 1983 and heavily inspired by her heartbreaking and hilarious marriage and subsequent divorce from her second husband, Carl Bernstein.[3] While the book centers on food writer Rachel Samstat and political journalist Mark Feldman, they are essentially stand-ins for Nora and Carl—and the affair with Thelma echoed the one her ex-husband had with Margaret Jay. Every sordid detail and scathing sentiment pours onto the page as Nora navigates the affair that cut like a knife through her marriage:[4] "I had gotten on the shuttle to New York a few hours after discovering the affair, which I learned about from a really disgusting inscription from my

Largely, it doesn't matter—just reading her do so is the fascinating part. Like when she recalls getting an operation near her collarbone that left her with a "terrible scar" in the titular essay: "I learned the hard way that just because a doctor was a famous surgeon didn't mean he had any gift for sewing people up. If you learn anything else from this essay, dear reader, learn this: Never have an operation on any part of your body without asking a plastic surgeon to come stand by in the operating room and keep an eye out." After all, Nora, like many of us, could be vain.[8]

In the collection's essay "I Hate My Purse," Nora pointedly writes about the chaos of a necessary but burdensome accessory—the purse—and has a beguiling ability to capture that even with the most unhinged of perspectives. As Nora details a friend's precious relationship with a non-waterproofed "Kelly" bag, her imagination runs wild thinking her friend might be forever stuck at a bistro with that overpriced purse as it rains; she even imagines the country songs that will be written about that very moment. Her friend's lips, she said, actually "pursed" when she saw water falling from the sky. The whole scenario was Nora's tipping point. "At that point, I stopped worrying about purses and gave up," Nora wrote.[9] Despite how far we've come with gender issues, both these essays remain universally relatable. In an era where social media and plastic surgery are paramount, women—regardless of age—are more concerned about their appearances than ever. And purses—they're still cumbersome, yet with the right designer at the helm, they're still status symbols. As *I Feel Bad About My Neck* is a book written by Nora in her sixties, it unsurprisingly also reflects on the idea of death and her own experience with it, using dark humor to confront her mother's passing.

In her final collection, 2010's *I Remember Nothing: And Other Reflections*, the essays are more truncated and her own looming mortality more palpable. In the titular work, "I Remember Nothing," and "Who Are You?" Nora details the pitfalls of memory loss with a sense of resigned acceptance that in some cases she's just better off. If she wants to remember something, she says, she can just use Google. Selective memory can be a benefit of getting older, but there's a universal fear of forgetting words or experiences that lingers—even shrouded in Nora's casual tone.

By far the standout piece of the book is a meditation on Nora's career, "Journalism: A Love Story," which details her career beginnings as a "mail girl" at *Newsweek* and her first job at the *New York Post* following the newspaper strike in 1962.[10] The essay is teeming not only with anecdotes about the inherent sexism of journalism at the time and Nora's move up the food chain, but also with the who's who—the insider-y stories that Nora recalls as if gossiping to an old friend.

Like *I Feel Bad About My Neck*, *I Remember Nothing* grapples with her relationship with her mother (and her mother's relationship with alcoholism), memory, and a legend about *New Yorker* writer Lillian Ross she desperately hopes to find truth in. She tries to re-create some of the witty soliloquies on fixations from her previous collection, such as a cowlick called "Aruba," the depressing nature of an egg-white omelet, and a send-off to Teflon, which weaves in a recipe for a ricotta pancake with a jab-like instruction to "heat up a Teflon until carcinogenic gas is released into the air.[11] But it's not as effortless as *I Feel Bad About My Neck*. Perhaps the sharpest commentary comes in a

Heartburn cover (1996 edition)

"Funny and touching . . . proof that writing well is the best revenge." —*Chicago Tribune*

Nora Ephron

Heartburn

A Novel

WITH A NEW FOREWORD BY STANLEY TUCCI

guide called "The Six Stages of E-mail," which details Nora's disillusionment with email. She's drowning in unanswered emails and spam and a new stage of friendship: "Email is a whole new way of being friends with people: intimate but not, chatty but not, communicative but not; in short, friends but not. What a breakthrough. How did we ever live without it?"[12] Email, once a technological wonder, is now a retro form of communication, romanticized like letter writing.

In one of the rare moments where Nora decides to self-interrogate about her career, she reflects on her creative flops. She shares that even the reappraisal of critical misfires as small masterpieces or cult classics doesn't make the pain of the initial failure sting less. Instead of using failure as a strategic growth tactic, Nora opts for the less shiny truth: "Failure, they say, is a growth experience; you learn from failure. I wish that were true. It seems to me the main thing you learn from a failure is that it's entirely possible you will have another failure." That's not something any motivational speaker would tell you, but Nora did.

Failures—women's failures, specifically—are something Nora had long tackled: the failures that were often rooted in patriarchy and double-edged societal expectations. Her 1975 classic *Crazy Salad*, which features an array of articles she wrote largely for *Esquire* and *New York* magazines during the sixties and seventies, is an exhaustive portrait of different kinds of complex women—including Julie Nixon Eisenhower and Linda Lovelace—through the lens of second-wave feminism, sprinkled with Nora's vivid memories tangentially related to each story or her own, often harsh, judgment.

One of her most famed essays in *Crazy Salad* is "A Few Words About Breasts," where Nora discusses boobs—her own—and how they relate to her trauma. In the article, she plumbs her adolescence and adulthood as a small-chested woman and describes how untrendy that was at the time. In a nutshell: "It was the 1950s for God's sake. Jane Russell. Cashmere sweaters."[13] Nora tried to play God with her own body—sleeping on her back for four years, splashing water on her breasts for "a perfect breastline"—hoping they'd grow, because being without an ample bosom or having an androgynous figure didn't win her any femininity awards at the time. Here, she recalls the rude commentary she endured about her small chest and the psychological toll it took on her. Years of therapy, and she concludes those who have larger busts and complain "are full of shit."[14]

BELOW *I Feel Bad About My Neck* (2006)

I Remember Nothing: And Other Reflections (2010)

Later in the tome, Nora addresses the misogyny rooted in office politics, in a scathing review of Jack Olsen's *The Girls in the Office*, which details the competition between fifteen single women who work at an office "scrambling for little favors and petty advances" from the married men they work for. While the book seems to focus on how desperate the women are, Nora points out how the men are worse, whether it's abusing said women or displaying their own immaturity. One man is so sinister that after the woman he's seeing ends their affair, he sends her a hot pepper explosive and pours acid in her shoes. Another masturbates while dictating notes to his secretary. Nora takes aim at the "boys will be boys" tone of the book and gets even with her words: "The men in this book are in every way as pathetic as the women they victimize."[15]

While *Crazy Salad* was full of anecdotes about women that were important to Nora, "Dorothy Parker" breaks down her own clichéd desire to be just like the satirist, dismantling the idea of the legend of her literary hero: "All I wanted in this world was to come to New York and be Dorothy Parker. The funny lady. The only lady at the table." While Nora admired her witty one-liners, she realized that the idea of Parker was just that—an idea. Parker, as Nora herself says, struggled to be a lauded writer—she was an alcoholic who had several affairs and survived multiple suicide attempts. But ultimately Nora takes a step back and critiques Parker's poetry, which she declares "dated" and not quite as alluring as she once believed. It's a thought-provoking meditation on blind worship and the mythology of flawed women. Blind worship can be a dangerous game, or it can be an awakening. For Nora, it was the latter. She had this notion that Parker's life, penning perfectly witty lines for the *New Yorker* and being a trailblazing scribe, was the life she wanted. But Nora discovered she wanted more: "One no longer wants to be the only woman at the table." Instead, Nora wanted the table crowded with funny ladies.[16]

In "The Littlest Nixon," Nora continues to dismantle the naivete that comes with believing in the idea of someone. This time, she delivers a deft observation of Julie Nixon Eisenhower, the daughter of former US president Richard Nixon, in the face of Watergate. She says, "There is something very moving about Julie Nixon Eisenhower—but it is not Julie Nixon Eisenhower. It is the idea of Julie

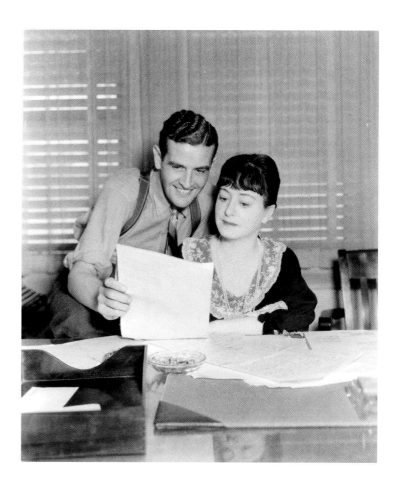

Nixon Eisenhower, the essence of a daughter, a better daughter than any of us will ever be. It's almost as if she's the only woman over the age of twenty who still thinks her father is exactly who she thought when she was six."[17] Nora highlights how skilled Eisenhower is at media manipulation, all the while mocking how untouchable the elite are. No matter her father's crimes, Nora reasons, Julie will always find a reason to justify his actions. "It is safe to say that breeding will win out, and all the years of growing up in that family will protect her from any insight at all, will lead her to conclude that he was quite simply done in by malicious, unpatriotic forces." For Nora, this meditation on Julie and Richard serves as a larger metaphor for the way people with money and prestige remain in power.[18]

Whereas *Crazy Salad* explored women amid American upheaval, *Scribble Scribble* documented Nora's disillusionment with journalism and media. She famously published a scorching takedown of former *New York Post* publisher Dorothy Schiff, whom she had apparently smoothed things over with before writing: "There is no other big city newspaper in

Dorothy Parker and her husband, Alan Campbell, working together on the script *One Hour Late* in 1934

America that so perfectly reflects the attitudes and weaknesses of its owner. Dorothy Schiff has a right to run her paper any way she likes. She owns it. But it seems never to have crossed her mind that she might have a public obligation to produce a good newspaper."[19] Ouch. She ultimately compares Schiff to Marie Antoinette as she details the lack of basic resources—such as chairs and phones in the newsroom—as well as how "stingy" she was with pay. Nora details the disappointment of chasing a story that seems to be leading to a dead end and the plight of trying to become a media star in "Porter Goes to the Convention." Being a reporter is

President Richard Nixon, daughter Julie, and friend Charles Rebozo in Miami in 1972

not as glamorous as it seems—especially when it means covering a story on the naked mayor of Tulark, Idaho, and his secretary.

Nora's essay collection *Wallflower at the Orgy* similarly compiles a collection of her biting articles from *Glamour* from the sixties and seventies. Like her other journalistic work, the collection traverses topics from self-image to feminism and showcases her skills as a reporter. She crafted these pieces after her first real reporting job at the *New York Post*. Before diving into the essays, she delivered a comical, self-deprecating introduction to the eye-catching title:

"Some years ago, the man I am married to told me he had always had a mad desire to go to an orgy. Why on earth, I asked. Why not, he

said. Because, I replied, it would be just like the dances at the YMCA I went to in the seventh grade—only instead of people walking past me and rejecting me, they would be stepping over my naked body and rejecting me. The image made no impression at all on my husband. But it has stayed with me—albeit in another context. Because working as a journalist is exactly like being the wallflower at the orgy. I always seem to find myself at a perfectly wonderful event where everyone else is having a marvelous time, laughing merrily, eating, drinking, having sex in the back room, and I am standing on the side taking notes on it all."[20]

Wallflower embodied the spirit of a journalist finding her voice and leaning into the first-person narrative that would become a hallmark of Nora's work. This introduction also acted as a clear indicator that she would never spare anyone, including herself. Those early years of Nora's reporting showed how she was always more perceptive than anyone else, and ready to talk about it.

Nora's earliest articles shine through in her later work on her relationship with beauty and aging and her intense fascination with notable women. In "Makeover: The Short, Unglamorous Saga of a New, Glamorous Me," Nora's high expectations for getting a makeover are squashed as she realizes the procedure's shortcomings: that a makeover will not transform her into Faye Dunaway. Instead, it will temporarily allow her to elevate her look, but not necessarily make her feel better. Nora's husband tells her she "looks artificial" with her painted face. Her friend thinks she looks forty—and then thirty-eight when she removes some of the makeup. While she learns some valuable tricks for adding cheekbones and sculpting her nose, Nora ultimately finds more contentment in the pre-makeover version of herself.[21]

Nora's food writing has also remained some of her most revered work. Aside from her meditations on romance, heartbreak, and aging, her essays on food excavated the most heart. Nora leaned into the messiness of home cooking in the same way she dug into the chaos of life itself. Food was emotional for her. As Nicole Cliffe wrote in the Hairpin, "Nora Ephron was Joan Didion for people who didn't really have their shit together. Joan Didion would never have told us that mashed potatoes were a horrible paradox of a comfort food, because when you're depressed, the last thing

you want to do is peel, boil, and mash potatoes, and if you actually have someone willing to peel, boil, and mash potatoes on your behalf, how depressed can you really be?"[22] Nora met readers where they were, and that approachability made her prose on soufflés and sandwiches tantalizing. And it was a bonus that her food writing was often full of insider gossip, overblown egos, and drama.

Like her once-hero Parker, Nora graced the pages of the *New Yorker*, penning one of the most poetic essays about a sandwich to ever exist, aptly titled "A Sandwich," an ode to a pastrami sandwich from Los Angeles—claiming it was "the finest hot pastrami sandwich in the world."[23] This declaration was shocking, especially since Nora's beloved New York City is the home of Katz's Deli, the spot where Sally Albright has a turkey sandwich on white bread, paired with the world's most memorable fake orgasm. But Nora named Langer's Delicatessen as the premier spot for the hot pastrami sandwich with visceral details about the fixings and the outpost's history that make this meal unparalleled. A food that is the opposite of haute cuisine, she writes. "It is characterized by two things. The first is that it is not something anyone's mother whips up and serves at home; it's strictly restaurant fare, and it's served exclusively as a sandwich, usually on Russian rye bread with mustard. The second crucial thing about pastrami is that it is almost never good. In fact, it usually tastes like a bunch of smoked rubber bands."[24]

It was Nora's particularities about food and the restaurant industry that stuck. Even in a 2006 op-ed, Nora wrote what was a quintessential guide for restaurant faux pas according to the food expert herself in "What to Expect When You're Expecting Dinner."[25] It's a combination of searing criticism of the present-day dining experience and a yearning for what used to be and what should be. From criticizing the use of tall glasses for Pellegrino pours to the impracticality of dessert spoons, Nora inserts every single dining opinion into said op-ed. Perhaps her biggest, for lack of a better

word, "beef" is with salt and pepper. On the former, she says, "The reason there's no salt is that the chef is forcefully trying to convey that the food has already been properly seasoned and therefore doesn't need more salt. I resent this deeply. I resent that asking for salt makes me seem aggressive toward the chef, when in fact it's the other way around."[26] When it comes to pepper, and specifically being asked whether anyone wants fresh ground pepper, she delivers a history lesson on a cultural shift in pepper shakers. A perfect dose of her quirks, nitpicky demeanor, and determined attempts to improve dining establishments everywhere just a little bit at a time. ♦

Wallflower at the Orgy
(2007)

From left: Katie Finneran,
Tyne Daly, Samantha
Bee, Rosie O'Donnell,
and Natasha Lyonne at
the opening night after-
party for *Love, Loss, and
What I Wore* in 2009

Nora's plays are often a less surveyed aspect of her career. She didn't plunge into the immersive world of theater until the last decade of her life, and not every stage production was critically acclaimed. Her trio of plays—*Imaginary Friends* (2003), *Love, Loss, and What I Wore* (2008), and *Lucky Guy* (2013)—were rooted in the subjects of her other work: complicated women, clothing and the memories they hold, and journalism, respectively.

Her first play, *Imaginary Friends*, debuted in 2003. The plot is based on a true story and revolves around two writers: Lillian Hellman—a former "friend" of Nora's whom she once described as a teller of tall tales—and Mary McCarthy. "'Friends' is probably not the right word—I became one of the young people in her life," Nora wrote of their relationship.[1] For years, Nora was entertained by Hellman's stories, which she eventually came to discover were "exaggerated," including the chapter of Hellman's memoir *Pentimento* in which she claimed to have smuggled fifty thousand dollars to a woman in 1939 Germany in a fur hat.

In fact, it was a lie—or a series of them—that ignited the real-life feud between Hellman and McCarthy. It was first sparked by McCarthy's 1979 appearance on *The Dick Cavett Show* when she was asked about who she thought was overrated. It was Hellman whom she called a "bad writer" and "a dishonest writer." "Every word she writes is a lie, including 'and' and 'the,'" she added.[2] Hellman wouldn't have it: soon after, she filed a $2.25 million libel suit against McCarthy.[3] As Nora noted in *I Remember Nothing*, Hellman "was dying for a fight. She loved confrontation. She was a dramatist and she needed drama."[4] Turning this public brawl into a Ryan Murphy–style soap seemed fitting for someone with that legacy—and that's what Nora did.

Between Marvin Hamlisch jingles, an appearance by puppets, and a literary rivalry stationed in hell, *Imaginary Friends* echoed the campiness of *Feud* and *Scream Queens*. Even in all its absurdity, *Imaginary Friends* was very much rooted in Nora's signature genre blend—fact and fiction. The truth was paramount to McCarthy—it had to be, considering she made such an egregious statement on live TV, but also because that was representative of her work "She abhorred opinions that were withheld, or were reshaped in order to please their audience or to serve some unstated agenda," Alan Acker wrote in his book *Just Words: Lillian Hellman, Mary McCarthy, and the Failure of Public Conversation in America*.[5] For the scandalous Hellman, it was secondary—she thrived off exaggerations. *Imaginary Friends* dissects these women as staunchly themselves and how their dynamic exploded into one of history's biggest catfights. Nora's fascination with them both was less than surprising: she spent her career as a journalist, author, and screenwriter striking the balance between cold, hard truths and carefully crafted tales. The audacious play, which starred Cherry Jones and Swoosie Kurtz as McCarthy and Hellman, respectively, was rife with fanfare, though according to theater critic Ben Brantley of the *New York Times*, it was more "like an especially jazzy class project." He added that "in trying to appeal to both those who are and those who are not familiar with the play's highbrow heroines, the show winds up sacrificing its dramatic energy to CliffsNotes–like expositions disguised in masquerade costumes."[6] Still, it was undeniably a clever ploy to reappraise two fascinating personalities postmortem.

Conceptually, Nora's next project played it a bit safer. For the woman who opined about the pitfalls of handbags and praised turtleneck sweaters, adapting Ilene Beckerman's 1995 memoir *Love, Loss, and What I Wore* into a play was a natural fit. After all, women, including Nora, have long mused about how sentimental and deeply revolted they are by their wardrobes.[7] "When you're 3 years old, one of the only things you have any say in is in what you wear. They start letting you get dressed. It's one of the first ways you start trying to figure out who you are," Nora told the *Chicago Tribune*.[8] In the play, Nora explores those sentiments intimately, ultimately revealing how unraveling ourselves can be as easy as staring at an old pair of boots.[9] Jay Reiner of the *Hollywood Reporter* described it thus: "Mother-daughter, sister-sister, and occasionally male-female relationships are examined, but the heart of the piece deals with female identity itself and how clothing and accessories are ways of expressing that identity."[10]

Cowritten by Nora and her sister Delia, *Love, Loss, and What I Wore* explores how deeply affecting an item of clothing can be, in *Vagina Monologues* style. Together, they used bras, prom and wedding dresses, boots, and even a Brownie uniform to detail yarns that range from whimsical to harrowing on marriage, divorce, motherhood, rape, abandonment, and body image issues.[11] In spite of the weighty subjects, the vignettes are moving, animated narratives that evoke the conversation that would happen over a cup of coffee with an old friend.

Back when it debuted at the Bridgehampton Community House in 2008, the script initially brought Linda Lavin, Karyn Quackenbush, Leslie Kritzer, Kathy Najimy, and Sara Chase to the stage.[12] Over the years, a rotating cast of women would take over, including Natasha Lyonne, Carol Kane, Rosie O'Donnell, Tracee Ellis Ross, Samantha Bee, Parker Posey, and America Ferrera. Lyonne, who was given her first acting gig by Nora as a "glorified extra" in *Heartburn*, was chuffed to reunite with the woman who she says was always helping her personally and professionally while she was trying to get sober, if even just for an audition.[13]

"I wanted a part in her play [2010's *Love, Loss, and What I Wore*], but I was having a really hard time with a boyfriend, and I said, 'While I have you—if you could just give me

PREVIOUS SPREAD Delia and Nora Ephron at the after-party for *Love, Loss, and What I Wore*'s five hundredth performance in 2011

OPPOSITE Opening night of *Lucky Guy* in 2013 at the Broadhurst Theatre at curtain call, featuring (from left) George C. Wolfe, Maura Tierney, Tom Hanks, Peter Scolari, and Deirdre Lovejoy

a little advice here. It doesn't matter if I get the job; I see this as a free therapy session,'" Lyonne told Lynn Hirschberg of *W* magazine.[14] She was just thrilled to work again with one of the most impactful people in her life.

The throughline of the play is told via Gingy and her garments, from girlhood to adulthood. Her story begins with a Brownie uniform before devastatingly detailing the pain of her dad leaving, by recalling the two navy dresses he bought for her right before he did. Later, the poignant details of her first time become a cautionary tale for the tedium—and often pressure—of sex: "Once you do something, you have to keep doing it." She swoons over dresses—"pink satin princess style" and "floral print pique"—to mark the memories of her marriages.[15] But other moments within the play stand out as well—an abbreviated rendition of Nora's persuasive "I Hate My Purse" essay, the trauma of buying your first bra, Madonna's enduring influence on style, and a sarcastic list of do's and don'ts women are told to follow.

Nora's third play focused on one of her other fixations: journalism. She once said, "I can't remember which came first—wanting to be a journalist or wanting to date a journalist."[16] Consider *Lucky Guy* an ode to both—its subject, Mike McAlary, was a real-life New York City tabloid reporter whose "bravado" landed him a citywide reputation and "a host of enemies."[17]

Lucky Guy, which premiered in 2013 a year after Nora's death, marked Tom Hanks's Broadway debut—something he thought he'd never do: "'I told Nora that McAlary sounded like a real jerk,' Mr. Hanks said, using a more piquant word—and a perceptive one, since McAlary's power came from his determination to be the biggest, baddest, bona fide . . . jerk who ever dug into corrupt cops," wrote the *New York Times*.[18] But after a chance reunion with Nora during the promotion cycle of the critical and commercial flop *Larry Crowne*, Hanks reconsidered. "Look, the title is 'Lucky Guy.' It's about somebody who is almost good enough to deserve what he achieves. And I understand that," he added.[19]

What drew Nora to McAlary's story is more about her relationship with journalism: it was teeming with contradictions. Her experience of being a "clipper" for *Newsweek* encompassed this paradoxical nature in a nutshell: "Being a clipper was a horrible job," she wrote, "and to make matters worse, I was good at it."[20]

Tyne Daly, Rosie O'Donnell, Samantha Bee, Katie Finneran, and Natasha Lyonne in *Love, Loss, and What I Wore*

Mustached hotshot Mike McAlary encompassed the dichotomy of the industry—a Pulitzer Prize–winning reporter who could uncover police brutality and corruption on a massive scale but also an egotistical columnist who could vehemently accuse a woman of forging her rape story ("Rape Hoax the Real Crime," read the headline), with the help of anonymous police sources.[21] Both things could be true—his own hubris could both take down and uphold a system of corruption that ultimately led to his tragic downfall—and that's what made his story a fascinating one. In 2018, the New York Police Department dug into the case again and found that a rape had indeed taken place and the perpetrator was convicted serial rapist James Edward Webb.[22]

Unlike *Love, Loss, and What I Wore*, *Lucky Guy*'s structure was drier at times since it relied heavily on a biographical approach, yet *New York Post* critic Elisabeth Vincentelli described it as "a really fun, really entertaining eulogy" of the smoke-filled boys' club tabloid newsrooms of the 1980s and 1990s—booze, writer-speak, and all.[23] Considering the project was "sidelined" as Nora became busy with other work (she began writing it in 1999) and stalled when she imagined it as a movie for HBO,[24] and that she rushed to finish the script before her death in 2012, it feels like a eulogy for her, as well.[25] Nora succeeds in portraying McAlary as a blistering reporter and egoist in a partial redemption story, flanked by the main subject confronting his own mortality at a young age.

Although Nora told her son Jacob she wouldn't be writing about her illness, he realized, as *Lucky Guy* was headed to the stage, "that part of what she was trying to do by writing about someone else's death was to understand her own." The end of Nora's life and her success with *Lucky Guy* mirrored the experience of its central character. Nine months after his colon cancer diagnosis, McAlary received the "scoop of his life" and ultimately went on to win a Pulitzer Prize for his story. *Lucky Guy* had been in flux for years until a former HBO exec–turned–independent producer took an interest in the script in 2008, not long after she got sick.[26] "As she saw him, McAlary was a role model not so much in life but in death, in the way that he used writing to maintain his sense of purpose and find release from his illness. In the six years my mother had MDS, she wrote 100 blog posts, two books and two plays and

Tom Hanks paying tribute to Nora Ephron on opening night of *Lucky Guy*

directed a movie. There was nothing she could do about her death but to keep going in the face of it," Jacob wrote in the *New York Times Magazine*.[27] It was as if Nora felt like she could control her legacy—and preserve her sense of self—by continuing to be prolific while knowing her fate.

While she did just that with *Lucky Guy*, the production received mixed reviews—sentimentality can only do so much. Film critic Lisa Schwarzbaum of *Entertainment Weekly* described *Lucky Guy* as "a dull, stalled play about a not-particularly-noteworthy mug with a flair for self-promotion,"[28] while theater critic Alexis Soloski of the *Guardian* called it "a profane love letter to the lost, rollicking world of New York tabloid journalism."[29] But it was a vital part of Nora's final act—and an endearing ode to her beginnings, made even more bittersweet with one of her muses taking on the lead role. It was one last chance to let the people who loved her from afar feel like they really knew her. ♦

CHAPTER 8

Nora Ephron, Fashion Icon

Annie (Meg Ryan) in a cardigan sweater set in *Sleepless in Seattle* (1993)

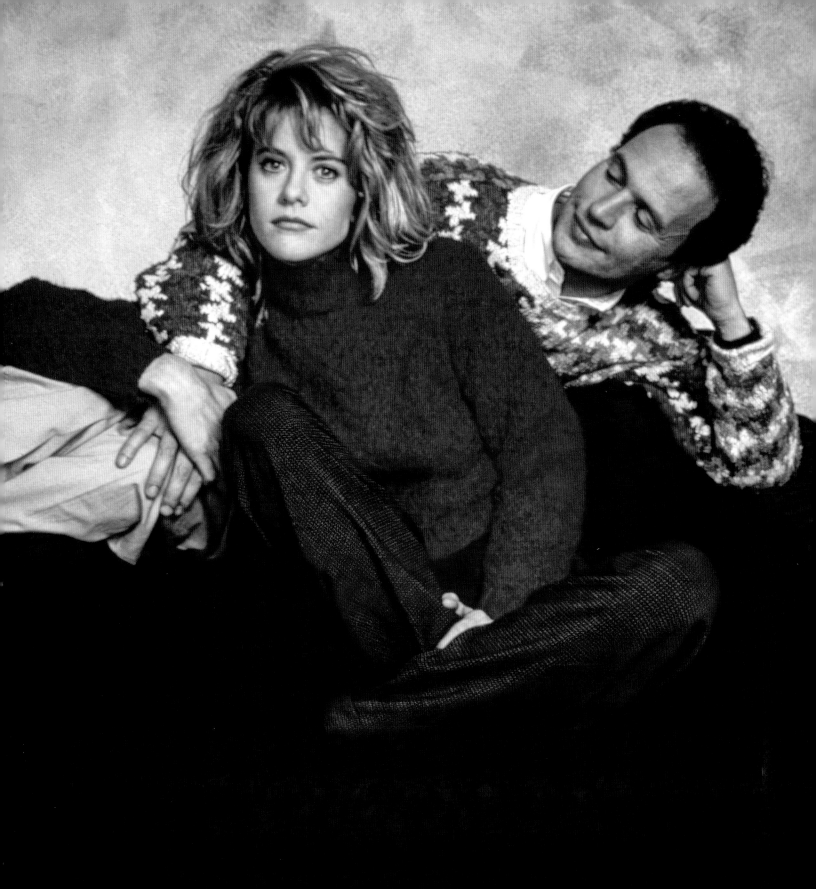

Cardigans, sure. Boxy blazers, definitely. Nora's films have played a pivotal role in nostalgic fashion by both continuing and resurfacing trends adored in bygone eras. And each year, the sartorial legacy that Nora cemented through her work is memorialized with odes to her characters' style in think pieces and Halloween costumes. The emotional relationship we all have with clothing is precious, and Nora knew that—it's why we still get wistful about Meg Ryan in a chunky sweater from 1998.

Nora's three most renowned films—*When Harry Met Sally*, *Sleepless in Seattle*, and *You've Got Mail*—have become fashion canon. Not because what the characters wore was revolutionary—in fact, what they sported was largely quite ordinary, but Nora was adept at curating an entire world around her characters, and that meant wardrobe, too, usually featuring an autumnal mood board: cozy, timeless, and big on menswear for all genders.

PREVIOUS SPREAD Meg Ryan and Billy Crystal in chunky sweaters in *When Harry Met Sally* (1989)

ABOVE Sally (Meg Ryan) in a turtleneck and Harry (Billy Crystal) in a plaid button-down shirt in *When Harry Met Sally*

Regardless of the decade Nora's movies were released in, a defined Ephron aesthetic has shone through. It has, of course, depended on the era. But setting has been an integral part of the author's storytelling—with the throughline being comfort.

In the eighties friends-to-lovers rom-com *When Harry Met Sally*, Nora follows Sally (Ryan) and Harry (Crystal) from college into adulthood as they go from loathing to friendship to love. In spite of the progressive time shift—and the film coming near the start of a new decade—the characters' sense of style sits firmly in that era. Scattered throughout the film are all kinds of sweaters—turtlenecks, V-neck, crewneck, chunky cable-knit—to mom jeans, straight-leg denim, boxy blazers, and glasses with lanyards attached. But the movie also has become a pillar of "Nora Ephron fall" for its autumnal-inspired getups.[1]

On its own, autumn is not revolutionary, but when combined with Nora, it's more than a season—it's a lifestyle. An image of Harry and Sally meeting in Central Park during the fall has lived on as social media fodder for not only the shift in weather but Sally's timeless, menswear-inspired ensemble: a velvet bowler hat with a tweed blazer, leather gloves, and a shoulder bag, as well as a polka-dotted blouse. Refined, but very Upper East Side.

Sleepless in Seattle, released in 1993, sees the shift in style from the eighties to the nineties, still incorporating both decades. For much of the movie, the main characters—Annie (Ryan) and Sam (Hanks)—are isolated from each other. But in terms of style, they're largely on the same page. The movie is flanked by cotton sweatpants, cardigans, trench coats, and a lot of pioneer-woman core looks that include maxi skirts and layers.

Annie was styled as a serious journalist with pantsuits, blazers, and an insatiable curiosity, while Sam was the endearing widower in his crewnecks and relaxed jeans. Both of them have lived on as fashion icons, the former for her work wear and the latter for his everyday look. Sam's style wasn't bold but it captured his personality: comfortable, reliable, and kind. And even though New York fall wasn't exactly the backdrop of this love story, ensembles that evoked the crispness of the city's season were very much responsible for the atmosphere.

When *You've Got Mail* was released in 1998, the fashion world had largely evolved out of

the boxy blazers and billowy pants of Nora's prior work. Following the enemies-to-lovers plot between independent bookseller Kathleen Kelly (Ryan) and bookstore magnate Joe Fox (Hanks) in the emerging world of email, *You've Got Mail* has a bookish underlying aesthetic. Kathleen dons sweater sets, pencil skirts, tights, and oxfords.

She layers turtlenecks and cardigans, while her coworkers sport collared shirts under crewneck sweaters. Somehow, it's the perfect combination of basics, neutral tones, and Kathleen's sense of whimsy. Of course, just like Sally in *When Harry Met Sally*, Kathleen embodies "Nora Ephron fall" with the aforementioned tights, skirt, and oxfords, and a pumpkin. It's an aesthetic that echoes Nora's own penchant for style with its own Kathleen spin.

Nora's sartorial impact throughout her filmography is less than surprising, considering her own personal relationship with style. In Nora's essay "I Feel Bad About My Neck" from her eponymous book, Nora contends with aging and how even though it affects her neck, surgery isn't an option. So it only makes sense that she would love to conceal it any way she could. "Anyway, sometimes we go out to lunch and I look around the table and realize we're all wearing turtleneck sweaters," she wrote in the essay.[2]

Fittingly, Nora found comfort years later in "her black turtleneck Chanel sweater," which she revealed to *Vanity Fair* when she was on the 2010 Best Dressed List. It's not surprising that scarves could also come in handy: "Sometimes, instead, we're all wearing scarves, like Katharine Hepburn in *On Golden Pond*. Sometimes we're all wearing mandarin collars and look like a white ladies' version of the Joy Luck Club," she wrote in "I Feel Bad About My Neck."[3] While handbags are the go-to accessory for many people, Nora scoffed at them. Unlike her friend who would have done anything to protect her Kelly bag, she "stopped worrying about purses and gave up," she wrote.[4] Instead, she landed on a bag emblazoned with a New York MetroCard. "Never having been in style, it can never go out of style," she says of her sartorial choice.[5] So Nora was a little bit Kathleen Kelly, a little bit Sally Albright, and largely a no-nonsense New Yorker.

For the writer-director, clothing was personal. That feeling permeated Nora and Delia's adaptation of Ilene Beckerman's book *Love, Loss, and What I Wore*, where a rotating cast of actresses detailed the emotional resonance a woman's wardrobe could hold—pain, power, grief, love. Nora related to that on a cellular level after reading the book: "I immediately wanted to call Ilene Beckerman (whom I didn't know) and tell her about the terrible dress I wore to my third wedding and the horrible embarrassment of not knowing, in the sixth grade, which shoes to wear, etc. I said to Delia, if we turn this into a play about women and their lives and their clothes, maybe we can make the audience react in the same magical way they do to the book." For her, it was simple: "Clothes are loaded with memory."[6] ♦

Meg Ryan in a tweed blazer in *When Harry Met Sally*

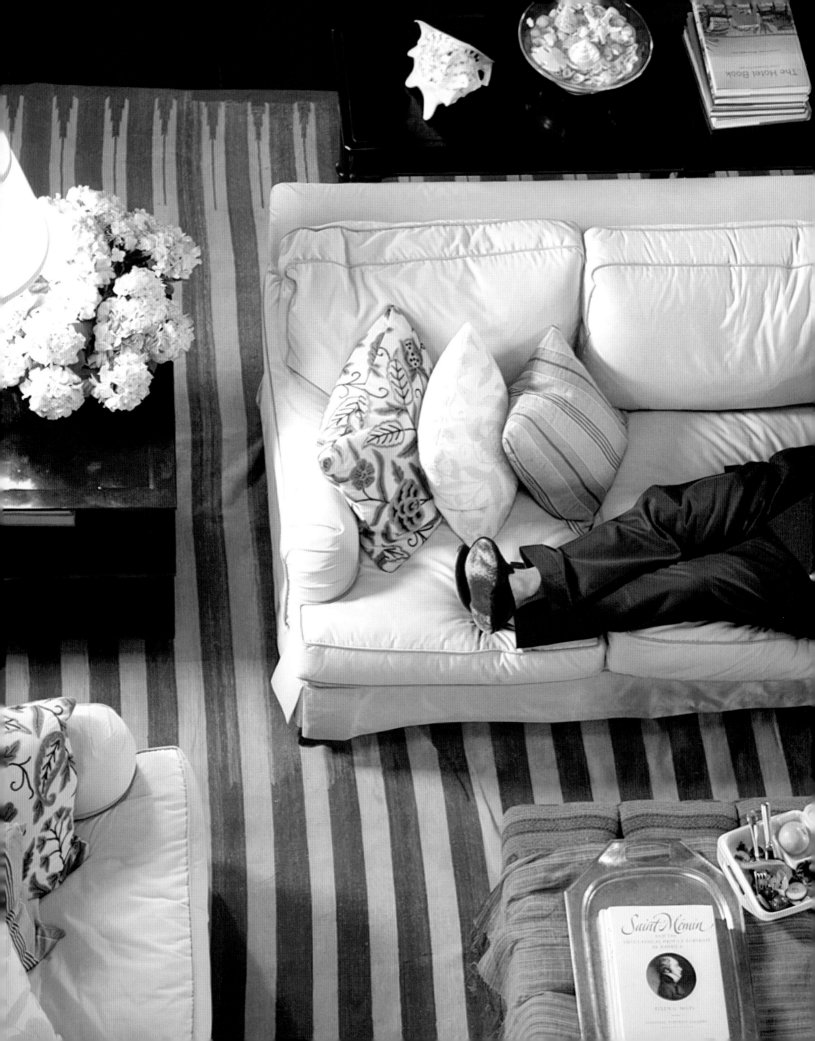

How Social Media Has Proliferated Nora Ephron's Legacy

Harry (Jack Nicholson) on a couch in Nancy Meyers's *Something's Gotta Give* (2003)

163

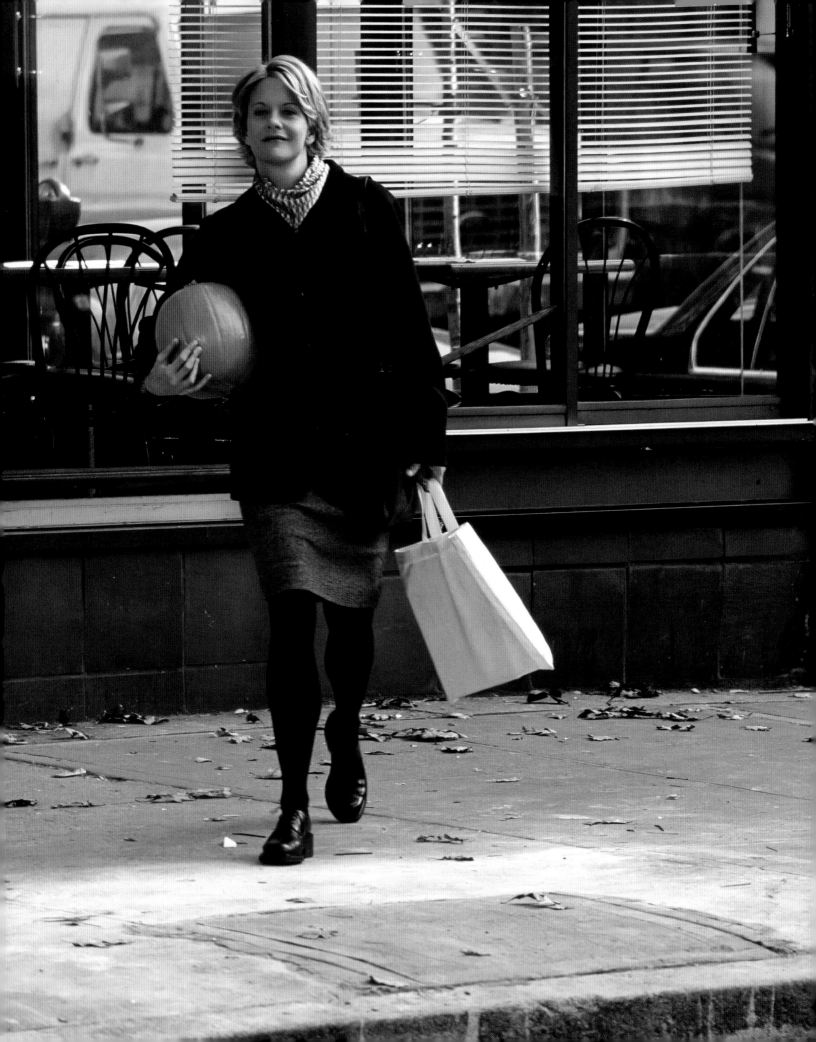

Every year when a whiff of the crisp New York air begins to smell like fall and the first leaf hits the pavement, so begins "Nora Ephron fall," the seasonal sentimentality that lingers in the atmosphere of Nora's work. Practically immortalized by the scene in *You've Got Mail* where Meg Ryan is crossing the street in her chunky turtleneck sweater, pumpkin in tow, this phenomenon has also been declared "Meg Ryan fall." That image has been supplemented by one of Crystal and Ryan surrounded by the leaves changing in Central Park in *When Harry Met Sally*.[1] The backdrop of New York in its (arguably) premier season paired with one of Nora's muses has become a source of comfort and familiarity for those who tolerate all the sticky summers and unpredictable winters of the city.

The proliferation of those images-turned-memes on social media has helped Nora and her legacy gain new life. It should be noted that the scenes themselves are provided with no context

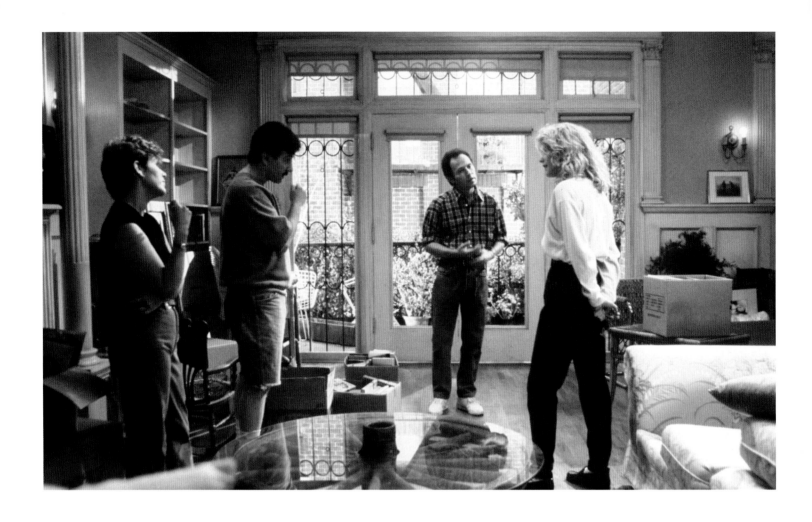

PREVIOUS SPREAD Kathleen (Meg Ryan) holding a pumpkin and walking in New York City in *You've Got Mail* (1998)

ABOVE Marie (Carrie Fisher), Jess (Bruno Kirby), Harry (Billy Crystal), and Sally (Meg Ryan) in front of the wagon wheel coffee table in *When Harry Met Sally* (1989)

but have become emblematic of her signature autumnal aesthetic. Beyond "Nora Ephron fall" and "Meg Ryan fall," the rise of "cozy boy fall" was propelled by Crystal's chunky sweater and straight-leg jeans in *When Harry Met Sally*. It's an understatement to say that this niche social media discourse has spread like wildfire online year after year.

Although Nora's signature rom-coms were released more than twenty-five years ago, social media has helped pass her films on to future generations. Like the writer-director's movies themselves, these screen grabs have become comfort food—a signal that coziness and rom-coms never go out of style.

Just as Nancy Meyers fans salivate over the polished kitchens in her movies, Nora's fans long for the cozy interiors featured in her films. So much so that there's an entire Instagram account with more than forty-four thousand followers dedicated to swooning over them.

After all, home has been a central part of Nora's work, whether she's detailing her old haunts of New York City or her time spent in her favorite apartment, in the Apthorp. In a wistful *New Yorker* essay about the latter, she described it as such: "From the street, it's lumpen, Middle European, and solid as a tanker, but its core is a large courtyard with two marble fountains and a lovely garden. Enter the courtyard, and the city falls away; you find yourself in the embrace of a beautiful, sheltered park. There are stone benches where you can sit in the afternoon as your children run merrily around, ride their bicycles, fight with one another, and threaten to fall into the fountain and drown. In the spring, there are tulips and azaleas, in summer pale-blue hostas and hydrangeas."[2]

The Instagram account @NoraEphron Interiors is an homage to Nora's screenwriting career and a close study of the scenery of some of her most memorable productions. While it serves as an immersive time capsule, what's most captivating about the account is how it hyperfocuses on the details: Annie's

bubble-gum kitchen in *Sleepless in Seattle*, Julia's "sculptural" kitchen set in *Julie & Julia*, Eve's "rustic bungalow" in *Hanging Up*, and the French doors in *You've Got Mail*. The Instagram wades through Nora's penchant for lived-in spaces with huge, down comforter–flanked beds, which not only provide home decor inspiration but remind viewers of how immersive Nora could make the worlds of her characters.

Nora's legacy has exploded on social media in other ways, too. When the former nanny of Olivia Wilde and Jason Sudeikis's two children spoke to the *Daily Mail* about the dissolution of the couple's relationship, she revealed that the *Ted Lasso* actor was allegedly so upset after Wilde tried to bring her rumored boyfriend Harry Styles a salad with her "special dressing" that he filmed her and "tried to prevent her leaving by lying under the car."[3]

The loaded tabloid story set fire to the internet: everyone and their mother, father, grandmother, every Twitter user, Luddite, etc. had questions about *the* dressing. People began scouring the ends of the Earth trying to figure out what it was.

And while everyone was doing that, Wilde posted a salad dressing recipe, but not just any recipe: the *Heartburn* vinaigrette. "Mix two tablespoons Grey Poupon mustard with 2 tablespoons good red wine vinegar. Then, whisking constantly with a fork, slowly add 6 tablespoons olive oil, until the vinaigrette is thick and creamy; this makes a very strong vinaigrette that's perfect for salad greens like arugula and watercress and endive." The infamous Nora recipe from her autobiographical novel about infidelity and divorce was the mic drop of the century that trended on Twitter and became a hit piece for every news site.[4] Those who knew about the vinaigrette told their stories about the salad dressing—how they had been making it for years, or how they knew instantly from Wilde's post that it was indeed Nora's salad dressing. For others, the recipe reveal just became a new addition to their lunchtime repertoire.

Really, this social media moment made everyone from Boomers to Gen Z discover (or rediscover) one of Nora's greatest works and perhaps grasp just how influential she has remained in literature, journalism, and film. Something as simple as a dressing recipe and the significance of its origins could rile up the internet forty years after its release. The fact that Nora has managed to cultivate this reaction tells you everything you need to know about her legacy. ◆

Julia (Meryl Streep) and Paul Child (Stanley Tucci) taking a bubble bath together in their pastel bathroom in *Julie & Julia* (2009)

Nora Ephron's Love Affair with Food

Nora baking an apple tart in 2009

"I don't think any day is worth living without thinking about what you're going to eat next at all times," Nora told *Gourmet* in 2009.[1] This philosophy was so ingrained for Nora that her relationship with food grew to be just as famous as her film career. With both fashion and food, memory and love were intrinsically linked. Throughout Nora's career, her interviews, columns, books, and characters were vehicles for sharing her hottest takes and wisdom on dining, eating, and recipes. And to a gourmet home chef, cooking was serious funny business—even though there was always an air of Nora's perfectionism, she maintained a sense of humor about it all, particularly in the advice department.

For instance, it was par for the course for Nora to always make too much food.[2] She believed "you should always have at least four desserts that are kind of fighting with each other."[3] She loved making barbecued shrimp that weren't really barbecued (they were hot and spicy shrimp with half a pound of butter).[4]

She didn't believe in egg-white omelets—in fact, "a really great omelet has two eggs and one extra yolk," she wrote in *I Remember Nothing*.[5]

You could say Nora's long love affair with food began when she was a child. She vividly reminisced about the family's southern cook, Evelyn Hall,[6] whose recipes included "roast beef and fried chicken and world-class apple pie."[7] But she truly immersed herself in the art of food in the 1960s when she, like Julie Powell in *Julie & Julia*, cooked her way through a good number of the recipes in Julia Child's famous cookbook *Mastering the Art of French Cooking*.[8]

Food made its way into her writing seamlessly. Often, it was a combination of her passion for certain dishes or critics and the joy she derived from industry gossip. In 1968, she penned an essay titled "The Food Establishment: Life in the Land of the Rising Souffle (Or Is It the Rising Meringue?)," which delivered a colorful history of some famous meals while detailing the war among dining's upper echelons about the future of food and dining.[9] She also mused from the sidelines about how earnest the women competing in the Pillsbury Bake-Off were in her essay "Bake-Off," living for the high stakes and women who were so devoted to winning.

Her anxieties about the danger of microwave ovens became one of the key takeaways of a story that blurred the lines between fact and condescension: "If God had wanted us to make bacon in four minutes, he would have made bacon that cooked in four minutes," she reasons.[10] Her "cookbook crushes"—chef and food critic obsessions—were the focal point of "Serial Monogamy: A Memoir." She gushes over *The Gourmet Cookbook* and *The Flavour of France* and food critics Michael Field and Craig Claiborne as if she's describing the best sex she ever had. She had imaginary conversations with her food heroes, until she actually got to know some of them.[11] Once she met Lee Bailey, everything she thought or knew about cooking and hosting changed: "It was horribly clear that my entire life up to that point had been a mistake. I immediately got a divorce, gave my ex-husband all the furniture, and began to make a study of Lee Bailey." It was overdramatic, but not entirely inaccurate—the knowledge she gained from Bailey became her bible.[12] *Heartburn*, her famed 1983 tome, was a "novel with recipes," scenes that remain immortalized because of the food, the pain, and the passion behind them.[13]

In Nora's on-screen work, food was just as pivotal. Many of her most striking scenes are remembered specifically because of the food, the advice that comes with the food, or the lyrical dialogue attached to the food.

Because *Heartburn* is so incredibly personal to Nora despite being fictionalized into a novel, it is teeming with not only emotion but food—each chapter of the book begins with a recipe. It's not that the items are anything striking or revolutionary; it's the feeling they convey and what they signify to her that make them matter to us. Nora filtered herself through her protagonist, Rachel Samstat, also a food writer. In both the book and the movie, really great sex ended with a bowl of homemade spaghetti carbonara in bed—Nora's version of a postcoital cigarette.

She inserted the humor that came with eating during life's biggest moments. In the film adaptation, when Rachel's water breaks, the food still needs to be cooked to her liking even if she's not there to enjoy it. So Rachel makes sure not to depart for the hospital without letting her friends know precisely how long the lamb needs to remain in the oven (twenty more minutes). Later, a really great Key lime pie becomes a prop for Rachel when she finally realizes she can't just rekindle her marriage with her cheating husband, Mark. So, he gets a Key lime pie to the face.

In real life, Nora's orders were legendary; on-screen, they were, too. Sally inherited her quirky ordering trait in *When Harry Met Sally*, which became some of Nora's most iconic on-screen food work. New York's famed Katz's Deli is forever intertwined with this film—and has continued to live on as a landmark because of it. Sally's order comes with a side of Nora humor—at one of the most celebrated Jewish delis in the nation, she orders blandly: a plain turkey sandwich on white bread, while taking a large chunk of the meat out of said sandwich. It was a nod to Reiner watching Nora order food—which she acknowledged was "horrifying." "I remember the sandwich, too," she says of the order. "It was avocado, bacon and sprouts and cheese, but I wanted half of it on the side and the mayonnaise in a little plastic [container]. It was the nineteenth time I had done my horrible ordering thing."[14]

With *Sleepless in Seattle*, Annie settles into a booth at a diner, telling the server she'll

have pie with a side of strawberry ice cream or fresh whipped cream. The freshness is a contingency of her order. If it's not fresh, she doesn't want anything at all. You can practically hear Nora's high-maintenance demands pouring out of the script. Then there's more pie. *Michael* has a five-minute-long scene dedicated to pie, where the cast dreamily professes their love for different flavors of the comforting dessert and covers the entire surface of the

declares. In response, Joe loads even more caviar onto his plate. Not only is the scene a way for Nora to express her own food standards but it's also key to character development: Joe's selfish attitude and Kathleen's self-assured, confrontational nature are effectively magnified.

And of course, Nora's final film, *Julie & Julia*, is a tribute to her lifelong affair with food and the art of cooking. There are strong parallels in Julie's and Nora's stories. Both Pow-

table in it. Then Dorothy sings about it. You can picture Nora's eyes rolling as Julie is forced to attend the "dreaded ritual Cobb salad lunch" in *Julie & Julia*, where each friend orders identical Cobb salads like lemmings and leaves Julie self-loathing. Nora, like her characters, always had an opinion about what went on her plate.

In *You've Got Mail*, one of the most defining scenes of the film unfolds as Kathleen and Joe face off at a book party over caviar. The caviar is molded into a ring around a platter of egg salad. During the party, Kathleen notices Joe snagging a hefty portion of the fish eggs and confronts him: "That caviar is a garnish!" Kathleen

ell's and Child's narratives underscored food as a source of self-discovery. As portrayed in the movie, the pursuit of cooking gave both Child and Powell direction when they needed it the most, the former while living in France because her husband was stationed there and the latter while stuck in an unfulfilling job.

But it's through Child's and Powell's stories in *Julie & Julia* that Nora's sacred relationship with food unfurls. "When I used to cook from Julia's cookbook, I had long imaginary conversations with her," Nora once told NPR. "And I used to think maybe she would come to dinner, even though I had never met

PREVIOUS SPREAD Julia Child on *The French Chef,* which aired 1962–1973

ABOVE Key lime pie reproduced from *Heartburn)*

Annie (Meg Ryan) peeling an apple at her kitchen table in *Sleepless in Seattle* (1993)

her, and never did." Powell could relate. Nora explained, "She, *I know*, dreamt that she would meet Julia, and Julia would salute her for her achievement, and at least write her a nice note. But that was not to be."[15] Like Child and Powell, Nora believed in the holiness of butter. "You can never have too much butter, that is my belief," Nora added. "If I have a religion, that's it."[16] So *Julie & Julia*, a movie rife with bubbling, sizzling food porn, as the multihyphenate's final film seemed fitting.

Exploring how food defines our memories remained paramount for Nora. In *Sleepless in Seattle*, Tom Hanks's character, Sam, comforts his son with a sweet vignette of his late wife and an oddly specific skill of hers: "She could peel an apple in one long, curly strip." Lo and behold, Annie absentmindedly thumbs a knife over an apple and just like magic, she has that special skill, too. It's a curious thing that connects Sam to his late wife and to a future with Annie before they've even met.

In the novel version of *Heartburn*, Rachel details her final day in Washington before leaving Mark, which includes a rundown of the food she made, including the vinaigrette she taught her soon-to-be ex to make. The vinaigrette is simply a way to demonstrate Rachel's inherent resilience and her choosing how she wants to remember their relationship.[17]

For Nora, food was love. And often, community. Her dinner parties for friends and colleagues were legendary soirees, often brimming with A-list guests (think a mix of Meg Ryan, Nicole Kidman, and Larry David) and always her own rubric for entertaining, which she learned largely from food-and-lifestyle luminary Lee Bailey.[18] Tables needed to be round, not rectangular, so guests could have one focused conversation. "I really became a sort of religious fanatic about round tables," she told *The Splendid Table*. She added that "there almost can never be one conversation at a long, narrow table."[19] To steer the chatter, her

dinner parties often came with prompts such as "What did you inherit from your mother and father that you like?" and "What did you inherit that you didn't like?," writer Patricia Marx told the *New York Post*.[20] Unsurprisingly, there needed to be assigned seating.[21] She would never serve fish if she was hosting—it was "no fun."[22] And she had a "Rule of Four": "Most people serve three things for dinner—some sort of meat, some sort of starch, and some sort of vegetable—but Lee always served four," she writes in *I Feel Bad About My Neck*. "And the fourth thing was always unexpected." That could mean anything from peaches with cayenne pepper to savory bread pudding. It didn't matter what it was, it mattered that that "rule" became emblematic of Nora's gatherings.[23]

The lore of her dinner parties has lived on, as have her hosting rules. The Nora Ephron dinner party has become a motif in and of itself with "how to" guides online and celebrities even taking cues from the famed writer-director. After giving birth to her daughter, Katherine, in 2017, Mindy Kaling hosted a Nora Ephron–themed holiday dinner party for the women on her team with "a three-course dinner inspired by *You've Got Mail* and *When Harry Met Sally*" and dishes like "Fox Books el Sprouts with Dates and Haloumi" and "Pie à la Sally."

Naturally, Nora's fondness for food developed into a cookbook of her own—aptly titled "Nora's Cookbook"—which went beyond the sixteen recipes scattered in her almost cookbook *Heartburn*. It has lived on as a coveted possession, little more than a self-published spiralized notebook that was only distributed to her friends and never for sale.[24] The cookbook was 174 pages of Nora's greatest hits, blending her own dinner-party insight with "using clarified butter with relatively simple recipes for dishes like chicken salad, monkey bread and pot roast." These were the best versions of Nora's favorite dishes.[25]

The cookbook, per the *LA Times*, is filled with Nora's dramatic prose and fussy attitude, as well as recipes such as a chocolate buttercream icing that she enjoyed but never made. "I have never made it and I never will. But I have eaten it and it's great," she declares. Like her famed "Nora's Meatloaf," a version that populated Graydon Carter's Monkey Bar,[26] her cookbook featured recipes inspired by literary celebrities, including "Joan Didion's Mexican Chicken Thing" and "Ben Bradlee's Scrambled Eggs." Other recipes were given witty titles such as "The Breakfast Pancake Thing You Make in the Oven," "Cornbread Pudding Made of Horrible Ingredients," or "Spaghetti with Sand." The most familiar part of this personal project, however, is a throughline of her work: the food absolutes she lived by that you would never, ever consider defying. "Everyone loves fried chicken, Don't ever make it. Ever. Buy it from a place that makes good fried chicken," she asserts in her recipe for the southern poultry dish.[27] Her advice for pie crust? The same. In detailing a recipe for a cherry cola mold, she staunchly declares, "There is no excuse for serving this, unless you are obsessed with jello." Such wisdom has been a gift.

Though most of us will never get to spill pancake batter on the pages of Nora's cookbook firsthand, her favorite recipes have invariably lived on in other ways: the lima beans with pears from *Heartburn*, her favorite crab dip, her peach pie, her whipped cream and meat loaf, as well as some of her favorite Child recipes such as boeuf bourguignon and lamb stew.

Her adoration for food never wavered, even toward the end of her life. In 2010, Nora appeared on *Charlie Rose* in a conversation that turned to her contemplating aging and death, which turned to the concept of last meals. At the time, it appeared to be like any other topic Nora had poured her neuroses into. "When you are actually going to have your last meal, you'll either be too sick to have it or you aren't gonna know it's your last meal and you could squander it on something like a tuna melt and that would be ironic. So it's important . . . I feel it's important to have that last meal today, tomorrow, soon," she told the talk show host.[28] Little did anyone know how timely that topic was. Only Nora's inner circle was aware that she was in her final act, as she'd quietly battled a rare form of leukemia for years, something the public wouldn't know until she passed away in 2012.[29] And during that sit-down she was certain what her last meal would be: "the greatest hot dog" from Nate 'n Al's deli in Beverly Hills with Gulden's mustard and garnished with sauerkraut or relish.[30] ◆

CHAPTER 11
Life After Ephron

Delia Ephron with Jacob Bernstein in *Everything Is Copy* (2015)

177

Filmmaker Joel Schumacher described the day Nora died as if a light went out in New York in the 2015 documentary *Everything Is Copy*.[1] She spent decades shocking fans and peers, with existential questions and nuanced tales about complicated women, but the biggest shock of all was her death at seventy-one in 2012. "She broke through a lot of glass ceilings. That meant a lot to women I know. So it made sense that for many, many people, her death was personal, even to people who didn't know her," Nora's editor Bob Gottlieb adds in the documentary.[2]

Although she was hardly known for avoiding personal details throughout her career, Nora's illness was long and intensely private. The woman who had rarely spared herself (or anyone else) in her writing had been privately battling myelodysplastic syndrome for years before it became a rare type of leukemia.[3] But few people actually knew about it—even her loved ones—and for those who did, she largely downplayed it. And until the end,

she kept working—*a lot*. She knew she was sick during the making of her final film, *Julie & Julia*, while writing *I Remember Nothing* and *I Feel Bad About My Neck*, and during *Love, Loss, and What I Wore* and *Lucky Guy*. Maintaining silence about what she was going through, for Nora, was a form of self-preservation.

"At various points over the years, she considered coming clean to her friends and colleagues about her illness. But she knew the effect it could have on her career," her son Jacob wrote in the *New York Times Magazine*.[4] She also didn't want to become a victim—stuck in tedious conversations of platitudes focused on her health. So when Nora died of pneumonia caused by leukemia at New York-Presbyterian Hospital on a day in late June, the secret she kept in whispers was a scream heard around the world.[5] The loss cut deep: to many, she was the best friend everyone

PREVIOUS SPREAD Nora Ephron in a scarf

wanted at their dinner table, the feminist icon who inspired women to pursue their ambitions, the enthusiastic truth-teller with insider access.

Even when she was gone, her influence never waned. In fact, it continued to permeate and perplex, particularly for her son Jacob, who spearheaded *Everything Is Copy*, which memorialized his mother with an intimate portrait only he could create, as he tries to decipher why her battle with her rare blood disease never became copy. With interviews from friends, including Barbara Walters, Amy Pascal, and Rob Reiner, as well as celebrities such as Reese Witherspoon and Rita Wilson reading Nora's writing, the film was equally touching, heartbreaking, and fascinating. It was also incredibly blunt, recalling Nora's charm and humor, as well as her shrewdness. Barbara Walters, a friend and fellow member of the legendary lunch group the Harpies, said it most bluntly: "She was very funny and very mean."[6] The documentary was flanked by the type of authenticity Nora herself always tried to convey in her work—any sentimental lore was matched by personal anecdotes that showcased her bossy, brash demeanor. In between old interview footage and Jacob and Delia reminiscing, one of the most revelatory moments of the film comes from her philandering ex-husband, Carl Bernstein, infamous for his role in the scathing autobiographical novel–turned–film adaptation *Heartburn*, who confessed how he spent years worried about how the portrayals would affect the way his sons viewed him.

But ultimately all of this is in service of Jacob's quest to understand the big secret his mother kept, which was much more nuanced than he thought. Through conversations with family and Nora's friends and colleagues, he acknowledged that perhaps Nora couldn't write about her illness because she couldn't find the humor in her own death. She didn't have control over her own narrative this time. "I think, for her, 'everything is copy' was a way to emerge victorious. She really believed this mantra of 'be the heroine of your life, not the victim.' How do you tell people that you have this thing without becoming the victim? How do you not become the person that everybody says, 'How are you? How are you feeling?'" Jacob said in an interview with Collider.[7]

Following her death, however, she has remained a part of the narrative, both real

everything is copy

Nora Ephron: Scripted & Unscripted

A Film By Jacob Bernstein

and fictionalized. She appeared in *Good Girls Revolt*, a short-lived but beloved Amazon series based in part on Lynn Povich's 2012 book *The Good Girls Revolt: How the Women of Newsweek Sued their Bosses and Changed the Workplace* that was "[as] if *Mad Men* were told from Peggy's perspective."[8] The show, which portrays workplace misogyny in journalism, modeled after a 1970 class-action lawsuit from forty-six women against *Newsweek*,[9] features Nora as the newsroom's feminist leader, sentimentally cast with Grace Gummer, Meryl Streep's daughter. Nora's presence on the show was an obvious choice for showrunner Dana Calvo, who considered her to be "the pied piper of girls." "She had no fear," Calvo told *Business Insider*. "She never had any fear, and that's an inspirational person for me."[10]

The actress prepared for the role by repeatedly watching Nora's Wellesley commencement speech from the nineties, in which she famously advised the graduating women to "be the heroine in your own life."[11] Gummer's research came in other forms, too. She told *InStyle*, "My mom was close with her, so that helped that she gave me some insight about Nora and what she was like. But mostly I did all the research on my own."[12]

Introduced as "Nora from Wellesley" in the inaugural episode, she boldly faces off with her boss after she points out she rewrote a male reporter's story. "Girls do not do rewrites," he says. When she asks "why not," he replies, "That's simply how we do things here." Nora ultimately protests by quitting her job. She's told by her boss, "Your name is all you have in journalism. So good luck, Nora Ephron!"[13] The joke's on him, in the end, considering the unparalleled career Nora ends up having.

While that sexist attitude was par for the course during the era, Nora's place in the timeline wasn't exactly. She left *Newsweek* after less than a year of working there, but it was years before 1970.[14] "Putting Nora in it was a little difficult because she wasn't really there at the exact time that this went on—the *Newsweek* story," notes Lynda Obst, executive producer of *Good Girls Revolt*. And according to Povich, the real Nora didn't have the "dramatic exit" her character does in the Amazon adaptation.[15] Still, Nora's presence on the show is a nod to her real-life impact.

In real life, Nora and her legacy as a writer and filmmaker are often romanticized. Her life is boiled down to the

ABOVE, FROM TOP
Erin Darke (Cindy) and Grace Gummer as a young Nora Ephron in *Good Girls Revolt* (2015)

Patti (Genevieve Angelson), Cindy, and Nora clapping

Patti and Nora in a meeting

#1 New York Times bestseller

NOT THAT KIND OF GIRL

Includes two new essays!

A young woman tells you what she's "learned"

Lena Dunham

Not That Kind of Girl by Lena Dunham (2014)

equivalent of one of her rom-coms. But Nora's work wasn't always loved—it was often divisive, reviled, and written off by critics. Of course, there have been some reappraisals over the years, but the conflation between the adoration for Nora and her work remains. As Rachel Syme points out in her *New Yorker* essay, Nora Ephron "has been reduced to sentimental lore." What Syme forces us to acknowledge, while examining Kristin Marguerite Doidge's biography on Nora, is how writers and fans often forget how Nora could be cutthroat with her takedowns. Her kitschiness was limited to her films.[16]

Nora remains an undeniable force—her impact, and the fact that she is still the subject of article after article—is a testament to her legacy. Noted *Girls* creator and star Lena Dunham, mentored and befriended by Nora, became her heir apparent. She was much less all-knowing than Nora, but she became the "voice of a generation"—the anxious, searching millennial whose vulnerable humor was painfully relatable.[17]

Dunham's 2014 memoir *Not That Kind of Girl* even paid tribute to Nora in the foreword and dedication.[18] "It's very hard for me

to describe what it was like to be friends with Nora because there were so many beautiful facets to the experience and I'm so grateful to have had her in my life for the brief time that I did. Her generosity with other women, with younger artists was completely unparalleled and she had a way of bringing everyone comfortably into her orbit and providing them with fuel that would take them through life, so I know I'm not alone and I know this dedication stands for a lot of women's feelings about Nora."[19] It makes sense: after all, it was Nora's directorial debut, *This Is My Life*, which she saw for the first time in the second grade, that made Dunham want to make movies.[20]

Mindy Kaling, a noted Nora fanatic, hasn't been shy about referencing her favorite Nora rom-coms in her work—she even once wrote under the pen name "Mindy Ephron."[21] Her hit series *The Mindy Project* featured the romantic misadventures of a flawed, ambitious, and hilarious lead named Mindy— played by Mindy herself—and had more than a handful of winks to Nora as it navigated the roller-coaster relationship between Mindy and Danny (played by Chris Messina). Not only does Danny visit Mindy when she's sick in bed—a nod to *You've Got Mail*—but he offers a romantic gesture à la *Sleepless in Seattle* where he meets Mindy on top of the Empire State Building and puts a spin on the *When Harry Met Sally* quote "I've been doing a lot of thinking, and the thing is, I love you," instead saying, "I've been doing a lot of thinking, and the thing is, I hate Danny Castellano."[22] *The Mindy Project* also channels Nora's work in the sense that Mindy and Danny's narrative follows the enemies to friends-to-lovers plotline of *When Harry Met Sally*.

Nora is even the reason why Tom Hanks, who released his debut novel, *The Making of Another Major Motion Picture Masterpiece*, in 2023, became a writer. "She told me that in response to the work I was doing in preparation for *Sleepless in Seattle*, in which I was fighting and cranky and having suggestions and wanting, and always asking, 'is this enough? Is this enough? I don't get it. I don't get it.' She put in something that had come out in our rehearsal process. When it was done, she said, 'You wrote that!' And I said, 'I didn't write that! I was just complaining during rehearsal, and you put it in.' And Nora says, 'Well, that's what writing is, isn't it?' From then on, I would always send her something and say, 'Is this

writing?' She would always come back and she says, 'It is writing, but you ain't done writing it. So get back to work,'" the actor told Sam Fragoso of Literary Hub.[23]

Beyond her brilliant successors, Nora's legacy always comes back around to those three little words—"everything is copy"—and how she was defined by the way she candidly shared her flaws, her failed relationships, and her insecurities in painstaking detail. Though, as Jacob notes in *Everything Is Copy*, the meaning of that quote has shifted. It seemed that she molded that adage to her likings. Everything was copy only when she wanted it to be—when she allowed it to be. Her final years battling her most personal crisis was decidedly not copy; it was not a news story, it was barely information to her loved ones. Maybe her final lesson was that it wasn't about sharing everything, it was about controlling your own narrative and telling it on your own terms. And that's perhaps what she wanted to leave behind, to her loved ones, her fans, and to the women who have followed in her footsteps. ♦

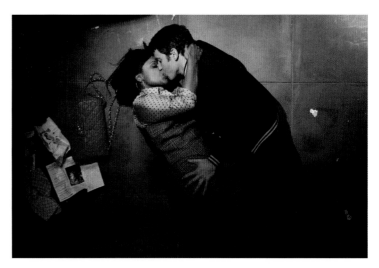

TOP Mindy kissing Danny at the top of the Empire State Building in an episode of *The Mindy Project* inspired by *Sleepless in Seattle*

BOTTOM Nick Pileggi and Nora Ephron arriving at the Public Theater Summer Gala in 2006

Interviews

Andie MacDowell as Dorothy in *Michael* (1996)

Andrew Lazar was a young producer early on in his career when he began pitching *Lucky Numbers*. But he had a handful of notable titles under his belt beforehand, including the 1999 teen rom-com *10 Things I Hate About You* and the 1996 cult classic *Bound*. He's since gone on to produce the 2002 spy film *Confessions of a Dangerous Mind*, the 2010 Western superhero movie *Jonah Hex*, the George Jones and Tammy Wynette limited series *George & Tammy*, as well as many others. While *Lucky Numbers* wasn't a critical or commercial success, the opportunity for him to work with one of the directors he most admired was invaluable. Though it was not entirely a successful feat, which made it one of the important stepping stones of his career. Here, he recalls working with Nora on *Lucky Numbers*.

How did you get involved with *Lucky Numbers*?
It was something that I sold as a pitch to my home studio, which after all this time still is Warner Bros. But Warner had passed on it and Paramount bought the pitch. And at the beginning, it was totally brilliant. There were a lot of people who wanted to do it. But it wasn't something that Nora developed. I adored Nora, but the script was a very black comedy. There were so many people who wanted to do the movie in terms of actors and directors and Nora was never top of mind for me in terms of a director, if I'm being totally honest. And the thing was, Paramount had a big success with her because she had done *Michael*. So, I just remember getting a call from John Goldwyn and Dede Gardner and them saying, "We've got great news, we have the perfect director for the film." And when they said Nora, I was a little shocked. I did not feel she was the right director for the movie. I felt that tonally, especially her most popular works, which are obviously those romantic comedies, did not line up with [what] was a really crazy black comedy. Those

are really tough anyway, tonally. For example, one director I was really interested in was Gore Verbinski, who had just done *Mousehunt*, which was super irreverent. I also wanted to make the movie much cheaper than they wanted to make it. I didn't think we needed to spend as much money as we did. But I got the call from Paramount, and it was clear that they really wanted to re-create the magic of *Michael*.

What was your experience working with Nora?
She was always gracious to me, and as a young producer, your role, especially when you're working with a big director like that, is diminished and can be because you're hopefully handing off your baby to someone who knows what they're doing. But she never made me feel like I wasn't welcome and my creative input wasn't wanted, and it's very easy for directors to do that. It wasn't like I had been nominated for an Academy Award at that point or done anything. I'd probably made, on my own, six movies at that time. She was lovely to me.

John Travolta smiling and pointing his finger as Russ in *Lucky Numbers* (2000)

Was John Travolta always the favorite to play the lead in *Lucky Numbers*?

At the time, I was really leaning into George Clooney. I knew that they had been talking to Travolta and I'm like, "Travolta had done *Get Shorty* and had that great resurrection of his career in *Pulp Fiction*." So it was like, okay, "Travolta's good, I kind of see that." But maybe it's Travolta and Gore. But then when Nora locked in as the director—and Paramount was very insistent on her—it was obvious that they were re-creating *Michael*.

How did Nora and the crew deal with some of the challenges of making *Lucky Numbers*?

Look, making a good movie is really hard. At the end of the day, there were some tonal challenges. In postproduction when we previewed the movie, the audiences didn't connect to certain things and it was a little uneven. The thing I really admired about [Nora] is she didn't dig her heels in and say, "This is my vision and this is it." She was like, "Okay, how can we make this better?" And I wouldn't even say the word "struggle," it was really enlightening to see a filmmaker doing what they can to make something as good as it can be under the circumstances of having shot something that may ultimately have been a little flawed. So the movie didn't work as well as we all wanted, both, I think, critically and commercially. But having now been in the same situation, regrettably, in other times in my career more recently, I kept on having this deep admiration for how Nora behaved, just trying to get the best out of the movie. It's almost impossible to make a good movie without a good script. But sadly, there are times where the movies don't live up to the potential of the script. And I do regrettably have to say, I think that was the case with *Lucky Numbers*.

It seems like she was always just trying to make the best out of a not-so-great situation with this movie.

Even though I feel at the end of the day, the exercise was a flawed one, and

Crystal (Lisa Kudrow) picks up lotto balls in a parking lot in *Lucky Numbers*

I might have been right about the tone and that [Nora] wasn't the perfect director to handle the delicacy of that black comedy, I respected her because she tried very hard, especially in the post process, to make it as good as it could be, and she didn't give up. I've been involved when people let their egos get in the way and get frustrated and she handled the process with a lot of grace and she was very steady with like, "Okay, I'm going to try this and that." And I actually say this about Nora, she got herself into a pretzel to try to make it better, and that's all I can ask for when you're in the trenches and something doesn't work. You want somebody who's going to go the extra mile to try to make it as good as it can be. That was my experience with her.

How would you describe Nora's approach to directing?

She loved interacting with the actors. I just read Mike Nichols's book [*A Life*, by Mark Harris] earlier this year, and I think Nora felt that if you cast the right actors, they will give you the performance that they need. And again, I never felt Nora had as firm a grip on the tone of the script, given how nuanced the dark nature of it was. But I found her to be, on set, very collaborative with the actors [and] would give them free range.

If there was something she wanted them to do, Nora was not afraid to speak her mind at any given moment. If she saw something that she wanted, she would certainly adjust their performance. I know there are some directors who get lost in the technical side of things, and that's certainly not Nora. Nora was very interested in the spoken word, the performance, and working with the actors.

Do you have any examples from the film that illustrate this?

Ed O'Neill was an amazing Shakespearean actor. He got on a big sitcom but he was amazing. So I believe when he was playing something really frustrating and volatile, she actually thought it would be funnier if it was totally quiet and he threw it away, and that was an adjustment she made. This was a scene at Travolta's workplace, and it was hilarious.

Obviously, food was such an integral part of Nora's life. Did that influence any part of making *Lucky Numbers*?

Even though *Lucky Numbers* didn't turn out creatively the way I wanted, I say to people what a good experience I had, and part of that, I always say, [was because] she had amazing taste with restaurants. We were in the sticks a little bit, so Nora had to do some of her

Tim Roth as Gig in *Lucky Numbers*

people would not think of her for *Lucky Numbers*. That was a bold choice.

Were there any significant storylines that were cut from the film you can recall?

We cut big chunks of the movie out. I don't even know if Chris Kattan is in the movie. He played this jockey, and that storyline was totally gone, and he was a pretty big star at *SNL*. There were a lot of people who came in because it's Nora. Between Francine [the casting director] and Nora, we got an ensemble of great people. Michael Moore is one of my heroes and he was in the movie. But that's why. She knew it was a very sought-after script. She knew it was good.

legwork. It's easy if you're shooting in LA or New York to find a restaurant. But she made it fun. I'm delighted that you asked me that question because when I talk about that experience, I throw that in there because it was indelible. And it's no doubt that when you are making a movie, [there's] that communal feeling . . . and she made it a ritual. It was one of my favorite parts of making the movie with her, just how gracious she was.

What about the script do you think appealed to Nora at the time?

She knew that was a really hot script. Everyone in town was talking about it. I sold it as a pitch. But then the script came in and it was really, really funny. I mean Adam Resnick [the writer], I love. It's very funny because we sold another pitch called *Death to Smoochy* and sadly, we got everything we wanted. It's still not a successful movie, but unlike *Lucky Numbers*, I love *Death to Smoochy*. I wear that as a badge of honor. Now, Adam is so particular, he didn't like either movie. But the bottom line is, and Nora [would] admit it, the reason she wanted to direct the movie is to show people she could do other things. I think, at that point in her career, she felt like her biggest hits were these rom-coms. She wanted to stretch as an artist. That's why she did the movie. She knew very well that

Did you ever have plans to work with Nora again?

There was a script [that] still exists, by a very well-known [writer] mostly in television, Bruce Eric Kaplan, called "Annotated Cinderella," which would probably have a better shot of getting made now. It was a very irreverent *Cinderella*, way before its time, and I got it to Nora. We were very close to her doing that movie, and I was excited because I'm like, "Ah, I get to make another movie with Nora." In spite of the relative failure of *Lucky Numbers*, which if I'm being honest, it was, commercially and critically, I was excited to make another movie with her. And I actually thought "Annotated Cinderella" is much more spot-on for Nora. I think Nora had some changes she wanted on the script and Bruce was pretty stuck on not changing it— he wasn't right, by the way—it would've been amazing. Now in fairness, I do think it wasn't that long after that Nora kind of got sick, so who knows what would've happened? But it's only as an example to say I really stayed in touch with Nora and I was excited to do another movie with her that actually worked and was a hit.

MARK RICKER
Production Designer for *Julie & Julia*

With *Julie & Julia*, Mark Ricker had the responsibility of creating a palette for two parallel stories—that of Julia Child, who made French cooking accessible to Americans, and writer and amateur cook Julie Powell. As production designer, he immersed himself in Parisian cookware for the former's home and in the Queens, New York, apartment of the latter to create a colorful portrait of both on the big screen. The project was special for Ricker, a lifelong Nora fan, who has been a production designer and art director for movies such as *The Help* and *Bombshell*.

Were you already a fan of Nora before you started working with her?

I was. Who could not grow up loving movies and not know *When Harry Met Sally* and *Silkwood*? *Silkwood* really resonated with me when I was younger, which people don't think about when they think of Nora Ephron because it's not the kind of thing that jumps to mind. It's the variety of expertise that she brought to the work. I knew *You've Got Mail* actually filmed in the building that I was living in. I think that she almost hit me with her car one day, which I delighted in telling her once I got to know her. I didn't expect to get the call to work with her, but I think the planets aligned. It was the idea of working with Nora, but also the particular project that I was doing [that drew me in].

How were you tapped as a production designer for *Julie & Julia*?

Well, I knew Amy Robinson, who was one of the producers on the film for years. I'd been a PA on projects with her, and so she thought that I'd be a good fit for it. I got the call, went to Nora's apartment and met with her for three hours, and she offered me the job on the spot that day. At that point in my career, it was a pretty big deal to do that movie, so I was thrilled to work with Nora on that subject matter. I was fascinated by the dual nature of the two stories as they were folded together. And to work with Meryl [Streep]? Everything about it was a slam dunk.

Why did *Julie & Julia* speak to you specifically?

I was particularly enamored with the idea of doing this movie about Julia Child and the dual nature of figuring out how to bring those two stories together visually, from an art direction point of view. So I was all in from the second that I read the script—and this was way before Amy Adams was even cast. I remember there was a concern

of whether the Julie Powell character would be likable enough. And the second she cast Amy Adams, I said, "Well, that's solved, because who doesn't love Amy Adams?" And she said, "You're exactly right." I loved it when Nora Ephron would say, "You're exactly right," because it was just the highest of praises.

How did you prepare for the movie?

Because we weren't going to start shooting until later, I went to Paris for my birthday and did some preliminary research. It was just really a joy from beginning to end. [It] wasn't completely easy the whole time, but it's not a bad gig to do a movie about food in Paris with Nora Ephron. We just ate in the best places, and we went to her favorite places. She was just a fascinating person to be around and to collaborate with— and hilariously, hugely funny.

Is there a favorite story about Nora that sticks out as a memory?

I remember we were in the hotel lobby one day having breakfast during the primary season when Barack Obama, Hillary Clinton, and John Edwards were still neck and neck in terms of trying to figure out who'd get the Democratic nomination, and I was just sitting there, having a croissant and a coffee with Nora, and she dropped the bomb about John Edwards having a child out of wedlock. Nobody knew this at the time, and I literally did a spit take with my croissant. But that's who Nora was. She just knew everything, and she knew everybody.

Did you keep in touch with Nora after filming?

I actually sent her an email later after we finished, and she emailed me back, "You made me laugh," and I knew that that was one of the highest praises if you made Nora laugh. After I did *The Help*, she sent me a lovely email saying how exquisite the work was. I would read a piece and I would just email her. I learned Nora was

Julia (Meryl Streep) at the fish market in *Julie & Julia* (2009)

the expert at the quick email, so it was fun to have that interchange with her, even after we made the movie.

Food is really the star of *Julie & Julia*. How did you approach its portrayal on-screen?

I just remember Nora describing the movie and the food in the movie as needing to be almost pornographic in how it was depicted. Everything had to sizzle. You had to smell it, you had to taste it. It just had to jump off the screen. So that was [made possible] in collaboration with Susan Spungen, who was the chef who was hired to do all of the cooking, and also Diana Burton, who was our prop master. Everything had to serve the food. We did nine or ten kitchens on it. To come to the project from a research and art direction point of view, I learned a lot about cookware, copper, and everything that it took.

Because Julia was historically quite tall and Meryl isn't, how did that affect the structure of the sets?

Because of Meryl, we lowered the counter heights by just a couple of inches on everything, so when she would stand in front of the counters, she would appear taller. We also did all kinds of cheats about that, but that was the main thing that I did in the art direction as it related to Julia's stature and how she related to literally stirring a pot with her height. We dropped those counter heights just

enough so that Meryl would have that same relationship to the spoon, the pot, the bowl, or the mortar and pestle. I spent a lot of time in Paris in old cook shops finding all of that stuff—the stuff that was so specific to Paris that Julia would've come across that we wouldn't necessarily find in the States.

How did you approach designing Julie's apartment?

When I was designing Julie Powell's apartment, I had the summer to think about the project, and I would wander around Queens, thinking about "Where do I think Julie would live? Or where would be an appropriate place?" And I found a couple of options. Then when I met Julie Powell a little bit later in the process, I wanted to go see her real apartment. She gave me the address for it, and she had switched a couple of numbers, so I had to call her and say, "I can't find this address." Then she gave me the right address, and it turned out to be one of the places that I found on my own. I actually found her real apartment and when we went in there [there] was a wainscot, like one of those pressed tin details from the original architecture, and there was a fleur-de-lis, literally in the tin. So we took a mold off that and put it into the set, because it was just one of those kismet moments. I couldn't believe that the real Julie Powell had a French fleur-de-lis in her apartment before the movie was ever

conceived. When I was designing her kitchen, I just remembered Nora saying, "Make it smaller. Make it smaller." So, I finally designed something where you wouldn't be able to open the stove, the oven door, and the refrigerator door at the same time. They would just hit each other. And she said, "Well, maybe not that small." So it's just a process. It's all about just constantly going back and forth, and trying to figure out what Nora would want.

How did that differ when it came to the production design for Julia's apartment in Paris?

With Julia, there were a lot of references. I actually went to her real apartment. I managed to, without speaking French, talk my way into her apartment, which we then tried to faithfully recreate. There were a lot of photographs of it in the Schlesinger Library [at Harvard], where she left all of her papers and archives. Because Paul was a photographer and an artist, he was just constantly photographing everything. So, there was a wealth of a lot of fantastic photographs, but it was all about the food. It was about Nora's love of food, Julia's love of food, Julie Powell's love of food, and it was just the perfect recipe to bring it all together. It still resonates with me as a joyous experience, all these years later.

Why do you think *Julie & Julia* resonated so much with audiences?

I just watched it recently with my mother myself, and I was really pleased with how it held up. I thought it was charming and romantic. It's different from her other films in terms of—it's not a romantic comedy. It's a love story. It's about married couples. There's just something that's so classic about those two women that were brought together across time and space, to find the parallels in their experience of being in a relationship with their husbands, but also in terms of finding themselves and with the complete support of their husbands. It was a story about relationships and a love story between married couples. I just was always fascinated by

how she found those parallels between two women, and how many parallels there were. Everybody loves Julia Child. To see the backstory of her and then through the lens of this other younger woman who's living in New York City at a completely different period of time in the shadow of 9/11, as Julia Child lived in the shadow of World War II [was fascinating]. They were both discovering themselves in a city, learning what they were passionate about and how to come through the other side.

That's such a common theme in so much of Nora's work—particularly in *Heartburn*, I think.

To me, it's almost like the second chapter that she explores so many times in her romantic comedies about people meeting. These people already knew each other. They were already married, so it was different in that way. It's unique to me in that way, that their love story is beyond just a typical romantic comedy. [Nora has] explored very personally in *Heartburn* the opposite side of a marriage. But I think that there is a timeless joy that Nora wanted to explore in examining these two women's experiences.

Nora had a handful of misfires before *Julie & Julia*, but the movie seemed to be a reset for her, even though it ended up being her final film.

Her film before *Julie & Julia* was *Bewitched*, which was a famous misfire. It had a unique voice. I always was fascinated by that film, but I also think that it's how I entered, because of the budget level and everything that went into that film. My understanding is *Bewitched* happened, and *Julie & Julia* was not going to have the same budget. So it was almost like Nora herself wanted to just meet new people and mix it up. I feel like I was able to get in there and meet her, in a moment of time where then I was able to bring my own skills and experience to it, in a way that might not have happened if *Bewitched* had been a colossal hit because she would've just been given more money.

Nora was sick during the making of *Julie & Julia*, but most people didn't know.

Nobody knew. Don [Lee Jr.] had been a producer who worked with her a number of times, and I think in hindsight, he noticed a difference. But I certainly had no idea because I didn't know her before my experience with *Julie & Julia*. I would not have ever noticed her being ill in any capacity through my experience of working on the film. I mean, I think that she was so passionate about the work and doing the work and making a good film, that it was a complete shock when I heard that she had been ill. When I found out how long she had known about her diagnosis, and to realize that, I think it was completely folded into her experience of making *Julie & Julia*. It still makes me sad to think of her not being here anymore, just reading all of her books. I gave my mother *I Feel Bad About My Neck*. Nora inscribed it for her, and she said, "Does she feel bad about her neck?" And I asked my mom, [and] she said, "No, actually not." But I love reading her stuff because I can

just hear her voice so much. The documentary that Jacob made was so touching. My mother's in hospice now, and I watched the documentary [*Everything Is Copy*] about Nora, and the way that ends with her quotes that came out of her last book, *I Remember Nothing*, where she talked about the list of things that she will miss, was particularly touching, watching it this last time that I saw it.

How is *Julie & Julia* emblematic of Nora's work?

When we were filming the wedding scene of Julia's sister getting married, and I was standing next to Nora at the monitor, and she was playing the Margaret Whiting version of "Time After Time," which was so beautiful, I just turned to her and I said, "Are you going to use this?" And she just said, "I hope so." And it is, it's in the film. I remember standing there with her with that particular music and just the recognition of time, and what it means to live and to experience life and relationships and food. That resonates for me, in terms of it being her last film.

Nora Ephron behind the scenes on *Julie & Julia*

SUSAN SEIDELMAN
Director of *Cookie*

Cookie is probably not the first film that comes to mind when you recall Nora's filmography. But the mob-adjacent movie fit in with the scribe's affinity for messy female protagonists and tunnel vision for character and dialogue, as opposed to plot. Ephron hadn't yet stepped into the director's chair just yet—that didn't happen until 1992 with *This Is My Life*—so Susan Seidelman, known for movies such as *She-Devil* and *Desperately Seeking Susan*, spearheaded the project.

How did you end up directing *Cookie*?
Cookie was originally developed at Fox, maybe under the auspices of a producer there named Larry Mark. I wasn't involved in that part of it. But what happened was, at some point, I guess they were looking for a director and I think Nora, Alice, and I had the same agent, a guy named Sam Cohn, who was at ICM at the time. I was a new client [and] he sent me the script. What I liked about it was that it was a mafia story told from a different point of view. It was a father-daughter mafia story, not the usual father and his sons—the whole macho thing. Then he put me in touch with Nora and Alice, and he was also ultimately very influential in getting the movie produced because it was put into turnaround. For whatever reason, Fox didn't want to make it, and he brought in or sent it to a company called Lorimar, and [they] wanted to do it. That's how it came together.

Nora's most beloved film works are her rom-coms—she's not primarily known for *Cookie*. But what about *Cookie* is representative of her oeuvre?
The best parts of the movie are Nora Ephron, the relationship stuff, especially the male-female relationship stuff, and also she writes great one-liners. I don't know exactly how or why she wanted to write the script. It came about around the time that she married Nick Pileggi [cowriter of *Goodfellas*], and he knew a lot about the mafia world. He introduced her to the world, and then she and Alice put that father-daughter spin on it. So the parts of the film that I think were most Nora and worked the best were the stuff like the relationships between Dino and Lenore, played by Dianne Wiest—the middle-aged adult romance story. I think also that the scenes with Peter Falk and his wife, Bunny, played by Brenda Vaccaro, were also funny and Nora-esque in a way. Just great, ballsy, sharp female characters. [Those are] also the kind of characters I gravitated to the most, including Cookie and Dino, the rebellious daughter with father.

Cookie wasn't a critical hit. Where do you think the film missed the mark?
Where all of us were a little out of our element, quite frankly, was probably in the machinations of the plot. There were a lot of double crossings and plot that needed to be tied up. And perhaps some of that, I'm not sure that that's Nora's and Alice's strengths. They write great characters and original characters. When I think about some of [Nora's] best movies, they're either character-driven [or] romantic comedies with good plot twist, but it's not big action sequences or mafia stings. And probably my strength isn't in that area as well. If you can separate out the mafia subplot and all the subplots from the character stuff, the Dianne Wiest, the Brenda Vaccaro, and even the Emily Lloyd stuff, they're a little bit like two separate movies, one of which I think we all felt more akin to or comfortable in: the character-oriented world. And let's face it, in the mid-to-late eighties, there were a bunch of mafia movies being made, so I think

Susan Seidelman on the set of *Desperately Seeking Susan* in 1985

the audiences were used to that stuff. Brian De Palma had done a movie called *Wise Guys*. There was *Married to the Mob*, which was also with those kinds of dapper mobster characters. John Gotti was in the news all the time. So that influenced *Cookie*, but I don't think that's the most original part of the film. Unless you did it really well and did it really uniquely, it wasn't the highlight of this movie. Personally, if I ever had the chance to redo it with Nora and Alice, I would say, "Let's stick to the character stuff, focus on that and thin out some of the plot machinations."

Nora was really so adept at character work!

Absolutely. And I think my favorite scenes in this movie are when Peter Falk gets to interact with the two adults, Dianne Wiest and Brenda Vaccaro, and also some of the scenes with Cookie, but not the scenes where he's interacting with the other mob guys.

What was your first impression of Nora?

Well, I remember the first time I met her, she and Alice came to my house. I was living in a loft in Soho at that time. I remember when they walked in, they must have been dressed to go to another event because most of the writers I knew were rumpled, sloppy, and kind of writerly. They were wearing fur coats, had their hair done, and looked very uptown chic. And I thought, "Wow, this is a different view of what writers could look like." So my first impression was that they were very uptown fancy ladies, but also very talented because I had certainly seen *Silkwood* a few years earlier, which was wonderful. I was probably a little intimidated when I first thought about meeting Nora because I knew she was really smart. I had read *Heartburn*, and I knew she was very witty, but meeting her, she was very respectful, which I appreciated. I was the director, and she allowed me to be the director.

I know food wasn't really a strong part of *Cookie*, but did you ever attend any of Nora's famous dinner parties?

Food wasn't that important in the movie per se, although she did come to visit the set one of the days we were filming the Christmas party because she had a line that she really liked. And I don't know if it even ended up in the movie, it might have ended up on the editing room floor, but it was about rice balls. It was an old-school Italian woman walking around the party wanting to give people these rice balls that she made, and Cookie walks up to her and says, "What's a rice ball?" And she says, "You take rice, you make it into a ball." And that was a line that was very Nora. What I remember about food really was more about getting to know her when we were working on the script, going to her apartment for script meetings, and she would, in the middle of the script meeting, decide to whip up pasta. I don't know if it was a carbonara, but it was a pasta that had bacon in it or pancetta, a smoky pasta. She'd be talking about the script and at the stove whipping up some food at the same time. So I was struck by her ability to multitask.

That's talent.

Nora also gave me the best advice that I still use today. She was such a foodie, and my husband and I still joke about it when we go to a restaurant; she said, "Never order the most expensive bottle of white wine. Ask, what's the coldest?" And that has been good advice ever since.

I love that. How often did Nora come to set?

I have to be honest: Nora [and] Alice stopped by occasionally, but they weren't on set that much. I think in the beginning when we started working on the script, *When Harry Met Sally* came about, but that wasn't a part of her life in the beginning when we first started working together. By the time I went into production, she got really busy with *When Harry Met Sally*. While I was filming, she spent a lot of her time working on that script, so really wasn't around the set or didn't have the time to be around the set as much as she might normally have been.

Do you have any stories about the making of *Cookie* that might surprise people?

We auditioned a lot of people for the role of Cookie until we came up with Emily Lloyd. There's always those people whom you audition and you always go, "Why didn't I cast that person?" because you're auditioning them at the time when they're still unknown. I remember Julia Roberts auditioned for the role of Cookie. It was before she did *Mystic Pizza*. I don't think she'd done a movie yet, or certainly not a big role in a movie. She was Eric Roberts's little sister. And then she didn't get the role in *Cookie* and went on to do *Mystic Pizza*. That really catapulted her into her movie career. Another person who auditioned was Phoebe Cates. But anyway, around this time, this movie, *Wish You Were Here*, which was a British movie that Emily Lloyd starred in, came out, and it was fantastic. And we all got all excited about Emily. The problem being that she wasn't American and we didn't know how her accent would work out. So we had to hire an acting coach, but it was really because of that movie, *Wish You Were Here*, and the quirkiness she brought to that character that we liked. That's why she got the part.

I'm processing the fact that Julia Roberts could have been Cookie, but were there any standout scenes you remember having to cut from the film?

There were a few scenes, and most of them had to do with what I thought was the better part of the movie, which is the character stuff. There was a scene with Cookie taking Dino's limo out for the night to party with her friends. That was the scene we ended up cutting. There was a scene where Cookie is dyeing or helping her mother, Lenore, dye her hair because the mother's thinking about going into the Witness Protection Program, and they have a nice dialogue scene about what name Lenore should take on as her new name. It was just a charming, funny scene where she runs names by Cookie, and she says, "No, that one sounds like a nun." It was a very

Cookie (Emily Lloyd) and Dino (Peter Falk) at a diner in *Cookie* (1989)

sweet mother-daughter scene and that ended up getting cut. Even though this is a mafia comedy, I think audiences have expectations there's going to be car chases, and there's going to be double crossing and scenes with mobsters pulling out guns. So some of the strengths of the script got combed back a little bit because they didn't propel the mafia part of the story along.

How do you look back on the film now?

Well, it's funny because I read a review that Roger Ebert, who gave it two stars, wrote. I think that was the best one. I think he's saying what Nora might have felt, and certainly what I felt, which was that the mafia crossings and double crossings were the weakest part of the script, and the character stuff, especially with the older characters, was the strong stuff. I think he also said the film's enjoyable. I do think the film is enjoyable and entertaining, but disappointing if you want a traditional mafia story. I think one of the other things that happened when the film came out was, right before the film was released, the company that put it out was sold and bought by Warner Bros. And if you know how the movie business often works is that the studios tend to focus on the projects that they developed themselves. So Cookie was like an orphan.

It'd been developed at another place. It had just been put into the care of Warner Bros., but it wasn't something that any of the Warner executives had a personal stake in. And the company didn't really have a big personal stake in the movie either. So I think it got lost in the shuffle. Reviews, and the way the public sometimes sees the film, do have a lot to do with how the studio positions it. A lot of movies with mediocre reviews become big successes because they've got a marketing and publicity department that are working their tails off to make that happen. *Cookie* got lost. It wasn't put into a lot of theaters, so it actually didn't get the number of reviews that movies get these days when they're released in big theaters—and there was no Rotten Tomatoes back then. There was no internet back then. So when you go on Rotten Tomatoes, a lot of the reviews are actually written ten years after the movie came out, colored by earlier reviews. It really didn't get a good shot at the box office.

That's so frustrating, but not surprising.

I can't speak for Alice, but from Nora's point of view and my own, at the time the film got released when maybe she could have been doing interviews, she was busy making *When Harry Met Sally*. And at the time the movie *Cookie*

was released, I was busy in preproduction on a Meryl Streep movie called *She-Devil*. So it didn't benefit from the kind of press that it could have used.

At its core, *Cookie* really is a Nora movie.

It's got some great lines. Nora has clever, funny one-liners, and this film has a bunch of them. That's why, to go back to the earlier point, if it could have had the focus on that and less on the plot, which takes over the last third of the movie—once they go free Dino's money and get revenge on Carmine—I think it could have been a really lovely, charming movie. A mafia movie told from a different point of view.

The third act is when it starts to get a bit muddled in *This Is My Life*, too.

That was more of an indie movie, but when you're making a studio movie where you're spending many millions of dollars to make it, there's pressure from the powers at the producers' studio to incorporate the kind of elements that they think audiences are going to like—like car chases, holdups, mafia, tough-guy scenes—that are in traditional gangster movies. So I don't know if Nora felt some pressure to go more in that direction toward the end of the movie. As I said, I wasn't involved in the early development of the script. I certainly think the film would've benefited from using more of what I think Nora, Alice, and I, as the director, were good at doing, which was quirky or nontraditional female characters.

Why do you believe Nora has cultivated such a legacy in the film world?

Well, I think she's not just a good writer, she's a social observer. When you look at her films, they reflect the social mores and culture of that time. They capture it. During that period of *When Harry Met Sally* and *Sleepless in Seattle* and *You've Got Mail*, they're very much rooted in the early nineties. She had her finger on the pulse of what was going on culturally at that time.

MEG WOLITZER
Author of *This Is Your Life*

For the past forty years, Meg Wolitzer has been an acclaimed novelist, exploring complex female relationships and "the landscape of contemporary feminism." Her second novel, *This Is Your Life* (1986), was the first project of hers to ever land an on-screen adaptation, and it became Nora's directorial debut. Known as *This Is My Life*, the movie follows a divorcée's overnight fame as a comedian and the way it transforms her relationship with her two daughters. The project fit seamlessly into Nora's oeuvre as a story about female ambition and sisterly bonds (the script was written by her and Delia). Since *This Is Your Life* was released, Wolitzer has had two more of her books adapted into movies—*Surrender, Dorothy* (2005) and *The Wife* (2017)—but *This Is Your Life* and Nora's adaptation hold a special spot in Wolitzer's memory all these years later.

Tell me what drew Nora to your novel.

She was looking for something to direct and found this. For me, I felt more connected to the daughter characters than the mother. At the time that I wrote it, I did not have children. I now, as of two months ago, have a grandchild. Life has just changed so much, but I think that both stories really resonated with her. Both resonated with me too, but the emphasis for me was on the daughters. For Nora and her sister Delia, with whom she cowrote it, it was a story about sisters and the tensions between work and raising two children. It just spoke to her on a lot of levels.

Did you both ever discuss whether she saw her mom in the script, particularly when it came to Dottie's pursuit of fame?

We didn't talk about it in terms of her mother at all. [I think she related to] the idea of being a working mother herself [and] that was part of her childhood and of her life growing up. So, the movie

Meg Wolitzer in 2013

that she wanted to make and the characters, we really kind of went very deeply into talking about who these girls and women were.

At the time, who did Nora relate to the most?

I have such happy memories of the whole experience. It's a beautiful movie, and it was a very wonderful experience in so many ways, but I don't think I can speak for her. I wouldn't try. I just know that it meant a lot to her to make the film, and they really worked to get it right. And there's a lot of affection, I think, that people have for this film that made no money. She's very tender toward all the characters, so I would conjecture she felt very [strongly] toward those three main characters. She understood them, so we can extrapolate from that.

But there is a real tenderness and depth of understanding of both what it is to be the daughter of a big mother and what it is to be the big mother. In the novel, Dottie Ingels was heavy, and her weight was part of her act. It was a very different kind of role that Julie Kavner came in and played. She was self-deprecating. Nora was nothing like that—she was not self-deprecating. The character was complicated, and I think she related to and responded to the complications of home and work, which are the tensions that we all feel in that.

What's so beautiful about this movie is how it's a coming-of-age story for both this Dottie who's an adult, but also for her children.

Yes, I do see it that way. Beyond that, what was moving for me is that Nora, of course, had a very big career for a long period of time before she made the film—in different worlds, of course, journalism, writing *Heartburn* and everything. But it was her first time directing, and for me, it was so exciting having a film made of a book [I wrote]. There's a sense of [us] coming into our own in a new way, too. So I think we both were

excited about that for ourselves, too, and we saw that in the characters as well.

Did you work with Nora and Delia on the screenplay at all?
No. They were very welcoming to me. I did some sort of work on writing, some consulting and writing some comedy lines that didn't make it into the movie—I was hired by the studio to do that. But I definitely was part of the process in an unofficial way. That wonderful script was them. And it's just charming and funny. But Nora included me in so much. [She] invited me to casting sessions at her apartment, and we went to comedy clubs—Nora, Delia, and I—to look at comedians to see women comics. There was just a generosity of everybody putting their heads together to just get this right.

What did you learn from working with and being around Nora during the process of making *This Is My Life*?
So much. How somebody who cares about the work that they're doing can really work so hard and get it right. It took a lot to get the movie made. It wasn't an easy sell. And as you said, it didn't

Julie Kavner in *This Is My Life* (1992)

make money. But her compassion for it, her desire to make it was so strong, and I think I saw that you just keep working on the things you care about. You just go back to them. You have a tenacity and take it very, very seriously. I'm a novelist, so I really, for the most part, work on my own. But I liked seeing the collaboration, seeing Nora in a big work setting, managing a lot of things. She just was so capable.

Were there any takeaways about comedy you gained from Nora?
She really appreciated people who were funny. She really appreciated a good line. She got so much pleasure out of it. And you took pleasure in making her laugh, of course. But the movie, it's not like a slap-your-knee comedy, I don't think. There's really funny things in it, of course, but it's also moving and there's a real melancholy in it, too. I saw how you manage and seem to convey various things across a spectrum. These daughters are so excited and proud of their mother, and then there's the sense of being left, so you can go from one thing to another pretty quickly. I saw that you can just move swiftly in something you're doing. There's a great sense of movement in this. So how to get things moving, I learned that from her.

***This Is My Life* is a film that has resonated particularly with women. Why do you think they connect with it so much?**
I think some people remember when they saw it when they were young, and that's part of it. I know some people who've written to me about how much the movie meant to them, and I think we sometimes connect to where we were when we saw something that seemed to speak to us. There weren't that many coming-of-age and motherhood stories that I'm aware of—studio films that had that kind of emotional resonance that I think this one does. Those beautiful performances, the three of them—Gaby Hoffmann and Samantha Mathis and Julie Kavner—was something where maybe if you were a young girl seeing it, you could just reach a little farther

ahead to see what awaited you. The idea of a boyfriend, and having sex was in it. There was the idea of your mother as somebody powerful, and a sort of freedom of these sisters who were left alone. And the world became much more [filled with] latchkey children—children who were left alone after school with a bologna sandwich or something. That idea of those children instead of the helicopter parents [replaced it]. I had created the comedian babysitters in the novel as the sort of replacement for the mother, because she was a good mother, but it was so hard for her to do everything. There was just no way the balance could ever really be a balance. But there's something about certain books that people love because they see themselves in them, and I think that's maybe true of this film. There weren't a lot of films that had explored young girls, wives, and mothers, and daughters in the same way, and it was funny; it wasn't just this tender thing.

So I know Lena Dunham credits *This Is My Life* with being the movie that made her want to make movies herself. Have you seen the influence of *This Is My Life* in her work?
One of the reasons that I've had films made of my books [is] because of the characters. I'm a very character-based writer and I think that that's made it possible for people to imagine what this would look like as a film and who could be in it. And I think for Lena Dunham's work, you know those characters. So I think that there's an overlap, a particularly strong interest in that aspect. The characters just feel real. When I watched *Girls*, I felt that way, and I think that maybe she felt that way seeing this film.

***This Is My Life* has one of the most realistic and awkward sex scenes ever, and it's ingrained in my mind.**
I did want to have an awkward sex scene, and oh my God, that really was one in the film. But it's different [in] the immediacy of film. It's so vivid and visceral. That was a great scene. I mean, I think that an awkward teen sex scene is

something that I was interested in writing and something Nora and Delia were interested in writing as well.

How did the comedy from the book translate onto the screen?
Well, it was never supposed to be this cutting-edge comedy. In the book, it was this sort of older-style comedy, not mean. It's not hilarious. I don't think it's supposed to be. It's her shtick, it's her brand, it's her wearing dots because Dot's her name. I see it being its own little snow globe of the movie.

Looking back, which part of the film did you most appreciate in terms of Nora translating from book to screen?
I think letting the sort of quiet moments speak for themselves when the girls are in bed talking to each other. The relationship that an older and younger sister have, I felt was really, really well done and sophisticated. There's this sense of them being so different from each other but they have the same mother. They're kind of looking out for each other, but she doesn't say that. She doesn't have to go out and say that so overtly. I'm a younger sister, too, and Nora is a sister, and the sister angle is something that we have in common. All the things that my sister and I talked about, some of which, in some translated way, made it into the film, had meaning to her as well. Sisters are something that I really knew that she got, and that sensibility made it into the film in a quiet and moving way.

Other than the holiday scene, food isn't a huge part of *This Is My Life*. But food was so personal to Nora.
You're missing the important food moment in the movie though, of course, when the Moss eats paper!

You're right. How did the paper-eating scene transpire?
That's something that Nora and Delia put in. I don't really know the genesis of it. And that's funny too, because there are things that are not from the book, like the line that gets quoted all the time about your mother in Hawaii.

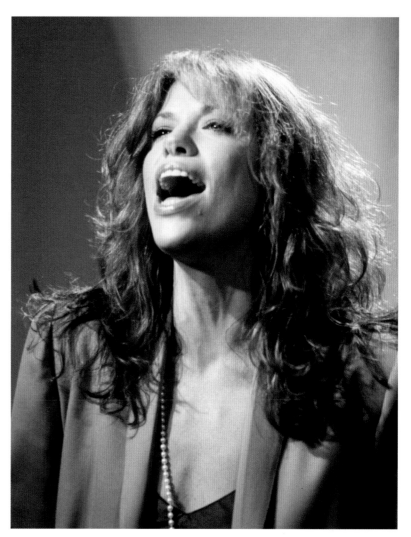

Carly Simon singing in the 1970s

Carly Simon scored the movie. Did you have a lot of input on that?
I had nothing to do with that, but I was thrilled, because the camp that I went to when I was a teenager, Carly Simon taught guitar there a million years ago. So I've always loved Carly Simon. I had nothing to do with that, but everybody I know who had a baby tells me that they've sung the song "Love of My Life." Not everybody, but people who've seen the movie and have a connection to it.

What's your favorite memory of Nora?
Well, lunches. Lunches with Nora were wonderful because you talk about work and both of you would talk about work, and she was just so interested and so curious. I think that kind of interesting curiosity is something that is a great way to live.

Why do you think Nora's work has become the blueprint for so many other female writers and filmmakers?
She's, first of all, done so many things and done them well. Those early essays are so fantastic, those *Esquire* essays and that voice. Voice is really important, and not everyone finds their voice, but she just was interested in exploring different things. She was an enthusiast, and I think that people really related to that a lot—and that goes back to food, filmmaking, and loving books. Enthusiasm is infectious. Somebody who's excited about things, you want to tell them what you love about their work, too.

LORRAINE CALVERT
Costume Designer for *You've Got Mail*

If you've admired the cardigans, khakis, and oxford shoes and tights Meg Ryan dons on the crisp autumn days in *You've Got Mail*, then you have Lorraine Calvert to thank for that. Alongside legendary costume designer Albert Wolsky, Calvert helped craft the heavy-on-the-knits-and-layers wardrobe for the 1998 rom-com. She has since worked as the costume designer on TV shows such as *The Sopranos* and *The Punisher* as well as films such as *Keeping the Faith*, *Year One*, and *Wanderlust*.

The style of *You've Got Mail* has really stood the test of time and has become immortalized on the internet thanks to memes. What was the moodboard for the movie's fashion like?

Well, Albert Wolsky was the costume designer, and I was his assistant, and the whole concept for the movie was based on *The Shop Girl*, which was an older movie. The concept was to do a sort of French shopgirl. So it was a timeless classic, lots of black, white, and gray. Everything in it was very classic and could work today because it was turtlenecks, pencil skirts, straight coats, and fun jumpers, not sweater jumpers but sheath dresses that had shirts underneath, big cardigans, oxford shoes and tights and stuff like that.

What was your experience collaborating with Nora on the film?

Nora was amazing to work with. She was very collaborative, as was Lauren Shuler Donner, the producer on it. They created this really amazing collaborative shoot with a lot of women, and I'd never been in a situation like that. Most of these jobs are pretty male-centric, and there are many more male producers than women and male directors than female directors. So, for that time period, 1998, that was amazing, just to see the respect and the vision she had. Everybody was important to her and every suggestion was a good suggestion worth talking and speaking about. I'll just never forget it. It was the most collaborative thing I've ever done or worked on.

Incredible. What do you believe is the most memorable look from *You've Got Mail*?

I would say the black sheath jumper with the white shirt. I think that was one of the best things—and all the little skirts with the cardigans. Also, her assistant who worked at the store, we based her on one of our production assistants who would wear very quirky things. She'd come in really with odd pieces put together with normal pieces. I don't know how else to explain it, but

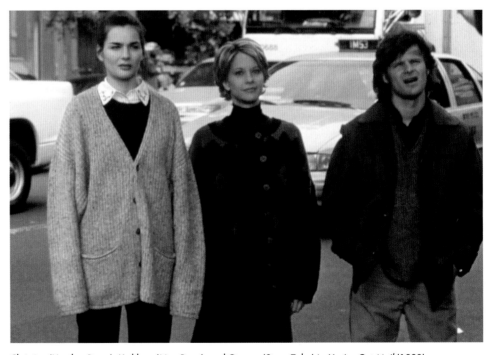

Christina (Heather Burns), Kathleen (Meg Ryan), and George (Steve Zahn) in *You've Got Mail* (1998)

it was really wonderful. She was such an inspiration to all of us for that character Christina (played by Heather Burns). And Jean Stapleton was really the wacky person and big pieces of jewelry. We shopped at Liberty, which is on the Upper West Side [and] kind of a precursor to the Eileen Fisher long sweater look and full skirts. But these were burnout velvets, beautiful patterns, and fun jewelry. It was so much fun to do that.

Because Nora and New York autumn are synonymous, how much did that inspire the wardrobe?
Oh, definitely a lot. The colors and definitely the palette [inspired it], although [Meg] was very much in blacks, nudes, whites, pale grays, and charcoal grays. But Tom Hanks was in, I would say, lots of suits that were olive green, brown, charcoal grays. Certainly, with shirts and ties, that was the color palette as well with him. And [with] Parker Posey, that was a very uptight pinstripe kind of look. Very "boss lady" versus the very soft "shopgirl" look for Meg Ryan. We also had some beautiful scarves that we used, if I recall, for Meg Ryan, and of course for Jean Stapleton, too.

How involved was Nora in the costume process?
I remember that she was involved in the fittings, and those were pretty great. She loved everything that Albert did, she respected him and certainly, Meg Ryan did. I think it was a very easy process. I think Tom Hanks was one of the most amazing actors I've worked with in terms of being nice, loving the job and loving everybody around him, and just loving the process. [He was] just very respectful of everything. That goes a long way, that real respect for the process.

Do you have any untold stories about the clothing in the movie?
Oh, one little story. You know the part in the film where the little girls come out of school dressed in the pilgrim costumes? She wanted my input on that. And if I recall, Albert said, "Lorraine, just do that part, whatever you think it should be." And I had my daughter, who was four or

Kathleen (Meg Ryan) typing in *You've Got Mail*

five at the time, help me with that. And I said, "What do you think these little girls would do?" She was totally enamored with the whole movie and still is. But I remember her coming up with that little thing that the kids wore, and that's what we used in the show. Albert was happy, Nora was thrilled, and that was in the movie. It was just a simple idea, a simple resolution to something like that without getting too crazy.

Why do you think the style from You've Got Mail has become such an internet phenomenon over the years?
Because it's classic. It was part of the time. Maybe it was the late 1990s and the aughts, and maybe it was a reaction to the classic look after so much hideousness in the eighties and nineties. Maybe it was just a reaction to that being such a much simpler look. It was much more defined, simple, and very French. If you look at shows now, something like *Emily in Paris*, you look at Sylvie. She dresses very classic, very simple, and repeats those same clothes. That look survives because so much of clothing and fashion right now is disposable, but those are timeless pieces that are never going to change. You all call it "Nora Ephron fall" for a reason.

Were there any French stores or designers you gravitated toward?
We did a lot of shopping at a French store, which I think still exists in Paris, but it does not exist in New York, [called] Anya Bay. The French clothing maker [is] very simplistic [and] I would say a more feminine version of Jil Sander. Around that time, Jil Sander was sort of popping up in Barneys. We did a lot of shopping at Barneys as well. But it was that whole minimalist look that was really coming into fashion, and that's what we went for—and also that Theory look of where you have a couple of good pieces like a charcoal pencil skirt and maybe a black turtleneck, and then you wear a black turtleneck with something else and you wear the charcoal pencil skirt with a white shirt. So it was a couple of classic pieces like that that survived time. I mean, look at Theory. They haven't changed their silhouette that much and they're still doing classic stuff. It's kind of Nili [Lotan]. In a way, it's just very simple.

LYNDA OBST
Friend and Producer or Executive Producer of *This Is My Life*, *Sleepless in Seattle*, and *Good Girls Revolt*

Lynda Obst was not only one of Nora's coveted creative collaborators but one of her closest friends. Like so many others, Lynda found Nora magnetic. Over the years, Lynda produced two of Nora's films, *Sleepless in Seattle* and *This Is My Life*. After Nora died, she executive produced the short-lived Amazon TV series *Good Girls Revolt*, which featured a young Nora Ephron (played by Grace Gummer). Her robust résumé also includes producing credits on *How to Lose a Guy in 10 Days*, *One Fine Day*, *Contact*, and *Hope Floats*, as well as executive producing credits on the TV series *Hot in Cleveland*.

How did you first meet Nora?
I first met Nora through my ex-husband, who was her ex-husband's agent. We all met at Marie Brenner's house back in the seventies. Nora was there, and we played a game of volleyball. All I remember from that occasion was that I never wanted to be a better volleyball player in my life, because she's a big competitor, and she was my idol from her *Esquire* women's columns. So I would only get her attention if I could spike, and I'm very short. So that's a challenge, but I played the greatest game of volleyball in my life, and I managed to get a little bit of her attention, and she liked me. I didn't realize at the time that she was a collector of interesting girls and women. And so I became a person she was interested in, and that was incredibly important to me. It grew into a very deep friendship.

Tell me about your experience getting *This Is My Life* off the ground.
The head of the studio at Columbia and I went to see *When Harry Met Sally* together, and I said to her as we were leaving the theater that "it's time for

Nora to direct." And she said, "You're absolutely right. Bring me something." So I told Nora and she wanted to do Meg Wolitzer's book *This Is Your Life*. So I brought it to Dawn [Steel], they set it up, she started doing a screenplay, but by the time it was to be greenlit or it was ready, Dawn had been fired, and the new person was named Joe Roth, who I think had never hired a woman director. So it was my job to get Joe to be as excited as Dawn had been. So I called Joe and he said, "Well, why don't we all have dinner or lunch at the Russian Tea Room, and I'll know by the way she orders if she's a director or not," which is, if you know Nora, literally the funniest thing anybody could say. Because she is the bossiest person about ordering who ever lived. We took him to the Russian Tea Room for lunch, where we had eaten maybe four hundred thousand times, and Nora told him he had to have the pelmeni and then the chicken Kiev. Nothing else was allowed. And he said, "Oh, she's definitely a director." And I thought to myself, "If all directing tests [were] this easy, we would be in great shape." So he approved her directing on the basis of how she ordered, which after you've seen Harry and Sally is hilarious, right?

You worked on *Sleepless in Seattle*. Tell me about the scene where Rita Wilson recites the plot of *An Affair to Remember*.
She gave Rita a one-word difference in how to do the reading, and suddenly it was hilarious. And I couldn't remember what the word was, but it was a word that was in the speech, and she had to emphasize that word, and then the whole meaning of the paragraph changed and became hilarious. Tom was really looking forward to it because he'd had to play with a kid the whole time and suddenly there were grown-ups around. So, he was so thrilled when Rita and Rob [Reiner] were there.

Lynda Obst with Julie Kavner and Nora Ephron at the *This Is My Life* premiere in 1992

I love that.

I'll tell you something else that's fabulous about Nora. Not fabulous, but that was singular. Or, not singular even, but just characteristic. When something happened that was important strategically, she would say, "Mafia." And that meant that we couldn't say anything to anyone about it. She would say, "Do you know what I'm saying, Lynda?" And I'd say, "Yes, Nora, I know what you're saying. Not a person, not a soul." I don't think she ever really believed that I could be completely confidential. It always made her a little nervous because she could really go "mafia," but she taught me to go "mafia." I was young then, [and] it's harder to go "mafia" when you're thirty, you know? Now I'm totally "mafia"—I don't tell anybody anything. I think that's part of why she didn't tell me she was sick because she didn't want anyone in the industry to know she was sick. She knew that it would be hard for me to contain my emotions and feelings, but I would've gone "mafia" if she told me to.

Interiors are such a hallmark of Nora's films. What made her aesthetic so distinct?

She loves iconic. I mean, she's not Nancy Meyers. I love Nancy, but she's not all about that. But she was able to show the taste and the sensibility of a character through their surroundings. And her characters were all different. They didn't live in gorgeous beach mansions, they lived in places where characters lived. Like, the houseboat was her idea, and then it was designed by the production designer. She was more involved day-to-day in the costumes and wardrobe, and then she approved the sets. She told them what she wanted, what the characters were like. She wants things to be real, and to sell where they were. That's one of the reasons her New York sets were so beautiful. Even her Seattle is beautiful. She looked for all the iconic places in Seattle. She loves beautiful pictures. I think in many ways that comes from having a troubled childhood that you want to make perfect. Her parents wanted to make it perfect, and they did that by making the house into

Grace Gummer as Nora Ephron in *Good Girls Revolt*

pretty pictures. And she was able to capture that beauty in film. I think it took her a couple of pictures under her belt to be very confident about her visual style. She'd always been a Lee Bailey fan, so her houses always looked great, white and never cluttered. Her taste got better and better, and her confidence in her taste got better and better.

You produced *Good Girls Revolt*. What was it like bringing Nora on-screen in that way?

Well, it was exhilarating and it was horrible. I got involved in it because my studio told me about the book. Nobody could get the rights to it, but they thought maybe I could because of my being a former journalist, and Lynn Povich and I had many mutual friends. So I reached out to her, she said yes, and then I assembled the team. Putting Nora in it was a little difficult because she wasn't really there at the exact time that this went on—the *Newsweek* story. With a small conflation of time, we were able to put her there, which I think was difficult for the family because they're documentarians. They're not fiction writers, except of course Nick is, but Benny doesn't consider Nora to be the subject of fiction. It was hard putting words in her mouth. It was hard getting dialogue for her because nobody can write her dialogue like she can. So that was always difficult, and casting her was very difficult. Although, I did have the idea to go for Grace Gummer because Meryl had played her, and Grace had grown up knowing her, so I thought that was

possible. Grace wanted to do it, so we just cast her and worked really hard on it. I thought she did a wonderful job.

It was a bummer that it ended after one season.

Well, it just wasn't picked up for another season. It was meant to originally be a limited series. Then people loved it and wanted another season, but my writers weren't ready. They hadn't thought of a second season yet, and we couldn't use Nora in the second season, so they had to make up a whole season, and they hadn't sorted it out enough to get the studio to agree.

Are there any filmmakers or screenwriters you think have really carried the torch for Nora since her passing?

No. I wish. There's certainly no rom-com writers on the scale of Nora since.

Tell me about what it was like casting with Nora.

When you cast with Nora, she had this concept that I constantly use now called "Food Group": What food group were they in? For her, people were either one of three kinds of animals: they were either a duck, a horse, or I forget the third one. That's how she categorized their faces, but food groups were kind of like what their range was. So she had these wonderful expressions for how we would put actors together since we needed people in the same food group. But what she really knew more than anyone I've talked with is who was funny.

DAN DAVIS
Production Designer for *You've Got Mail*, *Michael*, and *Lucky Numbers*

Production designer Dan Davis was one of a handful of collaborators who worked with Nora on several projects. But you can specifically thank him for the cozy, charming aesthetic that underscores *You've Got Mail*—bookstores, apartments, and all. After working on the famous rom-com, he joined Nora on *Michael* and later on *Lucky Numbers*. But you've probably experienced his work over the years in films such as *Beautiful Girls*, *The Deep End of the Ocean*, and *The Other Woman*, as well as TV shows such as *The Americans* and *Power*.

How did you come to work with Nora?

I worked with her on three projects. The first one I worked on was *Michael*, which was in Texas. They fired the designer for some reason. And I did a film with Ted Demme, *Beautiful Girls*, which she really liked. They asked to interview me, so I went to Texas and met with them. They still hadn't fired the guy yet, so I had to hide out in this hotel room, hoping he wouldn't find out.

Really. Oh my God.

I know. So that was a big jump for me. I mean, I'd worked on a bunch of stuff I really enjoyed, but it was the first big Hollywood movie that I'd worked on. A lot of the work had been done already by Andrew McAlpine, who was a very good designer. I'm not sure why they had a falling-out, or why he left the project. I really enjoyed working with Nora on that. It was a great experience for me. The producers, I'd known, and Don Lee was the production manager, I believe. He's someone I'd worked with quite a bit before. So it was comfortable for me.

It was fun being in Texas. I really liked Austin. I just tried to do what I usually try to do, which is make things real and not too "design-y." I like to hold back a bit.

What prompted you to take that approach on Nora's films?

I worked as an art director for a really good designer in New York, Mel Bourne. He did all those early Woody Allen movies. He was interesting. He had a great sense of the ordinary, as I say. So I try to follow in Mel's footsteps as much as I can. Sue [Bode], then she hired me on *You've Got Mail*. She had a designer on it whom I'd worked with before, who was a wonderful designer, Tony Walton, who somehow left the project. Then they called me in. That was a really rough job because it was Nora's world, all the publishing and books. She was so demanding. It was really hard sometimes. She'd walk on the set of this huge Fox bookstore, and she'd see two books that didn't belong beside each other on a shelf, about a hundred feet away, and I would get in trouble. I'm working on *Law & Order* [right now], so I walk by Fox

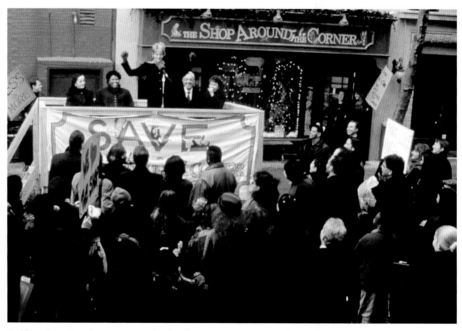

Kathleen (Meg Ryan) trying to save her bookstore in *You've Got Mail* (1998)

Books every morning because I walk to work, and it's horrible. But I think I did a good job. [Nora] seemed really happy. On those jobs Delia, her sister, was there a lot and whom I really liked. We used to complain sometimes about how rough Nora was with things. Delia said, "Oh, she's always been like that since she was a little girl."

How did you approach the production design of Kathleen's apartment in *You've Got Mail*?

We tried to romanticize everything a bit. Pushed everything a little over the top. It was all about a glorification of New York in a way, really. Certainly with Fox Books and with the other bookstore, and her apartment. I had a couple of great decorators, Ellen Christiansen and Susan Bode, who both did a fabulous job. It was just keeping Nora happy, basically. That's what you're trying to do, in every job.

***You've Got Mail* really had this autumnal feel. How did you incorporate that into the design?**

Oh God, that was an issue, because we had to paint all these fucking leaves on these trees for these exterior shots. That was the old days, when they didn't do stuff in post[-production] so much. We did tons of trees with fall leaves, all over the West Side. It was funny, because it was all about the West Side and loving New York. I don't think she really liked the West Side that much, personally. I remember once the leaves were too bright for Nora, and that was one time she got pissed. It wasn't so much for me, I think it was more for the DP, how he lit them. It was a huge deal for the Greens. We don't really do that anymore, but that was a big deal. The same with *Lucky Numbers*. We had this big snowmobile chase through Sacramento, and we had to snow blocks and blocks of locations. It was quite a big deal.

How did you conceptualize the bookstores in the movie?

Fox Books was started by Tony Walton, and I added onto it. I made some changes, but it was started by Tony. The other store [the Shop Around the

Meg Ryan and Tom Hanks in a promo shot for *You've Got Mail*

Corner] was pretty easy. We just tried to make everything as charming as we possibly could—cozy and charming and fun.

What made something particularly charming or cozy enough for Nora?

We did all these little mobiles hanging from the ceiling that made the set feel really fun. The front window was fun. It was just trying to make it fun and nice. Fox Books was different, but it was pretty charming. I think that's some of the best stuff I've ever worked on.

You also worked on *Lucky Numbers*, which was a misfire.

It was a really interesting script, but I don't think [Nora] did that good a job on that movie. It was quite a tough script, realistic and rough, and she cutesified it all. I don't think it really worked that well.

Why do you think Nora's work has stood the test of time?

I think she was interesting because she was a Hollywood person who wanted to be a New York intellectual. She had this New York intellectual thing going, but it was all based on being famous, from her Hollywood life. I think she just wanted to be a famous director. But her movies were good. They were old-fashioned screwball comedies, in a way. She really tapped into that, and that was interesting at the time. It was quite successful, obviously.

Do you have any untold stories about working on any of the films?

I remember when we were working on *Michael* that they made these wings for John Travolta. They cost a hundred thousand dollars or something because they had to move. Then somehow they got lost. The wings got lost, and it was a huge deal. But then they found them again, probably a couple of days later, so I don't know what the story was behind all that.

LAUREN SHULER DONNER
Producer of *You've Got Mail*

For Lauren Shuler Donner, producing *You've Got Mail* was the beginning of a long friendship with Nora. What followed were years of dinners, advice, and memories she's taken with her along the way—and books she often returns to just to be comforted by an old friend. In addition to *You've Got Mail*, Lauren has had a storied career producing films such as *St. Elmo's Fire*, *Pretty in Pink*, and the *X-Men* and *Deadpool* franchises.

What was your experience like when you first met Nora?

Well, I was in awe of her before meeting her, of course, and I made a decision that rather than try to do anything and try to impress her, we were going to work together, I was just going to be myself and very honest—and luckily if that worked out, she liked it. So it was very interesting. I met her at her apartment—her first apartment—the Apthorp. *Only Murders in the Building* was based on the Apthorp. She was gracious, brilliant, funny, wonderful. We had talked for several hours. As you know, it was based on the old Turner movie called *The Shop Around the Corner*, so I had offered her an old movie to contemporize. I had the idea that the way to contemporize the movie was to use the internet. So I was getting her thoughts, but we were meeting each other to see if we could work together. And it turned out to be wonderful, absolutely wonderful. She was just perceptive, funny, charming . . . everything I imagined.

In terms of casting *You've Got Mail*, what was your process like?

We talked about who would be ideal for Kathleen and Joe, the main characters, and we pretty quickly decided it would be really great if it was Tom and Meg. I volunteered to call Tom. I knew Tom. I had produced *Radio Flyer*, and he had a small but mighty role, and so he wasn't a stranger to me. He said, "I'm afraid I'm going to have to say yes, I think I have to do this." I literally said, "I want to scream but I'm going to be cool." And then once we had Tom, we then went to Meg; and thankfully she agreed. So it was based on the great script that Nora and Delia wrote. And based on Nora directing, it was a lot easier than other things that I have done.

Do you remember who else you guys were considering?

No, we didn't consider anybody else. We considered Tom and Meg.

What was the most memorable part of watching Nora on set?

There were a lot. She's very charming. She knows what she wants. She works well with people. She had a crew that she was somewhat familiar with, and that made it fun. But what was unique was that we were filming in her backyard, so to speak. We were filming on the Upper West Side and part of their, her and Delia's, take on the story was a love letter to the Upper West Side. So, seeing it through her eyes was a very rare air to breathe. And it was enormously fun to understand the places that she loved, to meet the people she loved in the literary, publishing, and political world. It was an invitation beyond what we showed you in the movie to really appreciate what the Upper West Side was at that time and what it meant to the people who lived there, particularly the people of that world. She was not a hundred percent precious about the world, which you would think she would be. She has a temper. She can also be wicked in a way, but I will tell you my memories were all fantastic. She remained my friend, her husband remains my friend, her kids were my friends, and of course Delia.

Why do you think *You've Got Mail* and Nora's rom-coms have really been her defining body of work?

Well, *You've Got Mail*, I believe it's because her words were front and center because [Meg and Tom were] writing to each other. So you hear the script, you hear and you see it on the page, their dialogues, and I believe that is why it is so beloved beyond the fact that it's a really fun story, and Meg and Tom are charming as is everybody in the camp. But beyond that, you get to appreciate the Ephron sisters' talent for writing. And in terms of rom-coms, I don't know, she came from that. Her parents wrote those and she, in a way, was perceptive about relationships, about people, very perceptive, unbelievably so, and her opinion always matters to everybody. Sometimes

she would of course challenge herself and go into other kinds of movies, fantasy like *Michael* and *Bewitched*, but they all came down to the same thing. They all came down to a romantic comedy.

Nora's legacy has extended to the internet over the years, and she's gained a new fan base because of it. Why do you think that is?

Well, her writings lived on beyond her movies because she was a profound artist, talent, who made a mark. Her words rang true to a lot of people—or she put a lot of people's feelings into words and entertained us—and underneath the entertainment was sometimes tragedy. One of her many talents was, as she would say, through her writing because she was very specific. So that moment would come alive with specificity, and that was how she did it. She would ground it with specificity, and that is what you're talking about in pop culture: that is the crewneck sweater or the very special twinkle lights for trees and certain things that live on beyond her.

I agree. Do you have any untold stories about the filming of the movie?

Oh God, yes. We filmed Meg's bookstore, Shop Around the Corner, in Chelsea Piers in New York. We built it, and therefore at lunchtime there was the sports center, which is bigger now, but at that time there was a track, [and] there was a bowling alley. So Nora had this great idea that we should have a bowling league—we should bowl during lunch. So we took the crew randomly, just divided them up and everybody bowled at lunch. It was just gobs of fun, and it was a really great way to regenerate your mind by doing something else, but it was team building because it was an equalizer. We gave everybody a bowling shirt after we moved from that location, and I can't say that on any other movie I've had that experience. So that resonates with me. It was a perfect idea.

The caviar scene between Kathleen and Joe is one of the most memorable parts of the movie. What do you remember about that one?

That was so difficult. We were up in somebody's apartment—it was on location and in tight quarters. [We] couldn't have everybody in the apartment because there was no space, which always makes it difficult, so it was not an easy thing to film, physically. In terms of their dynamic, it was great. Meg and Tom worked so well together, and Greg Kinnear and Parker Posey, what a delight. I will tell you another story. At the end of the movie, we wanted spring leaves, and the leaves didn't come. What we had to do on the Upper West Side was our art department had to go out and staple the leaves on the bare branches of the trees before we filmed—the same for the garden at the end on Riverside Drive. The garden hadn't warmed up enough so the flowers that are usually there hadn't bloomed yet; we had to go and plant that garden. Sometimes you have to make snow and sometimes you have to staple leaves on a tree.

I love that. Were you and Nora friends following the making of *You've Got Mail*?

Yes, for years until she died. We were very good friends. I have memories of fantastic dinners during *You've Got Mail*. She was incredible. She had a whole philosophy about food. She was a wonderful cook. She found it very easy to entertain. She would make most everything—unless it was something she felt was as good as she could make it and she could buy it in the neighborhood. I remember one dinner in particular where she had just discovered Greek yogurt with honey dripped on it, and that was a big-deal dessert for her. Everybody was very excited about it. But I've been to many dinners at Nora's, and she will cook. She'll put together a great curry. She had a philosophy about dinners that you should have four things on the table, a protein, a vegetable, a starch, and a surprise—a fourth dish that is fun to eat, like macaroni and cheese.

Even though Tom Hanks is lovable, Joe Fox is actually terrible and didn't age well as a character. Was that always the plan?

Her philosophy about romantic comedies was that the two characters were "I hate you, I hate you, I love you." So if you look at the heart of it, he's not a likable character. He had to come around and win her back. The irony is so interesting, because at the heart of it, it's about the big bookseller taking out the independent book companies. Now the big book companies are taken out by Amazon, but the small independent companies have remained. Nora would be very happy about that.

While Nora had a lot of success, she also had a series of films that didn't land with audiences and at the box office. How did she deal with those tougher moments in her career?

She was, as you would imagine, upset. It's a lot of work. She put her heart and soul into each and every movie, and she was heartbroken. But Nora is the kind of person who moved on. She was heartbroken, she grieved, and then she obviously moved forward.

I know you didn't work on her last film, *Julie & Julia*. But do you remember what that experience was like for her?

Well, I think it meant a lot to her. Meryl Streep was special to her, Julia Child definitely was very special to her, Paris was special to her, and food, as it should be. I remember we filmed in New Jersey at the Armory and Nora said, "There's the most wonderful pie place, we have to go. Let's get a car and get all these pies for the crew." So we all went and we got all these pies and brought them back so that the crew could taste pies in the area. She was very, very much about food. She told me the first day when I met her that they had forty people [at her wedding], and she had it catered and she regretted it because she could have done it herself. I thought, "Oh my God, can you imagine getting married and cooking your own wedding dinner?"

That's so funny. Why do you think that Nora and her work is so particularly important to women?

She just understood. She always had friends and so she could observe her

own life and her friends' lives. I just think she spoke to the truth, and she did it profoundly, with humor. She was a voice for us. If you look at her books [such as] *I Feel Bad About My Neck*, she tackled things like age—things that women think about—and gave us a window into it, not only saying "You're not alone" and thinking about it, but she would throw out some wonderful specific thoughts.

She obviously did that with pieces of clothing, too, and fashion is something that reverberated within her filmography. How has Nora Ephron's style really remained such a touch point of her work?

Well, she was very interested in fashion. She dressed absolutely beautifully. She hated purses. She would never carry a purse. Her mother told her never to buy a red dress, that sort of thing. When you're making a movie, what the character wears is very character defining. If she's making a character, for example, and *You've Got Mail* is on the Upper West Side, she's going to dress that way, but with good taste. Nora had very good taste in clothing. She remained petite, so everything looked good on her. It was an important element in her life and therefore it came out in her movies.

What about Nora sticks with you?

Well, like everybody who knew her well, I miss her every day. Her profundity. I go back, and I read her books a lot. I read them not only for her humor and her writing, but for her company because she was so remarkable. I treasure her for that, and we can all continue to treasure her. Fortunately, she left us enough words too, that we all can see comfort in it.

What's the best advice that she ever gave you or has been left with you?

Oh, I can tell you something funny that she said: "Go pick the round tables. Don't use a square table; use a round table because it's more conducive for talking."

ANDIE MACDOWELL
Actress in *Michael*

For nearly forty years, Andie Mac-Dowell has made an impression on Hollywood as both a model and an actress. She landed her breakout role as a part of the Brat Pack in *St. Elmo's Fire*, before going on to earn critical acclaim in Stephen Soderbergh's indie drama *Sex, Lies, and Videotape* a few years later. During the nineties she would become a national treasure for roles in rom-coms such as *Four Weddings and a Funeral*, *Groundhog Day*, and *Michael*.

What was your experience like working with Nora?
I was so impressed by her. We had the most generous rehearsal I've ever experienced with anyone. You know, she was fascinating. She came up during a time where it was really hard for women to be in that position, it's different now, she was tough. I remember one time she was getting down off some equipment, and somebody held up their hand to help her and she just knocked it away and then got down. Because of that generation, and women had to fight so hard, there was a part of her that was really strong, very dominant, hardworking—she def-

initely had all those qualities beyond her brilliance and her intellect and her shimmer. That's how I saw her because I saw her at work. I mean, there was a really soft side to her as well. But at work, she was very serious. That's how women had to be—you have to be tough for people to listen.

Michael was not critically well-received at the time. What was that experience like?
I would have loved to have heard what she felt about that whole project. How did she feel it turned out, and how did she feel about the response to it? I didn't

Andie MacDowell as Dorothy in *Michael* (1996)

realize that people were critically harsh on the movie. It did well, it performed well, but someone brought it to my attention recently that compared to other works, it wasn't critically acclaimed like some of her other works. But I thought the movie was good. I don't always like movies I'm in either.

Why do you think that the movie wasn't as favorable with critics?
I have a hard time with critics, I do. It's like one critic criticizes and the other jumps on the boat. I feel like that happens in Hollywood, as well—it's like the whispers somebody spreads. Now that I've lived here—I'd never lived here before until the last ten years—I see it really does exist. It's like if a certain crowd starts to whisper something negative, then that's what it becomes. For me, it's not always valid. I have to watch it myself and decide what I feel about it. And that's the great thing about an audience because the audience, quite often, doesn't care about the whispers. To me, the audience is the critic. That's what we make movies for—for people to go see them.

The most memorable moment in the movie is the pie scene. Do you have any untold stories about the making of the pie scene and singing "The Pie Song"?
I do remember going in to record it, and when I went and I sang it, I was really nervous. It turned out, and then I got my confidence up and tried to sing like a singer and I got worse and worse. So the take we used was when I was nervous, the very first take, just like my character would have been. And that was what

we used. The rest of them were horrible, I do remember that. I had a lot of fun making it. John doing the dancing thing was iconic just because it's him. William [Hurt and I], we had some heavy hitters in it. Mostly the thing I remember is rehearsal. You just don't ever get that much rehearsal. I think she does it very much like a play in that she maps it out and knows what she wants—at least that was my experience.

How much pie did you have to eat for that scene?
I don't remember. I was having so much fun. The great thing about the character that I play [Dorothy] is that she's not supposed to be that good. It's a dream more than anything, so that took a lot of the pressure off me.

It's funny because this movie was never considered a part of Nora's rom-com trilogy, but I do feel like it should be.
I think it's a great movie. I don't have any problems with it. It makes me sad for her that it can't have that kind of substance to still be something that people remember or that goes in with that whole genre of rom-coms when that's what everybody was doing. That it's not one of them, I think, is sad. It's sad for the movie and for what she accomplished. It confuses me sometimes why the critics are so hard on certain pieces of material. I don't understand, but I'm not a critic.

What was your audition process like for Dorothy?
I read it, I wanted it badly, I prepared, I auditioned, and I sang. I think it was

when I sang, that's what she liked. It was gutsy, and I had no inhibitions. That's probably what saved me and got me the job. I felt comfortable in the audition. I did not feel inhibited at all. So, I think that's what went well for me.

What was your experience like working with John Travolta?
I mean, he's John Travolta. He does that damn thing. He's bigger than life, really honestly, and it was a big time in his life getting so much attention. He had done *Pulp Fiction* and had this supposed revival, but he kept reminding me, he never really disappeared. But it definitely was enhanced by the quality of the work he was doing. It's like a huge presence.

I feel like Nora's legacy has obviously extended to the internet over the years and she's gained a new fan base because of it. Why do you think that is?
The quality of her work, I would imagine. If you look at so many movies and those kinds of movies being made, it was definitely a time when romantic comedies were very well-written, enjoyable, and fun—the kind of movie you wanted to get in bed and watch, and I think that a lot of the work is like that. So, maybe that's it. I'm not an expert, but I would imagine. I miss that era myself. I miss that kind of feeling.

Have you had to sing "The Pie Song" over the years?
People still ask me to sing "The Pie Song" all the time—and I will. I can still remember it.

JENNIFER KAYTIN ROBINSON
Writer/director/producer behind *Do Revenge*, *Someone Great*, and *Thor: Love and Thunder*

Since the release of her 2019 breakup rom-com *Someone Great*, writer and director Jennifer Kaytin Robinson has established herself as the millennial voice of rom-coms, adding a fresh twist to a genre that had stagnated. She's since followed up that hilarious debut with the rom-com meets dark comedy *Do Revenge* and the abortion buddy comedy *Unpregnant* and was even behind the screenplay of her first Marvel flick with *Thor: Love and Thunder*.

As someone making rom-coms of your own, what is your relationship with Nora Ephron's work?
The thing that made me become a fan was *When Harry Met Sally*. I accessed her through that film and then went backward from there where once I saw that writing, that story, and the characters, I looked her up and then I think from there found her writing, essays, and journalism. The first book of hers that I read I believe [was] *Heartburn*, and then it just became following her, watching the films she made, and watching her career move from writer to director.

Have any of your projects been directly influenced by Nora's work?
I think everything [has] because there are certain touchstones [but] I would say more writing than directing. Although I do think she is a really phenomenal director, I do think it is the writing that I come back to in that when you consume their work at a young age, it just becomes a part of your DNA. I feel like everything I do has a piece of Nora in it because she inspired me to want to do

what I do. But not just that, I think that you take on the thing that you admire and so, the cadence, and the way her dialogue flowed, is very present in how I write. The way that people talk and how the [characters] tell a story, how the story is interrupted, the quirks and the way that she creates a character, not only is that present in my work, but I also think it's present in me, the person. I would say it's very present both on the page and in my life.

You are one of the premier voices in the resurgence of the rom-com, putting your own twist on it with *Do Revenge* and *Someone Great*. Are there specific elements, scenes, or character elements that directly reference Nora's work?
I don't know that there's any kind of direct correlation or incorporation of her work into mine, but I do think that *Someone Great*, in a lot of ways, it's a different way into *When Harry Met Sally*. Because it's *When Harry Met Sally* in reverse rather than a story up until happily-ever-after. It's the end of a

Jennifer Kaytin Robinson (sitting on the floor) on the set of *Someone Great* in 2019

Jennifer Kaytin Robinson with Camila Mendes on the set of *Do Revenge* (2022)

happily-ever-after backward to the beginning. So while I don't think that was the intention, I would say that is probably the closest that I have in terms of a one-to-one [reference]. But I think so much of it is character development and dialogue and the way something sounds, feels, and is lived in. That is where the inspiration from her work lies within mine.

With *Do Revenge*, I feel like there are elements of *Heartburn*.
Yeah. That definitely wasn't a conscious choice for *Do Revenge*, but I do think that the idea of the scorned woman . . . [Camila Mendes] did such a beautiful job encapsulating that and the rage of that and making it fun and funny.

Why do you think Nora has the legacy she does?
I think her ability to be both incredibly singular but also so completely accessible, where every woman feels that they are looking in a mirror, but they also equally revere that woman and feel that she is untouchable, [is incredible]. There is such a perfect balance between those two, that dichotomy, and I don't know anyone who has been able to create that. She is at once in every woman and also someone that is held on the highest of pedestals. She lives on her own plane, in her own space, in her own sphere in

a way where I don't know that I would want to compare other people's work against hers, as much as I think that there is her work and there is other work that very clearly wouldn't exist without her.

That said, I think that there are many amazing writers who are making their own entry into the genre, and I think that is where the Nora inspiration lies. That is where I think Nora is the most present in all of the work that has come after her in creating a space for women writers and directors who can feel fearless in putting stories on-screen about women, about love, about life, about each other.

Love that. What aspects of Nora's writing, her tone, have you injected into your own script writing?
She had a very specific ear for how people actually sound and what conversations actually feel like, and to me, it's always needling at what is the truth of what this would really sound like if two women were sitting together. She was the queen of specificity and looking at that and learning from that and then applying that to my work in my own way—not just copying her but admiring her, how she created these fully lived-in people and then wanting to be able to create that for myself.

What do you think Nora's biggest impact on film has been?
I think that the way we depict modern love can be traced back to Nora Ephron. She was able to completely modernize without feeling like she was in any specific time. And I do think that everything can go back to *When Harry Met Sally* and that script, and I think that answering the question "Can men and women actually be friends?" changed the way we made movies from that point on in that genre.

Is there anything else you want to note about the impact of Nora on you or in general?
As a young woman, I come back to the *Everything is Copy* documentary all the time to listen to how Nora ran a set and how Nora was like, "Everything you need is in the script. If you don't read the script, you are gone." And it's like, you shouldn't feel weird about saying that, I don't think a man would feel weird about saying that, but it's hard because you as a woman are meant to be everybody's friend and mother. It's not that she wasn't all of those things, it's that she also stood really firmly in her position of power and did not compromise. That, to me, is the thing that I carry with me in this part of my life, in this part of my career. When I think about Nora and her influence, I will literally be standing in front of a group of people and I will be like, "Okay, Nora would do it this way." I'll think about how she would attack something, and whether that's true or not, it's like there's this little Nora who lives inside me who helps me be a stronger person just navigating through this industry.

HEATHER BURNS
Actress in *You've Got Mail* and *Bewitched*

For Heather Burns, Nora wasn't just a director she worked with but a mentor. She's a character actress who has starred in films like *Miss Congeniality* and *Two Weeks Notice*, but it was her film debut in *You've Got Mail* that was her big break. Later, she'd star in Nora's twist on *Bewitched* and would keep in touch with her throughout her career.

What was your experience working with Nora over the years?

Well, I have a special relationship in a way, because she found me out of nowhere. I was just out of school. I was auditioning. I had booked a TV pilot, but it hadn't shot yet. I went in for Francine Maisler, the casting director for *You've Got Mail*, and I auditioned for her. Then, I got a callback to meet with Nora, and she pulled up a chair right maybe three feet away, face-to-face, and we read the scenes. I read with her. And that was it. I got that part. It was my first movie—it was the first time I'd ever worked with actors like that—and she was really wonderful, understanding and gracious. Through the years, we remained in touch. I obviously admired her so much. She was just such a witty, incredible person to be around. We bumped into each other from time to time, and years later, I bumped into her at the hair salon. She was like, "I have a part for you," and that was *Bewitched*. That was a wonderful experience, because we were in LA for a long time. A lot of us were on location, and she would host these beautiful parties, and she took all the women on set to the Polo Lounge one day for a girls' lunch. She was almost a mentor to me in certain ways—in terms of being the first director of that stature I worked with, that she was a woman and [that] she was always full of advice. It was empowering also to see how she did everything as well.

What's the advice that Nora offered that sticks with you?

When we were doing *You've Got Mail*, I really couldn't grasp that this woman would go off with this capitalist raider. I was so young and so idealistic, and I was like, "Nora, I just don't understand. I don't know if I could do that. I don't know if I could fall in love with a guy like that." And she was like, "Well, Heather, things change, and the city changes. Things change and you've got to go with that in life." And I always took

that to heart, because they do. Now we look at Barnes & Noble as this quaint kind of store hearkening back to older days, and I always keep that in mind. The city changes, we change, and you can't be afraid of that.

Do you have any funny anecdotes to share about working with her?

One day we were on set on *You've Got Mail* and one of the actresses said to her, "Oh God, I feel so lucky to be here. I'm just so lucky," and I was like, "I feel so lucky, too," and she said, "You guys aren't lucky. Demi Moore is lucky. You have talent." It's so mean, but it's something she would say. You just laughed about that. She was always coming up with that kind of stuff. I don't think she'd mind me telling that joke.

What do you think is Nora's legacy?

The time that she came from, I feel like a lot of those women didn't have women before them to emulate and she had to figure that out on her own. I was reading one of her essays a while ago, and she was talking about when she first got a job at [a] magazine and the women went and delivered mail, and the guys got to go do reporting jobs. She was like, "That's just the way it was," and then she figured out that she wanted to be a reporter. It's not like she went in there fighting for that. [What] I find so cool about her is the way she's able to transform from being a journalist to then writing *Heartburn* to then writing films to then directing them; she just never locked herself into anything. She was so passionate and immaculate in terms of everything she did.

Is there anything Nora instilled in you as an actress that you've carried throughout your career?

Honestly, observing her, because she was so funny and dry, and her humor was so quick. The way she delivered her jokes in just conversational passing, I took a lot to heart. In *You've Got*

Mail, I felt the way she delivered humor and in a way tried to emulate that. She also encouraged me to keep working in film and theater, as opposed to TV. Television was very different at that time. There was a lot of pressure to do it. She's like, "You're more of a film actor, you should do that." She did tell me not to stutter—that helped. It was fun to watch her makeup because there was improvising and rehearsal and she would take our lines that she wanted and add them to the script, so that was pretty awesome as well.

I remember when she died, it was such a shock. I was eating out at a restaurant, and I was like, "Excuse me, I have to go outside," and I started crying. I heard her voice in my head say, "Heather, your food is hot. Go eat your dinner. Stop crying." She was like, "Women should never cry at work. Ever." It wasn't at work, but I just could hear her voice: "Don't cry, go eat your food. It's a good meal, it's warm. Don't let it go to waste."

Afterword

Nora made a special appearance at my wedding. Not as a ghost or a hologram, but in my vows. With tears streaming down my cheeks, I gushed about how much rom-coms, specifically Nora's trio of groundbreaking genre films, had shaped my core beliefs of finding true romance. All my dreams of finding love at Christmas (yes, even as a Jew) and meet-cutes at bookstores felt possible after watching a montage of Meg Ryan in cardigans connecting with a few of Hollywood's leading men on-screen.

So much of my life has been shaped by Hollywood's biggest rom-coms: I lived vicariously through Princess Mia and her foot-popping kiss in *The Princess Diaries*, the breathtaking ice-skating date in *Serendipity*, and Mary and Steve dancing during an outdoor screening of *Flirtation Walk* (1934) in *The Wedding Planner*. Nora is, in large part, responsible for all those on-screen fantasies. But she's also responsible for the way I view intimacy as an incredibly ordinary way two people can connect, which Harry and Sally, Annie and Sam, and Joe and Kathleen made seem so enticing on-screen. These characters Nora crafted—and these immersive worlds she designed—felt so real because they were often based on people she knew and situations tangential to her. It made it easy to believe that I was just one fateful night away from finding my Sam, Harry, or Joe. Or at least one step closer to manifesting it when I was wearing a Nora-approved chunky sweater.

So when I met my husband more than ten years ago, I had a lot of expectations. Over time I realized my romance was a less complicated version of *You've Got Mail*, sans the bookstore wars and frenemies part. But I know that my husband has melted my heart in a way that parallels Joe's impassioned plea outside Kathleen's apartment just moments before they finally "meet" and passionately kiss in Central Park: "How can you forgive this guy for standing you up and not forgive me for this tiny little thing of putting you out of business? Oh, how I wish you would." No, my husband never said those exact words, but that twinkle in his eye, that chill-inducing delivery—I've lived my own version of that scene, and as I recall, my heart melted into a puddle on a gray couch I despised in Brooklyn.

What has made Nora so irreplaceable is how much her manicured wit, rich characters, and storylines about romance have endured as guiding lights for not only filmmakers but people like me who were looking for their own charming New York City love story. It's why a sentimental lens remains around her work and legacy, even though the real Nora's prose could cut deep and leave a sour aftertaste, depending on the subject. Rachel Syme said as much in a *New Yorker* essay examining the conflation of Nora "the person" with her work. "If Ephron has a lasting legacy as a writer, a filmmaker, and a cultural icon, it's this: she showed how we can fall in and out of love with people based solely on the words that they speak and write."[1] That was the power Nora wielded with every calculated keystroke.

Because of lessons learned from Nora's leading ladies, I aspired to be ambitious, messy, flawed, and too honest. I wanted to harness the fiery truth-telling of Karen Silkwood, the pluckiness of Rachel Samstat, the neurotic certainty of Sally Albright, the passion of Annie Reed, the unwavering determination of Julie Powell. It's actually when I broke that barrier and allowed that version—the *real* version of me—to fully be seen that I met my husband, word vomiting and wine drunk at a now-defunct Brooklyn bar. Nora set the standard for romance, and I was finally the three-dimensional female protagonist in my own story. There was, after all, a lot of real life packed into her rom-coms, and mine was no different.

While I was compiling this book, I went through the exciting and tedious process of planning my wedding. But as my anxiety heightened, I found myself salivating over scrapping the entire thing in favor of an intimate, no-frills ceremony at city hall. In those moments of doubt near the proverbial finish line, I found myself comforted by the park scenes of *When Harry Met Sally*, the foundation they built for Harry and Sally's relationship and even my own. Reflecting on when Sally drops Harry at the Washington Square Park Arch and the eventual connection they later forge during an autumnal Central Park stroll brings me back to my first official date with my now husband, how sauntering throughout an empty Washington Square Park during the fall was integral to the foundation of my own relationship. It was grounding for me to reflect on the way Nora built the chemistry of Harry and Sally's connection through this understated lens—how precious my own modern-day fairy tale was because it had happened this way, too. And how Nora's New York was a character in my own love story.

As Becky tells her best friend, Annie, in *Sleepless in Seattle*: "You don't want to be in love, you want to be in love in a movie."[2] I've come to accept that my own life will never be an exact replica of a Nora Ephron on-screen romance, but that there are elements of her rom-coms found in everyday life. That line from Becky lives on as an adage that encompasses Nora's vision of love through her movies—an everlasting note from Nora to Nora and all her adoring fans. The screen legend made generations of women believe that life could be a movie—a love story filled with grief, loss, loneliness, and the possibility of a grand gesture worthy of your own silver-screen moment. And to me, that's her legacy.

Acknowledgments

It has been a long journey to make this book come to life. First and foremost, I have to thank my wonderful literary agent, Abby Walters. You championed me and helped me navigate this roller-coaster ride with your unwavering sense of optimism and wisdom along the way.

To my editors, Asha Simon and Holly Dolce: thank you for the thoughtful edits and guidance throughout the writing process. You challenged me and made me a more incisive writer, and for that I'm grateful. This book wouldn't have been possible without Meredith Clark, who approached me about writing it back in 2021. You knew a rom-com-obsessed gal when you saw her. To the design team at Abrams: the book is a stunner. You knocked the Nora Ephron fall aesthetic out of the park.

To my colleagues and friends: Kathy Iandoli, you are one of the most generous authors out there. You didn't have to talk to me on the phone for three hours straight, but you did it anyway and helped me find faith in myself. You are a real one. Maria Sherman, you are one of my favorite humans and writers of all time. Thank you for imparting your knowledge about the publishing process to me and talking me down from my panic attacks. Endless thanks to Annie Zaleski, Gerrick Kennedy, and Alison Jo Rigney for guiding me through the endless abyss of image licensing. Jason Newman, thank you for being a guiding light in the media space for me and so many other writers trying to find their way. Not sure I would have gotten to this point without people like you in my corner. Thank you to Rob Sheffield; you are the reason I became a writer at all.

Jason Diamond, you are a mensch! Thank you for generously lending your voice to the foreword of this book. You made Nora proud. Samantha Leach, you are an undeniably great connector of people and so kindly introduced me to Abby. Kristin Marguerite Doidge, you wrote the Nora bible for us all! Thank you for your moral support and for giving me some much-needed encouragement as I navigated all things Nora. Margaret Abrams, not only are you a wonderful friend, but you've been an incredible sounding board and peer editor.

Thank you to all the folks who took the time to speak with me for this project: Andie MacDowell, Jennifer Kaytin Robinson, Mark Ricker, Lauren Shuler Donner, Meg Wolitzer, Susan Seidelman, Lynda Obst, Dan Davis, Heather Burns, Lorraine Calvert, and Andrew Lazar. I appreciate it more than you know.

A big thanks and giant hug to all of my friends who listened to my worries as I navigated this process—and planned a wedding at the same time: Robyn Doane, Amanda Rich, Shuhan Hu, Leah Rodriguez, Marissa Muller, Rachel Brodsky, Sarah Avrin, Mike Tse, Bobby Irven, Royi Gavrielov, Keaton Bell, Elle Dwyer, Jack Irvin, Kailyn Dabkowski, Owen Myers, Avery Stone, Allison Schulz, Rachael Feeney, Chelsea Herman-Hill, Cole Hill, Anna Stodart, Brittany Spanos, and Erica Russell.

To the Kaplans and Schultzes: I am so lucky to have such a supportive family that cheers me on from afar. Jan and Charlie Schultz and Betty Gabriel: thank you for always supporting me and reading my words (even if you're not familiar with the person I'm writing about). Uncle Reese and Aunt Viv: thank you for always inspiring my sense of creativity and wonder; it has impacted my life more than you know. Mom and Dad: thank you for always encouraging me to follow my wildest dreams and fostering my sense of ambition. You've always been my biggest cheerleaders, and for that I'm so thankful. I hope I made you proud.

Last but not least, thank you to my husband, Derrick, for bearing with me while I simultaneously wrote this book and planned our wedding. You are my favorite person to hang out with, my moral compass, and the best cat dad. You are the Harry to my Sally if Harry were not chauvinistic and were covered in tattoos. Thank you for putting up with your neurotic wife.

Notes

INTRODUCTION

1. Megan Garber, "Nora Ephron: Prophet of Privacy," *Atlantic*, March 23, 2016, https://www.theatlantic.com/entertainment/archive/2016/03/nora-ephron-prophet-of-privacy/475011/.

2. Zachary Petit, "Remembering Nora Ephron: Before All the Hollywood Success," *Writer's Digest*, June 27, 2012, https://www.writersdigest.com/whats-new/remembering-nora-ephron-before-all-the-hollywood-success.

3. Charles McGrath, "Nora Ephron Dies at 71; Writer and Filmmaker with a Genius for Humor," *New York Times*, June 27, 2012, https://www.nytimes.com/2012/06/27/movies/nora-ephron-essayist-screenwriter-and-director-dies-at-71.html.

4. Hallie Ephron, "Coming of Age with the Ephron Sisters—and Their Mother," Oprah.com, February 22, 2013, https://www.oprah.com/spirit/nora-ephrons-mother-hallie-ephron-essay/all.

5. Ephron, "Coming of Age."

6. Nora Ephron, "Dorothy Parker," in *Crazy Salad: Some Things About Women* (New York: Alfred A. Knopf, 1975).

7. Nell Beram, "The Troubled Marriage That Inspired Nora Ephron," Salon, August 17, 2013, https://www.salon.com/2013/08/18/the_troubled_marriage_that_inspired_nora_ephron/.

8. Ronald Bergen, "Nora Ephron Obituary," *Guardian*, June 27, 2012, https://www.theguardian.com/film/2012/jun/27/nora-ephron.

9. Wellesley College, "Nora Ephron speaking at Wellesley College Commencement 1996," YouTube, 2012, https://www.youtube.com/watch?v=DVCfFBlKpN8.

10. Kristin Marguerite Doidge, *Nora Ephron: A Biography* (Chicago: Chicago Review Press, 2023).

11. Lou Lumenick, "DVD Extra: 'Take Her, She's Mine,'" *New York Post*, October 15, 2012, https://nypost.com/2012/10/15/dvd-extra-take-her-shes-mine/.

12. Doidge, *Nora Ephron*; and Garry Wills, "How to Repossess a Life: Nora Ephron," *Time*, January 27, 1992, https://content.time.com/time/subscriber/article/0,33009,974746-3,00.html.

13. Lumenick, "DVD Extra"; and *Take Her, She's Mine*, Concord Theatricals (n.d.), https://www.concordtheatricals.com/p/3850/take-her-shes-mine.

14. Jessica Bennett and Jesse Ellison, "Tea with Nora Ephron, and Talk of Newsweek and Women Writers," Daily Beast, July 14, 2017, https://www.thedailybeast.com/tea-with-nora-ephron-and-talk-of-newsweek-and-women-writers.

15. "Nora Ephron," Britannica.com, June 22, 2023, https://www.britannica.com/biography/Nora-Ephron.

16. "You've Got Rapture," Oprah.com, June 15, 2002, https://www.oprah.com/omagazine/nora-ephrons-books-that-made-a-difference/all.

17. Nora Ephron, "A Few Words About Elizabeth Bennet," in *Nora Ephron Collected* (New York: Avon Books, 1991).

18. *You've Got Mail*, directed by Nora Ephron, 1998, Warner Bros.

19. "Nora Ephron's Favorite Love Stories," Austin Film Society, May 13, 2019, https://www.austinfilm.org/2016/05/nora-ephrons-favorite-love-stories/.

20. Nora Ephron, "Nora Ephron's Favorite Love Stories," Daily Beast, October 10, 2019, https://www.thedailybeast.com/nora-ephrons-favorite-love-stories.

21. Jake Rossen, "9 Movies That Are Remakes of Remakes," Mental Floss, August 17, 2016, https://www.mentalfloss.com/article/84669/9-movies-are-remakes-remakes.

22. Meredith Blake, "Legacies: An Honest, Confident Voice Set Nora Ephron Apart," *Los Angeles Times*, July 7, 2012, https://www.latimes.com/entertainment/tv/la-xpm-2012-jul-07-la-et-st-nora-ephron-legacy-20120708-story.html#:~:text=%E2%80%9CHer%20movies%20took%20interesting%2C%20complicated,Traister%2C%20only%20half%2Djoking.

PROLOGUE: REINVENTING THE ROM-COM

1. Caroline Siede, "After When Harry Met Sally, Almost Every Rom-Com Tried to Have What Nora Ephron Was Having," A.V. Club, March 16, 2018, https://www.avclub.com/after-when-harry-met-sally-almost-every-rom-com-tried-1823690771.

2. Scott Meslow, *From Hollywood with Love: The Rise and Fall (and Rise Again) of the Romantic Comedy* (New York: Dey Street Books, 2022), 2.

3. Annie Lord, "Five Aspects of Pretty Woman That Didn't Age Well," *Independent*, March 23, 2020, https://www.independent.co.uk/arts-entertainment/films/features/pretty-woman-julia-roberts-richard-gere-shopping-scene-restaurant-a9413636.html.

4. Kate Erbland, "The Rom-Com Boom Owed Everything to Its Leading Ladies," IndieWire, August 18, 2022, https://www.indiewire.com/features/general/rom-coms-90s-women-1234750886/; Box Office Mojo, "Pretty Woman," accessed November 14, 2023, https://www.boxofficemojo.com/release/rl2439742977/weekend/.

5. Shanna Yehlen, "A Brief History of Romantic Comedies," *Glamour*, February 14, 2016, https://www.glamour.com/story/a-brief-history-of-romantic-co.

6. Ringer Staff, "The 50 Best Rom-Coms since 1970," Ringer, April 18, 2022, https://www.theringer.com/movies/2022/4/18/23026994/rom-com-movies-ranking.

7. Andrew O'Hehir, "Nora Ephron's Romantic-Comedy Revolution," Salon, June 27, 2012, https://www.salon.com/2012/06/27/nora_ephrons_romantic_comedy_revolution/.

8. Erin Carlson, *I'll Have What She's Having: How Nora Ephron's Three Iconic Films Saved the Romantic Comedy* (New York: Hachette Books, 2018).

9. O'Hehir, "Nora Ephron's Romantic-Comedy Revolution."

10. Rob Reiner, "Rob Reiner Remembers Nora Ephron, the Sally to His Harry," Daily Beast, July 14, 2017, https://www.thedailybeast.com/rob-reiner-remembers-nora-ephron-the-sally-to-his-harry.

11. Bethany Edwards, "This Is the Best Modern Rom-Com for Nora Ephron Vibes," Collider, August 6, 2023, https://collider.com/best-modern-rom-com-i-want-you-back/.

12. Ronald Bergan, "Nora Ephron Obituary," *Guardian*, June 27, 2012, https://www.theguardian.com/film/2012/jun/27/nora-ephron.

13. Caroline Siede, "It's No Strings Attached versus Friends with Benefits in a Rom-Com Showdown," A.V. Club, August 30, 2019, https://www.avclub.com/it-s-no-strings-attached-versus-friends-with-benefits-i-1837518578.

14. Dino-Ray Ramos, "'Sleeping with Other People' vs. 'When Harry Met Sally' Proves That Platonic Relationships Are Always in Style," Bustle, September 11, 2015, https://www.bustle.com/articles/109226-sleeping-with-other-people-vs-when-harry-met-sally-proves-that-platonic-relationships-are-always-in.

15. Ashley Spencer, "'While You Were Sleeping' Turns 25: An Oral History of the Sandra Bullock Rom-Com Favorite," *Washington Post*, April 23, 2020, http://washingtonpost.com/lifestyle/style/while-you-were-sleeping-sandra-bullock-oral-history/2020/04/20/13f37222-7e8b-11ea-9040-68981f488eed_story.html.

16. Meghan Winch, "Sandra Bullock's 'While You Were Sleeping' Should Be a Holiday Go-To," Collider, December 22, 2022, https://collider.com/sandra-bullock-while-you-were-sleeping-rom-com/.

17. Advaita Kala, "A New Playbook for Romance in a Film That Successfully Deals with Mental Illness," *Daily Mail*, March 4, 2013, https://www.dailymail.co.uk/indiahome/article-2288105/Silver-Linings-Playbook-film-successfully-deals-mental-illness.html/ .

18. Philip French, "Serendipity," *Guardian*, December 23, 2001, https://www.theguardian.com/film/News_Story/Critic_Review/Observer_review/0,,624100,00.html.

19. Mary Elizabeth Williams, "Randall Park Plays 'the Closest Thing to Me' in 'Always Be My Maybe,'" Salon, August 28, 2019, https://www.salon.com/2019/06/08/randall-park"-plays-the-closest-thing-to-me-in-always-be-my-maybe/.

20. Olivia Singh, "The 'To All the Boys' Author Shares the 7 Romantic Movies to Watch If You Love the Series," Insider, February 12, 2021, https://www.insider.com/to-all-the-boys-author-jenny-han-favorite-romantic-movies-2021-2.

21. Francesca Babb, "Nancy Meyers: The Rom-Com Queen," *Independent*, January 9, 2010, https://www.independent.co.uk/arts-entertainment/films/features/nancy-meyers-the-romcom-queen-1862430.html.

22. Amy Kaufman, "It's Not Complicated: Nancy Meyers Is a Perfectionist," *Los Angeles Times*, December 26, 2009, https://www.latimes.com/archives/la-xpm-2009-dec-26-la-et-meyers26-2009dec26-story.html.

23. Haley Mlotek, "A Presentation of Seamlessness: A Roundtable Discussion on Nancy Meyers," Hairpin, August 1, 2017, https://www.thehairpin.com/2015/09/a-presentation-of-seamlessness-a-roundtable-discussion-on-nancy-meyers/.

24. Daphne Merkin, "Can Anybody Make a Movie for Women?" *New York Times*, December 15, 2009, https://www.nytimes.com/2009/12/20/magazine/20Meyers-t.html.

25. Mlotek, "A Presentation of Seamlessness."

26. O'Hehir, "Nora Ephron's Romantic-Comedy Revolution."

27. Patricia Garcia, "Is Gillian Robespierre Our Generation's Nora Ephron?" *Vogue*, July 28, 2017, https://www.vogue.com/article/gillian-robespierre-interview.

28. Brent Lang, "Billy Eichner Is Here to Fight Hollywood Homophobia and Fulfill Your Gay Rom-Com Dreams," *Variety*, 2022, https://variety.com/2022/film/features/billy-eichner-bros-romcom-lgbtq-cast-1235353964/.

29. O'Hehir, "Nora Ephron's Romantic-Comedy Revolution."

30. Leah Asmelash, "A Genre Reborn: Inside the Evolution of the Rom-Com," CNN, August 29, 2021, https://www.cnn.com/2021/08/29/entertainment/romantic-comedy-evolution-trnd/index.html.

CHAPTER 1: ROM-COMS

When Harry Met Sally

1. Rob Reiner, "Rob Reiner Remembers Nora Ephron, the Sally to His Harry," Daily Beast, July 14, 2017, https://www.thedailybeast.com/rob-reiner-remembers-nora-ephron-the-sally-to-his-harry.

2. Scott Meslow, *From Hollywood with Love: The Rise and Fall (and Rise Again) of the Romantic Comedy* (New York: Dey Street Books, 2022), 5–7.

3. FilMagicians, "When Harry Met Sally Discussion with Nora Ephron & Rob Reiner," YouTube, 2017, https://www.youtube.com/watch?v=q5-j7K8Mbzk.

4. Meslow, *From Hollywood with Love*, 11.

5. Billy Crystal, as told to Ashley Lee, "Billy Crystal: How Rob Reiner and I Built a Bromance of Four Decades (Guest Column)," *Hollywood Reporter*, September 8, 2016, https://www.hollywoodreporter.com/movies/movie-news/billy-crystal-how-rob-reiner-926344/.

6. Marlow Stern, "'When Harry Met Sally' Turns 25: Director Rob Reiner Reveals the Secrets of the Romcom Classic," Daily Beast, July 12, 2017, https://www.thedailybeast.com/when-harry-met-sally-turns-25-director-rob-reiner-reveals-the-secrets-of-the-romcom-classic.

7. Richard Cohen, *She Made Me Laugh: My Friend Nora Ephron* (New York: Simon & Schuster, 2016).

8. Lisa Bonos, "Analysis | 'I'll Have What She's Having': How That Scene from 'When Harry Met Sally . . .' Changed the Way We Talk about Sex," *Washington Post*, July 12, 2019, https://www.washingtonpost.com/lifestyle/2019/07/12/ill-have-what-shes-having-how-that-scene-when-harry-met-sally-changed-way-we-talk-about-sex/.

9. Roger Ebert, "When Harry Met Sally . . . ," RogerEbert.com, July 12, 1989, https://www.rogerebert.com/reviews/when-harry-met-sally—-1989.

10. Terrence Rafferty, "Eighties Hollywood: Lies, Lies, and More Lies," *New Yorker*, July 31, 1989, http://www.newyorker.com/archive/1989/08/07/1989_08_07_073_TNY_CARDS_000136866.

11. Box Office Mojo, "When Harry Met Sally . . . ," accessed July 28, 2023, https://www.boxofficemojo.com/release/rl1196852737/weekend/.

12. Cheryl Lu-Lien Tan, "'When Harry Met Sally': For Some, It's Become a Film Icon," *Seattle Times*, February 16, 2001, https://archive.seattletimes.com/archive/?date=20010216&slug=harry16. hive/1989/08/07/1989_08_07_073_TNY_CARDS_000136866.

Sleepless in Seattle

13. Ree Hines, "Meg Ryan Shares How She Really Felt about Being Called 'America's Sweetheart,'" TODAY.com, June 11, 2018, https://www.today.com/popculture/meg-ryan-opens-gwyneth-paltrow-about-america-s-sweetheart-t130650.

14. E. Nina Rothe, "Meg Ryan: How a Hollywood 'Girl next Door' Came of Age," National News, August 6, 2018, https://www.thenationalnews.com/arts-culture/film/meg-ryan-how-a-hollywood-girl-next-door-came-of-age-1.757453.

15. Luchina Fisher, "How 'Sleepless in Seattle' and Nora Ephron Changed Romantic Comedies 25 Years Ago," *Good Morning America*, June 25, 2018, https://www.goodmorningamerica.com/gma/story/sleepless-seattle-nora-ephron-changed-romantic-comedies-25-56092785.

16. American Film Institute, "Nora Ephron on Writing Sleepless in Seattle," YouTube, 2020, https://youtu.be/98fFUH0HVsk.

17. Sony Pictures Home Entertainment, "Sleepless in Seattle (1993) discussion with Meg Ryan & Gary Foster," YouTube, 2020, https://www.youtube.com/watch?v=MPbsEJjpT88.

18. Erin Carlson, *I'll Have What She's Having: How Nora Ephron's Three Iconic Films Saved the Romantic Comedy* (New York: Hachette Books, 2018).

19. Sony Pictures Home Entertainment, "Sleepless in Seattle (1993) discussion."

20. American Film Institute, "Nora Ephron on Writing Sleepless in Seattle."

21. Vincent Canby, "Review/Film; When Sam Met Annie, or When Two Meet Cute," *New York Times*, June 25, 1993, https://www.nytimes.com/1993/06/25/movies/review-film-when-sam-met-annie-or-when-two-meet-cute.html.

22. Peter Travers, "Sleepless in Seattle," *Rolling Stone*, June 25, 1993, https://www.rollingstone.com/tv-movies/tv-movie-reviews/sleepless-in-seattle-120253/.

You've Got Mail

23. Erin Carlson, "You've Got Nora: A Valentine's Day Tribute to Nora Ephron," *Vanity Fair*, February 13, 2015, https://www.vanityfair.com/hollywood/2015/02/youve-got-mail-oral-history.

24. Benjamin Svetkey, "See Meg Ryan and Tom Hanks' 'You've Got Mail' EW Cover in Honor of the 20th Anniversary," EW.com, December 18, 2018, https://ew.com/movies/2018/12/18/tom-hanks-meg-ryan-youve-got-mail-ew-cover/.

25. Svetkey, "See Meg Ryan and Tom Hanks' 'You've Got Mail' EW Cover."

26. David Ng, "'Parfumerie,' a 1936 Hungarian Play, Is an Overlooked Inspiration," *Los Angeles Times*, November 27, 2013, https://www.latimes.com/entertainment/arts/culture/la-et-cm-parfumerie-play-20131127-story.html.

27. Svetkey, "See Meg Ryan and Tom Hanks' 'You've Got Mail' EW Cover."

28. Meagan Day, "The Romance of American Clintonism," *Jacobin*, October 21, 2020, https://jacobin.com/2020/10/youve-got-mail-nineties-films-rom-coms-capitalism.

29. Kathryn Lindsay, "You Can Still Visit These Iconic Locations from 'You've Got Mail,'" You've Got Mail NYC Filming Locations, Walking

Tour Map, December 18, 2018, https://www.refinery29.com/en-us/2018/12/219771/youve-got-mail-nyc-tour-map-bookstore-location.

30. Lael Loewenstein, "You've Got Mail," *Variety*, December 14, 1998, https://variety.com/1998/film/reviews/you-ve-got-mail-1200456233/.

31. Roger Ebert, "You've Got Mail," RogerEbert.com, December 18, 1988, https://www.rogerebert.com/reviews/youve-got-mail-1998.

32. Michael O'Sullivan, "'Mail:' Pushing Your Buttons," *Washington Post*, December 18, 1988, https://www.washingtonpost.com/wp-srv/style/movies/reviews/youvegotmailosullivan.htm.

CHAPTER 2: RESILIENCE

This Is My Life

1. Andy Marx, "Movies: This Is Her Life, Too: Screenwriter and Working Mother Nora Ephron Recognized Herself in Meg Wolitzer's Novel—and Seized the Chance to Direct the Movie," *Los Angeles Times*, February 16, 1992, https://www.latimes.com/archives/la-xpm-1992-02-16-ca-4653-story.html.

2. Marx, "Movies: This Is Her Life, Too."

3. Meredith Berkman, "Nora Ephron's 'This Is My Life,'" EW.com, March 6, 1992, https://ew.com/article/1992/03/06/nora-ephrons-this-my-life/.

4. Paula Span, "Nora Ephron, Born to Be Bossy," *Washington Post*, March 6, 1992, https://www.washingtonpost.com/archive/lifestyle/1992/03/06/nora-ephron-born-to-be-bossy/32c5fdca-f3ea-4d8e-be4e-389916ff2558/.

5. Lena Dunham, "Seeing Nora Everywhere," *New Yorker*, June 28, 2012, https://www.newyorker.com/culture/culture-desk/seeing-nora-everywhere.

6. The Bobbie Wygant Archive, "Julie Kavner & Nora Ephron 'This Is My Life' 1992 - Bobbie Wygant Archive," YouTube, 2020, https://www.youtube.com/watch?v=usAlS_LBjEw.

7. IMDb, "This Is My Life," February 21, 1992, https://www.imdb.com/title/tt0105577/.

8. Roger Ebert, "This Is My Life," RogerEbert.com, March 6, 1992, https://www.rogerebert.com/reviews/this-is-my-life-1992.

9. Owen Gleiberman, "This Is My Life," EW.com, February 28, 1992, https://ew.com/article/1992/02/28/this-my-life/.

10. The Bobbie Wygant Archive, "Julie Kavner & Nora Ephron."

11. Janet Maslin, "Review/Film; Being Both Monstrous and Charming," *New York Times*, February 21, 1992, https://www.nytimes.com/1992/02/21/movies/review-film-being-both-monstrous-and-charming.html.

Silkwood

12. John Blades, "When Nora Met Alice . . . ," *Chicago Tribune*, February 13, 1990, https://www.chicagotribune.com/news/ct-xpm-1990-02-13-9001130053-story.html.

13. "The 56th Academy Awards: 1984," Oscars.org, accessed July 28, 2023, https://www.oscars.org/oscars/ceremonies/1984.

14. Chris Hall, "From the Archive: Meryl Streep as Karen Silkwood, 1984," *Guardian*, February 23, 2020, https://www.theguardian.com/lifeandstyle/2020/feb/23/from-the-archive-meryl-streep-as-muclear-whistleblower-karen-silkwood-1984-mike-nichols-film.

15. Roger Ebert, "Silkwood," RogerEbert.com, December 14, 1983, https://www.rogerebert.com/reviews/silkwood-1983.

16. Ebert, "Silkwood."

17. Neda Ulaby, "Ephron: From 'Silkwood' to 'Sally,' a Singular Voice," NPR, June 27, 2012, https://www.npr.org/2012/06/27/155809446/ephron-from-silkwood-to-sleepless-a-deft-touch.

18. Chris Hall, "From the Archive."

19. Mark Harris, "Am I Doing This Right? (1981–1982)," chapter 22 in *Mike Nichols: A Life* (New York: Penguin, 2021).

20. Gary Arnold, "Silkwood as Saint and Sinner," *Washington Post*, December 14, 1983, https://www.washingtonpost.com/archive/lifestyle/1983/12/14/silkwood-as-saint-and-sinner/a2b332c3-ca81-4ac9-92c7-98962486ca7d/.

21. Janet Maslin, "Cher Hoping 'Silkwood' Is Her Turning Point," *New York Times*, January 7, 1984, https://www.nytimes.com/1984/01/07/arts/cher-hoping-silkwood-is-her-turning-point.html.

22. IMDb, "Silkwood," January 27, 1984, https://www.imdb.com/title/tt0086312/.

23. Vincent Canby, "Film: Karen Silkwood's Story," *New York Times*, December 14, 1983, https://www.nytimes.com/1983/12/14/movies/film-karen-silkwood-s-story.html.

24. Duane Byrge, "'Silkwood': THR's 1983 Review," *Hollywood Reporter*, November 22, 2014, https://www.hollywoodreporter.com/news/general-news/silkwood-review-1983-movie-751496/.

CHAPTER 3: PERSONAL PAIN

Heartburn

1. Chuck Conconi, "Divorce with a Heartburn Clause," *Washington Post*, June 28, 1985, https://www.washingtonpost.com/archive/lifestyle/1985/06/28/divorce-with-a-heartburn-clause/7c454cdc-09f3-4f4a-b72c-4c1959402030/.

2. Nora Ephron, *Heartburn* (New York: Vintage Contemporaries, 1996), 13.

3. Mark Harris, "A Shot Across the Bow (1985–1986)," chapter 24 in *Mike Nichols: A Life* (New York: Penguin, 2021).

4. Harris, *Mike Nichols: A Life*.

5. Harris, *Mike Nichols: A Life*.

6. Alex Witchel, "Mandy Patinkin: 'I Behaved Abominably,'" *New York Times*, August 21, 2013, https://www.nytimes.com/2013/08/25/magazine/mandy-patinkin-i-behaved-abominably.html.

7. Harris, *Mike Nichols: A Life*.

8. Box Office Mojo, "Heartburn," accessed July 29, 2023, https://www.boxofficemojo.com/release/rl2253817345/weekend/.

9. Roger Ebert, "Heartburn," RogerEbert.com, July 25, 1986, https://www.rogerebert.com/reviews/heartburn-1986.

10. Walter Goodman, "Screen: 'Heartburn,' Streep and Nicholson," *New York Times*, July 25, 1986, https://www.nytimes.com/1986/07/25/movies/screen-heartburn-streep-and-nicholson.html.

11. Paul Attanasio, "Movies," *Washington Post*, July 25, 1986, https://www.washingtonpost.com/archive/lifestyle/1986/07/25/movies/471d2bf2-1d33-4f2a-bd0c-1d0fb9de0e88/.

Hanging Up

12. Irene Lacher, "Daddy's Girl: When Delia Ephron's Father Faced Death, It Was Her He Called. And Called. Writing a Novel Helped Her Come to Terms with Their Painful Relationship," *Los Angeles Times*, August 24, 1995, https://www.latimes.com/archives/la-xpm-1995-08-24-ls-38661-story.html.

13. Lacher, "Daddy's Girl."

14. Hallie Ephron, "Coming of Age with the Ephron Sisters-and Their Mother," Oprah.com, February 22, 2013, https://www.oprah.com/spirit/nora-ephrons-mother-hallie-ephron-essay/all.

15. Andrea Cuttler, "Delia Ephron on Sister, Mother, Husband, Dog and the Challenges of Collaborating with Nora," *Vanity Fair*, October 30, 2013, https://www.vanityfair.com/culture/2013/10/delia-ephron-nora.

16. Lacher, "Daddy's Girl."

17. EW Staff, "Hanging Up," EW.com, February 11, 2000, https://ew.com/article/2000/02/11/hanging/.

18. Kevin Courrier, "Hanging Up: Diane Keaton Directs Herself in Sister Act," Tribute, https://www.tribute.ca/magazines/tribute/12000/hanging_up.htm.

19. The Numbers, "Hanging Up (2000) - Financial Information," accessed July 29, 2023, https://www.the-numbers.com/movie/Hanging-Up#tab=summary.

20. Peter Bradshaw, "Hanging Up," *Guardian*, May 12, 2000, https://www.theguardian.com/film/2000/may/12/culture.reviews.

21. Stephen Holden, "'Hanging Up': Cell Phone Frolics, and Dear, Ditsy Dad," *New York Times*, February 17, 2000, https://archive.nytimes.com/www.nytimes.com/library/film/021800hanging-film-review.html#:~:text=Maddy%20is%20the%20slightly%20lost,with%20a%20misty%2Deyed%20hug.

22. Roger Ebert, "Hanging Up," RogerEbert.com, February 18, 2000, https://www.rogerebert.com/reviews/hanging-up-2000.

CHAPTER 4: UNDER THE RADAR

Cookie

1. Myra Forsberg, "Susan Seidelman's Recipe for 'Cookie,'" *New York Times*, May 29, 1988, https://www.nytimes.com/1988/05/29/movies/film-susan-seidelman-s-recipe-for-cookie.html.

2. Forsberg, "Susan Seidelman's Recipe for 'Cookie.'"

3. IMDb, "Cookie," August 23, 1989, https://www.imdb.com/title/tt0097109/.

4. Roger Ebert, "Cookie," RogerEbert.com, September 15, 1989, https://www.rogerebert.com/reviews/cookie-1989.

5. Sheila Benson, "MOVIE REVIEW: 'Cookie's' Frail Farce Crumbles Under Heavy Plot Line," *Los Angeles Times*, September 15, 1989, latimes.com/archives/la-xpm-1989-09-15-ca-91-story.html.

My Blue Heaven

6. Dave Davies, "A Laugh A Minute, On Screen And In Life," *Fresh Air*, NPR/WNYC, June 27, 2012, https://www.npr.org/2012/06/27/155841542/a-laugh-a-minute-on-screen-and-in-life.

7. Davies, "A Laugh A Minute."

8. Henry Hill and Gus Russo, *Gangsters and Goodfellas: Wiseguys . . . and Life on the Run* (Edinburgh, Scotland: Mainstream, 2004).

9. John M. Wilson, "The Movies: The Fine Art of Making the Deal," *Los Angeles Times*, June 2, 1990, https://www.latimes.com/archives/la-xpm-1990-05-27-tm-441-story.html.

10. *My Blue Heaven* production notes, quoted in chapter 13 of Kristin Marguerite Doidge, *Nora Ephron: A Biography* (Chicago: Chicago Review Press, 2023), 116, S.1.

11. Wilson, "The Movies."

12. Tyler Coates, "'Goodfellas' and 'My Blue Heaven' Are About the Same Infamous Mobster," Decider, November 18, 2015, https://decider.com/2015/11/18/goodfellas-my-blue-heaven-henry-hill/.

13. *My Blue Heaven* production notes.

14. Megan Garber, "Crime and 'A-Ru-Gula': Revisiting 'My Blue Heaven' at 25," *Atlantic*, August 18, 2015, https://www.theatlantic.com/entertainment/archive/2015/08/a-ru-gula-25-years-of-my-blue-heaven/401531/.

15. Caryn James, "Review/Film; When Heaven Turns Out Not to Be," August 18, 1990, https://www.nytimes.com/1990/08/18/movies/review-film-when-heaven-turns-out-not-to-be.html.

16. Owen Gleiberman, "My Blue Heaven," EW.com, August 31, 1990, https://ew.com/article/1990/08/31/my-blue-heaven-2/.

17. Sheila Benson, "Movie Reviews: Thank 'My Blue Heaven' for Bill Irwin," *Los Angeles Times*, August 20, 1990, https://www.latimes.com/archives/la-xpm-1990-08-20-ca-826-story.html.

Mixed Nuts

18. Jacqueline Cutler, "Nora Ephron's Life and Legacy Celebrated in New Book," New York *Daily News*, July 7, 2022, https://www.nydailynews.com/entertainment/ny-nora-ephron-biography-20220707-qnhlgcz24rbtzgaewysa4qvj6e-story.html.

19. Kristin Marguerite Doidge, *Nora Ephron: A Biography* (Chicago: Chicago Review Press, 2023), 137.

20. Jacqueline Cutler, "Nora Ephron's Life and Legacy Celebrated in New Book," New York *Daily News*, July 7, 2022, https://www.nydailynews.com/entertainment/ny-nora-ephron-biography-20220707-qnhlgcz24rbtzgaewysa4qvj6e-story.html; and "Martin, Ephron Pass 'Nuts' Insights Around," *Morning Call*, October 3, 2021, https://www.mcall.com/1994/12/23/martin-ephron-pass-nuts-insights-around/.

21. "Martin, Ephron Pass 'Nuts' Insights Around."

22. Variety Staff, "Mixed Nuts," *Variety*, January 1, 1994, https://variety.com/1993/film/reviews/mixed-nuts-1200435509/.

23. Roger Ebert, "Mixed Nuts," RogerEbert.com, December 21, 1994, https://www.rogerebert.com/reviews/mixed-nuts-1994.

24. Janet Maslin, "Hysterics All Dressed Up for the Holidays," *New York Times*, December 21, 1994, https://www.nytimes.com/1994/12/21/movies/film-review-hysterics-all-dressed-up-for-the-holidays.html.

Michael

25. *Michael* production notes, quoted in chapter 17 of Kristin Marguerite Doidge, *Nora Ephron: A Biography* (Chicago: Chicago Review Press, 2023), 144–47, S.l.

26. *Michael* production notes.

27. *Michael* production notes.

28. The Bobbie Wygant Archive, "John Travolta 'Michael' 11/23/96 - Bobbie Wygant Archive," YouTube, July 7, 2021, https://www.youtube.com/watch?v=C2gLhPMr3yE.

29. *Michael* production notes.

30. The Numbers, "Michael (1996) - Financial Information," accessed July 29, 2023, https://www.the-numbers.com/movie/Michael-(1996)#tab=summary.

31. Emanuel Levy, "Michael," *Variety*, January 5, 1997, https://variety.com/1997/film/reviews/michael-3-1200448615/.

32. Kevin Thomas, "'Michael': Inspired Blend of Fantasy, Comedy," *Los Angeles Times*, December 25, 1996, https://www.latimes.com/archives/la-xpm-1996-12-25-ca-12362-story.html.

Lucky Numbers

33. "Lucky Numbers," *Charlie Rose*, 2000, https://charlierose.com/videos/29937.

34. "Nick Perry, 86; Radio Star Jailed for Fixing Pennsylvania Lottery," *Los Angeles Times*, April 29, 2003, https://www.latimes.com/archives/la-xpm-2003-apr-29-me-passings29.1-story.html.

35. Mike Sullivan, "How a Good Script Becomes a Bad Movie: The Inside Story of 'Lucky Numbers,'" Vulture, September 1, 2015, https://www.vulture.com/2015/09/how-a-good-script-becomes-a-bad-movie-the-inside-story-of-lucky-numbers.html.

36. Sullivan, "How a Good Script Becomes a Bad Movie."

37. "Lucky Numbers," *Charlie Rose*.

38. "John Travolta Gets 'Lucky' After 'Battlefield' Setback," *Morning Call*, October 4, 2021, https://www.mcall.com/2000/10/27/john-travolta-gets-lucky-after-battlefield-setback/.

39. Box Office Mojo, "Lucky Numbers," accessed July 29, 2023, https://www.boxofficemojo.com/release/rl2086700545/weekend/.

40. Roger Ebert, "Lucky Numbers," RogerEbert.com, October 27, 2000, https://www.rogerebert.com/reviews/lucky-numbers-2000.

41. Elvis Mitchell, "It Sure Takes More Than a Dollar and a Dream," *New York Times*, October 27, 2000, https://www.nytimes.com/2000/10/27/movies/film-review-it-sure-takes-more-than-a-dollar-and-a-dream.html.

42. Michael O'Sullivan, "Get 'Lucky,'" *Washington Post*, October 27, 2000, https://www.washingtonpost.com/archive/lifestyle/2000/10/27/get-lucky/63e3d238-6e60-4999-9c73-dad7b24ac2ab/.

43. O'Sullivan, "Get 'Lucky.'"

Bewitched

44. "Bewitched," *Charlie Rose*, 2005, https://charlierose.com/videos/10101.

45. Ed Leibowitz, "Hexed in Hollywood: How a Film Mirrors Its Subject," *New York Times*, May 8, 2005, https://www.nytimes.com/2005/05/08/movies/moviesspecial/hexed-in-hollywood-how-a-film-mirrors-its-subject.html.

46. "Bewitched," *Charlie Rose*.

47. ScreenSlam, "Bewitched: Nicole Kidman Exclusive Interview ScreenSlam," YouTube, 2015, https://www.youtube.com/watch?v=c1-OQ1iCEjE.

48. "Bewitched," *Charlie Rose*.

49. Box Office Mojo, "Bewitched," accessed July 29, 2023, https://www.boxofficemojo.com/release/rl3510928897/

50. Manohla Dargis, "Trying to Update the 60's, Just a Twitch at a Time," *New York Times*, June 24, 2005, https://www.nytimes.com/2005/06/24/movies/trying-to-update-the-60s-just-a-twitch-at-a-time.html.

51. Brian Lowry, "Bewitched," *Variety*, June 17, 2005, https://variety.com/2005/film/markets-festivals/bewitched-2-1200525093/.

52. Roger Ebert, "Bewitched," RogerEbert.com, June 23, 2005, https://www.rogerebert.com/reviews/bewitched-2005.

CHAPTER 5: THE FINAL FILM

Julie & Julia

1. Kenneth Turan, "Culinary Sisterhood," *Los Angeles Times*, August 7, 2009, https://www.latimes.com/archives/

la-xpm-2009-aug-07-et-julie-julia7-story.html.

2. *Julie & Julia* production notes, quoted in chapter 22 of Kristin Marguerite Doidge, *Nora Ephron: A Biography* (Chicago: Chicago Review Press, 2023), 192, S.1.

3. "Full TimesTalks; Meryl Streep, Stanley Tucci & Nora Ephron," YouTube, 2012, https://www.youtube.com/watch?v=5Oqo_fFCkps.

4. *Julie & Julia* production notes.

5. "15 QS with Meryl Streep, Amy Adams and Nora Ephron of 'Julie & Julia,'" Hollywood.com, May 28, 2014, https://www.hollywood.com/general/15-qs-with-meryl-streep-amy-adams-and-nora-ephron-57178101.

6. Nora Ephron, "My Cookbook Crushes, by Nora Ephron," *New Yorker*, February 6, 2006, https://www.newyorker.com/magazine/2006/02/13/serial-monogamy.

7. Charles McGrath, "Nora Ephron Dies at 71; Writer and Filmmaker with a Genius for Humor," *New York Times*, June 27, 2012, https://www.nytimes.com/2012/06/27/movies/nora-ephron-essayist-screenwriter-and-director-dies-at-71.html.

8. Kyle Smith, "Nora Ephron's Dying Secret," *New York Post*, September 23, 2015, https://nypost.com/2015/09/23/why-nora-ephron-kept-her-fatal-illness-a-secret-until-the-end/.

9. Nikhita Venugopal, "'Food Is Love': Remembering Nora Ephron and 'Julie & Julia,'" Ringer, August 7, 2019, https://www.theringer.com/2019/8/7/20757318/nora-ephron-julie-and-julia-anniversary.

10. Megan McArdle, "Her Voice Sounded like Money . . . ," *Atlantic*, July 18, 2008, https://www.theatlantic.com/business/archive/2008/07/her-voice-sounded-like-money/3848/.

11. Debbie Cerda, "Interview: Julie Powell of 'Julie & Julia' | Slackerwood," Slackerwood, August 12, 2009, https://www.slackerwood.com/node/506.

12. Box Office Mojo, "Julie & Julia," accessed July 29, 2023, https://www.boxofficemojo.com/release/rl2740815361/.

13. Kenneth Turan, "Culinary Sisterhood."

14. Owen Gleiberman, "Julie & Julia," EW.com, August 7, 2009, https://

ew.com/article/2009/08/07/julie-julia-2/.

15. Dana Stevens, "Julie & Julia Reviewed," Slate, August 6, 2009, https://www.slate.com/articles/arts/movies/2009/08/julie_julia.html.

16. Jessica Chou, "Nora Ephron Secretly Published Cookbook, Not for Sale," Daily Meal, June 28, 2012, https://www.thedailymeal.com/nora-ephron-secretly-published-cookbook-not-sale/.

17. Rhianna Malas, "'Julie & Julia': The Beauty of Escapism and Food," Collider, November 4, 2022, https://collider.com/julie-and-julia-beauty-of-escapism-and-food/.

CHAPTER 6: BOOKS AND ESSAYS

1. Heather Havrilesky, "Slouching Toward Neck Trouble: How Nora Ephron Defined the Comic Spirit of New Journalism," *Bookforum*, December 18, 2013, https://www.bookforum.com/print/2004/how-nora-ephron-defined-the-comic-spirit-of-new-journalism-12469.

2. Julia Felsenthal, "Jacob Bernstein on Memorializing His Mom, Nora Ephron, in Everything Is Copy," *Vogue*, March 21, 2016, https://www.vogue.com/article/everything-is-copy-nora-ephron-jacob-bernstein-interview.

3. Karen Heller, "Nora Ephron's Novel 'Heartburn' Still Scorches 40 Years Later," *Washington Post*, February 23, 2023.

4. Nora Ephron, *Heartburn* (New York: Vintage Contemporaries, 1996).

5. Ephron, *Heartburn*, 4.

6. Ephron, *Heartburn*, 179.

7. Nora Ephron, "I Feel Bad About My Neck," in *I Feel Bad About My Neck: And Other Thoughts on Being a Woman* (New York: Alfred A. Knopf, 2006).

8. Ephron, "I Feel Bad About My Neck."

9. Nora Ephron, "I Hate My Purse," in *I Feel Bad About My Neck*.

10. Nora Ephron, "Journalism: A Love Story," in *I Remember Nothing: And Other Reflections* (New York: Vintage Books, 2010).

11. Nora Ephron, "I Just Want to Say: Teflon," in *I Remember Nothing: And Other Reflections*.

12. Nora Ephron, "The Six Stages of E-mail," in *I Remember Nothing: And Other Reflections*.

13. Nora Ephron, "A Few Words About Breasts," in *Crazy Salad: Some Things About Women* (New York: Alfred A. Knopf, 1975).

14. Ephron, "A Few Words About Breasts."

15. Nora Ephron, "The Girls in the Office," in *Crazy Salad: Some Things About Women*, 30.

16. Nora Ephron, "Dorothy Parker," in *Crazy Salad: Some Things About Women*, 131–34.

17. Nora Ephron, "The Littlest Nixon," in *Crazy Salad: Some Things About Women*.

18. Ephron, "The Littlest Nixon," 194.

19. Nora Ephron, "Dorothy Schiff and the New York Post," in *Scribble Scribble: Notes on the Media* (New York: Bantam Books, 1979), 168–69.

20. Nora Ephron, "Introduction," in *Wallflower at the Orgy* (New York: Bantam Books, 2007).

21. Nora Ephron, "Makeover: The Short, Unglamorous Saga of a New, Glamorous Me," in *Wallflower at the Orgy*, 57–59.

22. Nicole Cliffe, "RIP, Nora Ephron," Hairpin, June 27, 2012, https://www.thehairpin.com/2012/06/rip-nora-ephron/.

23. Nora Ephron, "A Sandwich, by Nora Ephron," *New Yorker*, August 12, 2002, https://www.newyorker.com/magazine/2021/09/06/magazine20020819a-sandwich.

24. Ephron, "A Sandwich, by Nora Ephron."

25. Nora Ephron, "What to Expect When You're Expecting Dinner," *New York Times*, September 13, 2006, https://www.nytimes.com/2006/09/13/opinion/13ephron.html.

26. Ephron, "What to Expect When You're Expecting Dinner."

CHAPTER 7: PLAYS

1. Nora Ephron, "Pentimento," in *I Remember Nothing: And Other Reflections* (New York: Vintage Books, 2010).

2. Elisabeth Vincentelli, "Not Everything Tastes Better with 'Hellman,'" *New York Post*, March 27, 2014, https://nypost.com/2014/03/26/not-everything-tastes-better-with-hellman/.

3. Herbert Mitgang, "Miss Hellman Suing a Critic For 2.25 Million; Was Discussing Novel 'I Barely Knew Her,'" *New York Times*, February 16, 1980, https://www.nytimes.com/1980/02/16/archives/miss-hellman-suing-a-critic-for-225-million-was-discussing-novel-i.html

4. Ephron, "Pentimento."

5. Franklin Foer, "The Libelous Truth," *New Republic*, November 16, 2023, https://newrepublic.com/article/91900/mary-mccarthy-lillian-hellman-libel-suit.

6. Ben Brantley, "Literary Lions, Claws Bared," *New York Times*, December 13, 2002, https://www.nytimes.com/2002/12/13/movies/theater-review-literary-lions-claws-bared.html.

7. Arifa Akbar, "Love, Loss and What I Wore Review – All Dressed Up by the Ephron Sisters," *Guardian*, May 19, 2020, https://www.theguardian.com/stage/2020/may/19/love-loss-and-what-i-wore-review-nora-delia-ephron-ilene-beckerman-92y.

8. Chris Jones, "Ephron Sisters' 'Love, Loss, and What I Wore' Is Dressed for Success in Chicago," *Chicago Tribune*, September 16, 2011, https://www.chicagotribune.com/ct-ae-0918-fall-theater-big-show-20110916-column.html.

9. Akbar, "Love, Loss and What I Wore Review."

10. Jay Reiner, "Love, Loss, and What I Wore - Theater Review," *Hollywood Reporter*, October 14, 2010, https://www.hollywoodreporter.com/movies/movie-reviews/love-loss-and-what-i-29593/#!

11. Akbar, "Love, Loss and What I Wore Review"; and Nora Ephron, Delia Ephron, and Ilene Beckerman, *Love, Loss and What I Wore* (New York: Dramatists Play Service, 2008).

12. Andrew Gans, "Lavin and Najimy Star in Aug. 2 Reading of Nora and Delia Ephron's Love, Loss, and What I Wore," playbill.com, accessed July 29, 2023, https://playbill.com/article/lavin-and-najimy-star-in-aug-2-reading-of-nora-and-delia-ephrons-love-loss-and-what-i-wore-com-152125.

13. Lynn Hirschberg, "The Many Lives of Natasha Lyonne," *W*, August 16, 2022, https://www.wmagazine.com/culture/natasha-lyonne-russian-doll-season-2-interview-dallas.

14. Hirschberg, "The Many Lives of Natasha Lyonne."

15. Ephron, Ephron, and Beckerman, *Love, Loss and What I Wore.*

16. Hilton Als, "Newsies," *New Yorker*, April 8, 2013, https://www.newyorker.com/magazine/2013/04/15/newsies.

17. David Firestone, "Mike McAlary, 41, Columnist with Swagger to Match City's," *New York Times*, December 26, 1998, https://www.nytimes.com/1998/12/26/nyregion/mike-mcalary-41-columnist-with-swagger-to-match-city-s.html.

18. Patrick Healy, "Tom Hanks, Broadway's New Kid," *New York Times*, February 20, 2013, https://www.nytimes.com/2013/02/24/theater/tom-hanks-in-lucky-guy-his-broadway-debut.html.

19. Healy, "Tom Hanks, Broadway's New Kid."

20. Nora Ephron, "Journalism: A Love Story," in *I Remember Nothing: And Other Reflections.*

21. Meagan Flynn, "Police and a Big-Time Columnist Called a Woman's 1994 Rape a 'Hoax.' Here's Why Police Are Now Apologizing," *Washington Post*, October 30, 2018, https://www.washingtonpost.com/nation/2018/10/30/police-big-time-columnist-called-womans-rape-hoax-heres-why-police-are-now-apologizing/.

22. Flynn, "Police and a Big-Time Columnist Called a Woman's 1994 Rape a 'Hoax.'"

23. Elisabeth Vincentelli, "Tom Hanks Revives Old-School NY Tabloids in Nora Ephron's 'Lucky Guy,'" *New York Post*, April 2, 2013, https://nypost.com/2013/04/02/tom-hanks-revives-old-school-ny-tabloids-in-nora-ephrons-lucky-guy/.

24. Jacob Bernstein, "Nora Ephron's Final Act," *New York Times*, March 6, 2013, https://www.nytimes.com/2013/03/10/magazine/nora-ephrons-final-act.html.

25. Vincentelli, "Tom Hanks Revives Old-School NY Tabloids."

26. Bernstein, "Nora Ephron's Final Act."

27. Bernstein, "Nora Ephron's Final Act."

28. Lisa Schwarzbaum, "Lucky Guy," EW.com, April 1, 2013, https://ew.com/article/2013/04/01/lucky-guy-2/.

29. Alexis Soloski, "Lucky Guy – Review," *Guardian*, April 2, 2013, https://www.theguardian.com/stage/2013/apr/02/lucky-guy-review.

CHAPTER 8: NORA EPHRON, FASHION ICON

1. Julia Guerra, "The Ultimate Nora Ephron Fall Fashion Guide," *InStyle*, October 11, 2022, https://www.instyle.com/nora-ephron-fall-fashion-guide-6748382.

2. Nora Ephron, "I Feel Bad About My Neck," in *I Feel Bad About My Neck: And Other Thoughts on Being a Woman* (New York: Alfred A. Knopf, 2006), 4.

3. Ephron, "I Feel Bad About My Neck," 4.

4. Nora Ephron, "I Hate My Purse," in *I Feel Bad About My Neck*, 15.

5. Ephron, "I Hate My Purse," 15.

6. Tracey Lomrantz Lester, "Q&A: We Chat with Delia and Nora Ephron About Their New Play, 'Love, Loss, and What I Wore,'" *Glamour*, October 14, 2009, https://www.glamour.com/story/qa-we-chat-with-delia-and-nora.

CHAPTER 9: HOW SOCIAL MEDIA HAS PROLIFERATED NORA EPHRON'S LEGACY

1. Julia Guerra, "The Ultimate Nora Ephron Fall Fashion Guide," *InStyle*, October 11, 2022, https://www.instyle.com/nora-ephron-fall-fashion-guide-6748382.

2. Nora Ephron, "Moving On," *New Yorker*, May 29, 2006, https://www.newyorker.com/magazine/2006/06/05/moving-on-nora-ephron.

3. Ephron, "Moving On."

4. Nora Ephron, *Heartburn* (New York: Vintage Contemporaries, 1996), 4, 177.

CHAPTER 10: NORA EPHRON'S LOVE AFFAIR WITH FOOD

1. Mark Rizzo, "My Day on a Plate: Nora Ephron," gourmet.com, August 3, 2009, http://www.gourmet.com.s3-website-us-east-1.amazonaws.com/food/2009/08/my-day-on-plate-nora-ephron.html.

2. James Oliver Cury, "Nora Ephron," Epicurious, accessed July 29, 2023, https://www.epicurious.com/archive/chefsexperts/interviews/noraephroninterview.

3. Cury, "Nora Ephron."

4. Nicki Gostin, "15 Food Questions for Nora Ephron," *Newsweek*, May 18, 2010, https://www.newsweek.com/15-food-questions-nora-ephron-220580.

5. Nora Ephron, "I Just Want to Say: The Egg-White Omelette," in *I Remember Nothing: And Other Reflections* (New York: Vintage Books, 2010).

6. Cury, "Nora Ephron."

7. Nora Ephron, "Serial Monogamy: A Memoir," in *I Feel Bad About My Neck: And Other Thoughts on Being a Woman* (New York: Alfred A. Knopf, 2006).

8. Ephron, "Serial Monogamy: A Memoir."

9. Nora Ephron, "The Food Establishment: Life in the Land of the Rising Souffle (Or Is It the Rising Meringue?)" in *Wallflower at the Orgy* (New York: Bantam Books, 2007).

10. Nora Ephron, "Baking Off," in *Crazy Salad: Some Things About Women* (New York: Alfred A. Knopf, 1975), 115.

11. Ephron, "The Food Establishment."

12. Ephron, "Serial Monogamy: A Memoir."

13. Sutanya Dacres, "40 Years Later, This Is Still the Best Recipe for Surviving Heartbreak," *Wall Street Journal*, March 6, 2023, https://www.wsj.com/articles/40-years-later-this-is-still-the-best-recipe-for-surviving-heartbreak-6fb2475b.

14. FilMagicians, "When Harry Met Sally Discussion with Nora Ephron & Rob Reiner," YouTube, 2017, https://www.youtube.com/watch?v=q5-j7K8Mbzk.

15. Linda Wertheimer, "Nora Ephron on Julie, Julia and Cooking Like a Child," NPR, August 7, 2009, https://www.npr.org/2009/08/07/111543710/nora-ephron-on-julie-julia-and-cooking-like-a-child.

16. Wertheimer, "Nora Ephron on Julie, Julia and Cooking Like a Child."

17. Nora Ephron, *Heartburn* (New York: Vintage Contemporaries, 1996), 177.

18. Meghan Daum, "I Was a Wallflower at Nora Ephron's Hollywood Soiree," *Elle*, December 25, 2014, https://www.elle.com/culture/celebrities/a18949/i-went-to-a-marvelous-party/.

19. "Entertaining with Nora Ephron," *Splendid Table*, June 7, 2002, https://www.splendidtable.org/episode/2002/07/06/entertaining-with-nora-ephron.

20. Barbara Hoffman, "Friends Remember Nora Ephron," *New York Post*, June 6, 2013, https://nypost.com/2013/06/06/friends-remember-nora-ephron/.

21. Todd S. Purdum, "Remembering Nora Ephron, an Unequaled Dinner Companion and Friend," *Vanity Fair*, June 27, 2012, https://www.vanityfair.com/news/2012/06/nora-ephron-remembered-dinner-companion.

22. Nora Ephron, "How I Learned to Stop Worrying . . . ," *New York Times*, November 5, 2000, http://www.nytimes.com/library/magazine/specials/20001029mag-ephron23.html.

23. Ephron, *I Feel Bad About My Neck*, 25.

24. John Horn, "Nora Ephron's 'Cookbook' Showcases Passion for Food, Prose," *Los Angeles Times*, June 28, 2012, https://www.latimes.com/entertainment/movies/la-xpm-2012-jun-28-la-et-mn-ephron-cookbook-20120628-story.html.

25. Horn, "Nora Ephron's 'Cookbook' Showcases Passion for Food, Prose."

26. Sam Sifton, "Potlucky," *New York Times*, July 22, 2009, https://www.nytimes.com/2009/07/26/magazine/26food-t-000.html.

27. Horn, "Nora Ephron's 'Cookbook' Showcases Passion for Food, Prose."

28. "Nora Ephron Talked 'Last Meals' with Charlie Rose," HuffPost, August 26, 2012, https://www.huffpost.com/entry/nora-ephron-last-meal_n_1629660.

29. Charles McGrath, "Nora Ephron Dies at 71: Writer and Filmmaker with a Genius for Humor," *New York Times*, June 27, 2012, https://www.nytimes.com/2012/06/27/movies/nora-ephron-essayist-screenwriter-and-director-dies-at-71.html.

30. "Nora Ephron Talked 'Last Meals' with Charlie Rose."

CHAPTER 11: LIFE AFTER EPHRON

1. Jacob Bernstein and Nick Hooker, *Everything Is Copy*, 2015, HBO, 6:10.

2. Bernstein and Hooker, *Everything Is Copy*, 6:00.

3. Pam Belluck, "Ephron's Leukemia Was Uncommon and Complicated," *New York Times*, June 28, 2012, https://www.nytimes.com/2012/06/28/science/nora-ephrons-leukemia-was-an-uncommon-and-complicated-type.html.

4. Jacob Bernstein, "Nora Ephron's Final Act," *New York Times*, March 6, 2013, https://www.nytimes.com/2013/03/10/magazine/nora-ephrons-final-act.html.

5. Chuck Bennett, "'Sleepless in Seattle' Writer Nora Ephron Dead at 71," *New York Post*, June 27, 2012, https://nypost.com/2012/06/27/sleepless-in-seattle-writer-nora-ephron-dead-at-71/.

6. Jeannette Catsoulis, "Review: 'Everything Is Copy,' a Son's Tribute to Nora Ephron," *New York Times*, March 17, 2016, https://www.nytimes.com/2016/03/18/movies/review-everything-is-copy-a-sons-tribute-to-nora-ephron.html.

7. Sheila Roberts, "Jacob Bernstein on Directing Everything Is Copy, Nora Ephron," Collider, March 21, 2016, https://collider.com/everything-is-copy-nora-ephron-jacob-bernstein-interview/.

8. Eliana Dockterman, "Good Girls Revolt on Amazon: The True Story, as Told in 1970," *Time*, October 28, 2016, https://time.com/4547689/the-true-story-behind-good-girls-revolt-as-told-in-1970/.

9. NPR Staff, "'Good Girls Revolt': Story of a Newsroom Uprising," NPR, September 9, 2012, https://www.npr.org/2012/09/09/160685709/good-girls-revolt-story-of-a-newsroom-uprising.

10. Jethro Nededog, "Inside 'Sleepless in Seattle' Screenwriter Nora Ephron's Pivotal Role on Amazon's 'Good Girls Revolt,'" *Business Insider*, October 28, 2016, https://www.businessinsider.com/nora-ephron-amazon-good-girls-revolt-2016-10.

11. Greatest Speeches, "Nora Ephron Commencement Address to Wellesley class of 1996 | Empowerment of women," YouTube, 2021, https://www.youtube.com/watch?v=dBoOFxC2Qjs.

12. Tessa Trudeau, "How Meryl Streep Helped Daughter Grace Gummer Prepare for Her Role on Good Girls Revolt," Yahoo! News, October 29, 2016, https://www.yahoo.com/news/meryl-streep-helped-daughter-grace-164500475.html.

13. Sony Pictures Entertainment, "Good Girls Revolt - Girls Don't Do Rewrites," YouTube, 2015, https://www.youtube.com/watch?v=M7RmbSsM9xo.

14. Dockterman, "Good Girls Revolt."

15. Dockterman, "Good Girls Revolt."

16. Rachel Syme, "The Nora Ephron We Forget," *New Yorker*, August 15, 2022, https://www.newyorker.com/magazine/2022/08/22/the-nora-ephron-we-forget.

17. Patrick Ryan, "Lena Dunham: 'Voice of a Generation' Label Will Be on My Tombstone," *USA Today*, April 17, 2017, https://www.usatoday.com/story/life/entertainthis/2017/04/17/lena-dunham-girls-hbo-series-finale/100561780/.

18. Michiko Kakutani, "Hannah's Self-Aware Alter Ego," *New York Times*, September 23, 2014, https://www.nytimes.com/2014/09/24/books/lena-dunhams-memoir-ish-not-that-kind-of-girl.html.

19. Lena Dunham, *Not That Kind of Girl* (New York: Random House, 2014).

20. Lena Dunham, "Seeing Nora Everywhere," *New Yorker*, June 28, 2012, https://www.newyorker.com/culture/culture-desk/seeing-nora-everywhere.

21. John Heilpern, "OTL: Mindy Kaling," *Vanity Fair*, November 17, 2011, https://www.vanityfair.com/news/2011/12/mindy-kaling-201112.

22. The Mindy Project, "Winning Back Mindy - The Mindy Project," YouTube, 2021, https://www.youtube.com/watch?v=X9xwWkHpscU.

23. Sam Fragoso, "Tom Hanks on What Nora Ephron Told Him About Writing," via *Talk Easy*, July 11, 2023, https://lithub.com/tom-hanks-on-what-nora-ephron-told-him-about-writing/.

AFTERWORD

1. Rachel Syme, "The Nora Ephron We Forget," *New Yorker*, August 15, 2022, https://www.newyorker.com/magazine/2022/08/22/the-nora-ephron-we-forget.

2. *Sleepless in Seattle*, directed by Nora Ephron, 1993, TriStar Pictures.

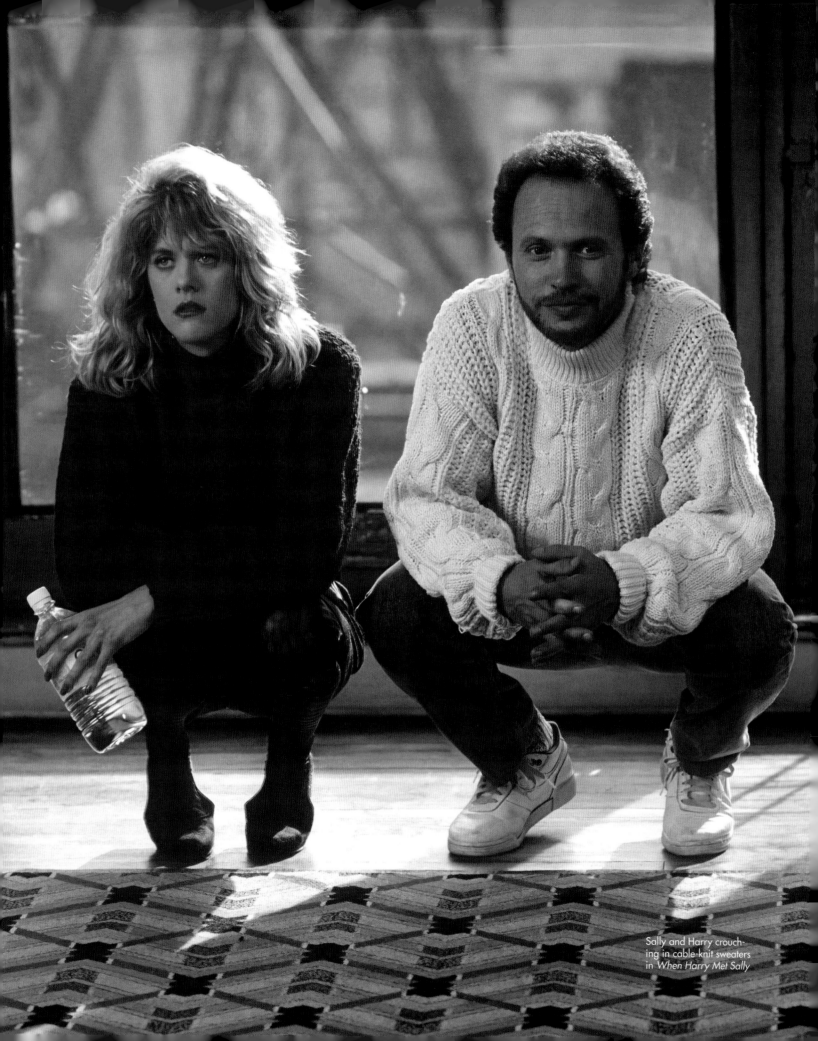

Sally and Harry crouching in cable-knit sweaters in *When Harry Met Sally*

Image Credits

p. 2: Cinematic/Alamy Stock Photo

pp. 4, 14, 15 (third from top), 52, 53, 54–56, 57 (left), 58, 59, 60 (left), 61 (both), 67, 68, 69, 196: trademark and copyright © 20th Century-Fox Film Corp./Courtesy Everett Collection

pp. 7, 12, 21 (bottom), 38, 40, 41 (bottom left), 42 (all), 43 (both), 44, 45, 140, 146, 197, 198, 199, 202: Courtesy Everett Collection

pp. 8, 28–29, 46, 48 (top), 49 (both), 50 (both), 51, 86–87, 88, 90, 91 (all), 92 (all except bottom right), 93, 94, 96, 97 (all), 98 (all), 99, 156–157, 164: © Warner Bros. Pictures/Courtesy Everett Collection

pp. 11, 22 (center), 70–71, 72, 74 (both), 76, 77 (both), 78 (both), 79, 114, 116, 117 (all), 118, 119, 186, 188: © Paramount Pictures/Courtesy Everett Collection

pp. 13, 200: Bei/Shutterstock

pp. 15 (top left), 145: CPL Archives/Courtesy Everett Collection

p. 15 (top right): Mirrorpix/Courtesy Everett Collection

p. 15 (second from top): Mary Evans/AF Archive/Courtesy Everett Collection

pp. 15 (bottom), 41 (top), 100, 102, 103 (all), 104, 106 (all), 107 (left and right), 174: © TriStar Pictures/Courtesy Everett Collection

p. 16: DMI/The LIFE Picture Collection

p. 17: Neville Elder/Contributor/Getty Images

pp. 18, 22 (top left): © Universal Pictures/Courtesy Everett Collection

p. 20: © Buena Vista Pictures/Courtesy Everett Collection

pp. 21 (top), 23, 25 (right), 27, 32 (both), 33, 34 (all at right), 36, 80, 82 (both), 83 (all), 84 (both), 85, 120, 122 (all), 123, 124, 125 (top), 126, 127, 158–159, 160, 161, 162–163, 166, 167, 222: © Columbia Pictures/Courtesy Everett Collection

p. 22 (top right): © NBC/Courtesy Everett Collection

p. 22 (bottom): © Miramax/Courtesy Everett Collection

p. 23 (bottom): Linda Kallerus/© IFC Films/Courtesy Everett Collection

p. 25 (left): Mary Evans/Simon Fields Productions /Tapestry Films/Ronald Grant/Courtesy Everett Collection

p. 26: Masha Weisberg/© Netflix/Courtesy Everett Collection

pp. 30, 34 (left), 37, 48 (bottom left): Mary Evans/Ronald Grant/Courtesy Everett Collection

p. 41 (bottom right): Moviestore Collection Ltd./Alamy Stock Photo

p. 48 (bottom right): AJ Pics/Alamy Stock Photo

p. 57 (right): Kerry Hayes/TM and © 20th Century-Fox Film Corp./Courtesy Everett Collection

p. 60 (right): Mary Evans/© 20th Century-Fox Film Corp./Ronald Grant/Courtesy Everett Collection

pp. 62, 64, 65 (both), 66 © MGM/Courtesy Everett Collection

p. 75: Ron Galella/Ron Galella Collection via Getty Images

pp. 92 (bottom right), 187, 194: United Archives GmbH/Alamy Stock Photo

p. 105: Mary Evans/Tristar Pictures/Ronald Grant/Courtesy Everett Collection

p. 107 (center): Andy Schwartz/© TriStar Pictures/Courtesy Everett Collection

pp. 108, 110 (all), 111 (top), 112 (both), 113 (all), 184–185, 207: © New Line Cinema/Courtesy Everett Collection

p. 111 (bottom): Mary Evans/New Line Cinema/Ronald Grant/Courtesy Everett Collection

p. 125 (bottom): Fernando Leon/Everett Collection

pp. 128–129, 130, 132 (both), 133 (both), 134, 135, 136 (both), 137, 190, 191: Jonathan Wenk/© Columbia Pictures/Courtesy Everett Collection

pp. 138–139: New York Times/Katherine Wolkoff/Trunk Archive

p. 142: Fred W. McDarrah/MUUS Collection via Getty Images

pp. 143, 144 (both): Copyright © Alfred A. Knopf

p. 147: Copyright © Bantam Books

pp. 148–149: Rob Kim/Courtesy Everett Collection

pp. 150, 195: Gregorio T. Binuya/Courtesy Everett Collection

pp. 153, 155: WENN Rights Ltd./Alamy Stock Photo

p. 154: Sara Krulwich/The New York Times/Redux

pp. 168–169: Jennifer Altman/Contour RA by Getty Images

p. 170: Paul Child/© PBS/Courtesy Everett Collection

p. 173: Erica MacLean

pp. 176–177, 180: © HBO/Courtesy Everett collection.

p. 178: RGR Collection/Alamy Stock Photo

pp. 181 (all), 201: Jessica Miglio/© Amazon/Courtesy Everett Collection

p. 182: © Random House

p. 183 (top): Jordin Althaus/© Fox/Courtesy Everett Collection

p. 183 (bottom): Brad Barket/Courtesy Everett Collection

p. 192: © Orion Pictures/Courtesy Everett Collection

p. 203: Warner Bros. Pictures/Album/Alamy Stock Photo

p. 209: Sarah Shatz/© Netflix/Courtesy Everett Collection

p. 210: Kim Simms/© Netflix /Courtesy Everett Collection

Page 2: Julie, played by Amy Adams, and Eric, played by Chris Messina, in *Julie & Julia* (2009)

Editor: Holly Dolce
Designer: Danielle Youngsmith
Design Manager: Zach Bokhour
Managing Editor: Lisa Silverman
Production Manager: Kathleen Gaffney

Library of Congress Control Number: 2024933742

ISBN: 978-1-4197-6363-2
eISBN: 978-1-64700-766-9

Text copyright © 2024 Ilana Kaplan
Image credits can be found on page 223

Cover © 2024 Abrams

Published in 2024 by Abrams, an imprint of ABRAMS. All rights reserved.
No portion of this book may be reproduced, stored in a retrieval system, or
transmitted in any form or by any means, mechanical, electronic, photocopying,
recording, or otherwise, without written permission from the publisher.

Printed and bound in China
10 9 8 7 6 5 4 3 2 1

Abrams books are available at special discounts when purchased in quantity
for premiums and promotions as well as fundraising or educational use.
Special editions can also be created to specification. For details, contact
specialsales@abramsbooks.com or the address below.

Abrams® is a registered trademark of Harry N. Abrams, Inc.

ABRAMS The Art of Books
195 Broadway, New York, NY 10007
abramsbooks.com